The Official Guides to Italian Museums

Luisa Arrigoni
Emanuela Daffra
Pietro C. Marani

The Brera Gallery
The Official Guide

Touring Club Italiano

Soprintendenza per i Beni
Artistici e Storici, Milan

This book has been
sponsored by

UniCredito Italiano

Touring Club Italiano
President: Giancarlo Lunati

Touring Editore
Managing director: Armando Peres
Assistant managing directors:
Adriano Agnati e Radames Trotta
Editorial director: Marco Ausenda
General coordinator: Michele D'Innella

Editorial coordination: Asterisco srl
Editing: Silvana Marzagalli
Graphic design: AchilliGhizzardiAssociati
English translation: David Stanton

Photographs: Pinacoteca di Brera
Filmsetting: Emmegi Multimedia, Milan
Printing and binding: Poligrafiche Bolis,
Azzano San Paolo - Bergamo

© 1998 Touring Editore s.r.l, Milan
© 1998 Soprintendenza per i Beni
Artistici e Storici, Milan

Note
The numbering of the paintings
follows the order in which they are
displayed in each room: this is
in a clockwise direction, beginning
to the left of the entrance door.
There are, however, a few exceptions
to this rule: room I, where the
numbering follows the alphabetical
order of the artists because, for
reasons of space, not all the works
are on display at the same time;
rooms IV and V, where the paintings
are described in chronological order.
The white numbers in red squares
denote the most outstanding paintings
in each room.

ISBN 88-365-1406-5
Code A2M
Printed in Italy, 1999

Contents

Preface *by Luisa Arrigoni* ... 8
Room I
The Jesi Gift: 20th-century paintings and sculptures 16
Room IA
The Chapel of Mocchirolo ... 48
Room II Room III Room IV
Italian paintings from the 13th to the 15th centuries 52
Room V
Venetian paintings of the 15th and 16th centuries 70
Room VI
Venetian paintings of the 15th and 16th centuries 78
Room VII
Venetian portraits of the 16th century 90
Room VIII
Venetian paintings of the 15th century 100
Room IX
Venetian paintings of the 16th century 112
Room XIV
Venetian paintings of the 16th century 122
Room XV
Lombard paintings and frescoes of the 15th and 16th centuries 138
Room XVIII
Lombard paintings of the 16th century 150
Room XIX
Lombard religious paintings and portraits
of the 15th and 16th centuries .. 164
Room XX
15th-century paintings from Ferrara and Emilia-Romagna 176
Room XXI
15th-century polyptychs from the Marches 186
Room XXII
15th- and 16th-cent. paintings from Ferrara and Emilia-Romagna 198
Room XXIII
16th-century paintings from Emilia-Romagna 210
Room XXIV
Piero della Francesca, Signorelli, Bramante and Raphael 216
Room XXVII
The painting of Central Italy in the 15th and 16th centuries 222
Room XXVIII
The painting of Central Italy in the 17th century 230
Room XXIX
Caravaggio and the Caravaggisti ... 238
Room XXX
Lombard painting in the 17th century 246
Room XXXI
Flemish and Italian paintings of the 17th century 254
Room XXXII Room XXXIII
Flemish and Dutch paintings of the 16th and 17th centuries 266
Room XXXIV
Religious painting of the 18th century 278
Room XXXV Room XXXVI
Venetian paintings, Italian genre paintings
and portraits of the 18th century 290
Room XXXVII Room XXXVIII
Italian paintings of the 19th century 310
Index of artists .. 332
Glossary and Select Bibliography .. 336

This exhaustive "official guide" to Milan's most prestigious museum, which the Touring Club Italiano has published with the valuable collaboration of the Soprintendenza per i Beni Artistici e Storici, Milan, and with the support of Credito Italiano, goes well beyond the limits of a catalogue. It has the systematic approach of the catalogue insofar as that, for each painting, it gives all the technical details; these are accompanied by a reproduction of the work so that it may be recognized during the visit to the gallery and, before or after this, studied more profoundly. On the other hand, it contains the wealth of information that is typical of the guide, leading the visitor through the rooms in numerical order and providing complete information in each entry for the individual works. The introduction gives an account of the history of the Brera, starting with the period prior to the foundation of the Gallery and the glorious Academy of Fine Arts, then proceeding to outline its development to the present day. The entries reconstruct the vicissitudes of each picture before it reached the Brera, highlighting the overall design, the symbols, allusions and cultural influences – not only of an artistic nature – that inspired their creation; and, naturally, they lay particular emphasis on their artistic quality. Also typical of a guide are the suggestions given to prospective visitors with regard to the especially outstanding paintings in front of which it is worth lingering a little longer. Thus, readers will learn that the masterpieces of the Brera are not limited to the extremely famous works by Piero della Francesca, Tintoretto, Raphael, Veronese, Mantegna and Giovanni Bellini. They will discover, in particular, that the Brera has gone far beyond the objective that, in 1812, its governors set themselves "of constituting a collection that, thanks to the quantity of works and the range of its interests, is worthy of the Kingdom of Italy". The subsequent acquisitions of notable works have further accentuated its role as a museum of national importance. Indeed, if Milan can rival the more famous historic cities of Italy, it owes this, at least in part, to its splendid Art Gallery. With this volume – for which special thanks are due to the former superintendent Pietro Petraroia – the Touring Club Italiano is proud to pay homage both to the culture of the city where it was founded in 1894 and to the artistic genius of Italy and the rest of Europe. And it is particularly delighted to do so on the eve of the completion of the "Grande Brera" project, which follows the lines of development that have helped to revitalize all the world's leading museums.

Giancarlo Lunati
President of the Touring Club Italiano

The catalogue is the essence of a collection. In the proprietorial guise of the inventory, or the methodical one of a list arranged by categories, or the descriptive one of the guide, the enumeration of the single objects that make it up is an operation that is not only indispensable but also constitutive. Unlike other Italian museums originating from aristocratic or dynastic collections, or individual cultured collectors, and deriving their identity from their genesis (that is, from the original inventory), the Brera's *raison d'être* lies in the continuous, repeated cataloguing of its contents. The first public museum in Italy and a product of the Enlightenment, the Brera Gallery can boast the largest number of catalogues, ranging from the one compiled by the then secretary, Giuseppe Bossi, in 1806, to the nine volumes edited by the late lamented Federico Zeri recently published by Electa. However, a guide that, like this one, sets out to describe the disposition of the paintings in each room – on each wall, even – seems to be a hazardous undertaking due to the continuous need to critically reassess the way the collections are displayed, following what is virtually a conceptual taxonomy, so that the works may be seen to the best advantage. Although the new premises in the Palazzo Citterio have yet to be completed, the collection continues to grow, so that the criteria for the display of the pictures have to be continuously reconsidered. The present ones are reflected in this guide, the urgent need for which was felt by the former superintendent for fine arts in Milan, Pietro Petraroia, and the authors, all members of the Brera staff: the director, Luisa Arrigoni, Emanuela Daffra and Pietro C. Marani. This necessity was also perceived by the Touring Club Italiano, on behalf of which the managing director Armando Peres and the editorial director Marco Ausenda have done all within their power to facilitate the publication of this guide, which contributes to making Italy's artistic heritage better known, thereby safeguarding it. Moreover, this volume would not have been possible without the generous support of Credito Italiano, which is to be commended for its faith in the successful outcome of the enterprise. The obvious fact that a museum is made up not only of exhibits but also of people is further demonstrated by the excellent photographs Patrizia Mancinelli and Antonia Prudenzano have taken of the paintings. All these people deserve the thanks of those who will be consulting this guide, which will lead them through the rooms of the gallery to admire the remarkable artistic heritage on display.

Bruno Contardi
Soprintendenza per i Beni Artistici e Storici, Milan

Preface

by Luisa Arrigoni

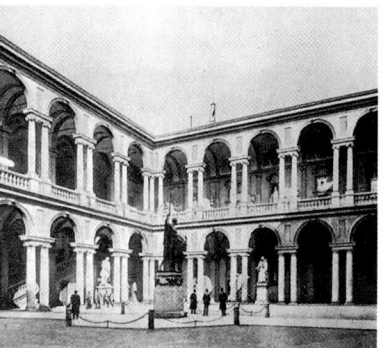

The bronze statue of *Napoleon as Mars the Peacemaker*, by A. Canova, has only dominated the courtyard since 1859, the date of Napoleon III's visit to Milan.

The Palazzo di Brera

The severe monumental complex of the Palazzo di Brera, built in Late-Baroque style during the Counter-Reformation, dates back to the time of the Humiliati, a semi-monastic order that was the result of the heretical pressure and social unrest in Lombardy after the year 1000; involved both in religious practices and, above all, productive activities, it became famous for its production of wool cloth, which was sought-after throughout western Europe. This order had its mother-house at Brera from 1201 to 1571, and this was flanked by the church of Santa Maria. The church was completed in 1347 with a façade in black and white marble and an elegant Gothic portal with sculptures by Giovanni di Balduccio. The monastery and church have now almost entirely disappeared (fragments of the decoration and sculptures are now kept at the Castello Sforzesco, in Milan, while a number of 14th-century frescoes attributed to Giusto de' Menabuoi are visible in a room in the Brera Academy), but they were the original nucleus of the Brera complex, which can only be fully appreciated today from the Botanical Garden and the private garden in Piazzetta Brera.
In 1571, Pope Pius V, at the request of Cardinal Charles Borromeo, dissolved the congregation of the Humiliati; the monastery, with the adjoining land, was given to the Jesuits, who undertook to set up schools and a college there. The first projects for the buildings required were drawn up between 1573 and 1590 by Martino Bassi, but the work did not get very far. In 1627 Francesco Maria Richini, the leading Milanese architect in the first half of the 17th century, took over the project and the first concrete results were obtained. The monastery was rebuilt and the first classrooms of the school were built. Because of modifications, the design and work

proceeded very slowly and it was only in 1651 that the general of the Jesuits approved Richini's final project in which the main façade comprised a wall faced in dark red brick, reinforced at the corners and adorned with sturdy pilasters in grey ashlar, projecting cornices forming the string-courses and windows surmounted by broken-bed pediments, alternately straight-sided and segmental, also in stone. For the interior, in addition to two rustic courtyards, following the example of the Jesuit college in Rome, the Borromeo one in Pavia and the palaces designed by Galeazzo Alessi in Genoa, there was a large rectangular courtyard enclosed by two tiers of loggias with arches taking the form of the Serlian motif in which the elegant pink granite double columns had Tuscan capitals on the ground floor and Ionic ones on the upper floor. The courtyard was linked to the loggia by an imposing double staircase. After Richini's death in 1658, the work was executed by his son Giandomenico, and also by Gerolamo Quadrio and Giorgio Rossone, up-and-coming architects at the time. For a century the work proceeded according to Richini's designs and the building took the solid, austere form typical of Late-Baroque Lombard architecture, which, nevertheless, allows it to stand out in its urban context.

An innovatory development in 1764-65 was the construction, on the initiative of Ruggero Boscovich – a Jesuit priest who was a renowned mathematician, astronomer and geodesist – of an observatory that was later expanded and modernized. In 1773, with the dissolution of the Society of Jesus, the Brera college became state property, and Maria Theresa of Austria decided that the palace should be completed. In 1774 she commissioned the Royal Imperial Architect, Giuseppe Piermarini, a pupil of Vanvitelli, to plan and carry out the work. In 1776 the former Jesuit institutes were taken over by the newly-founded Brera Academy and Società Patriottica (later Istituto Lombardo di Scienze e Lettere), which had the task of studying and experimenting with innovations in agriculture and industry. Piermarini began with the Library, which was entirely rebuilt and enlarged, and provided with access from Richini's staircase and sober, elegant shelves in walnut (still in place in the Sala Maria Teresa, visible from room I in the gallery), and then continued with the Observatory, the Botanical Garden and the Academy. Between 1778 and 1795 the upper floor of the section facing Via Brera was finished, as was the main entrance, now on the same street and consisting of a monumental Neoclassicist portal in the form of an arch with columns, while the courtyard was completed with a new wing facing the piazza.

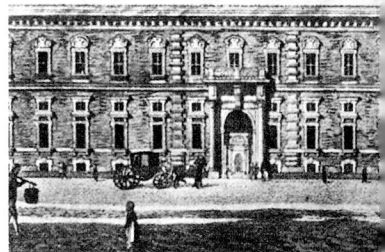

The severe contrast of colours resulting from the dark red bricks and the grey pilasters lends a solemn air to the façade of the Palazzo di Brera.

With the arrival of the French in 1796 and the rise to power of Napoleon, political and cultural changes gave different stimuli to the institutions at Brera, where the Academy began to dominate. In 1801 the appointment of the painter Giuseppe Bossi as secretary and, in 1802, the presence of Andrea Appiani, also a painter and, above all, the powerful and dynamic commissioner for fine art, were decisive for the subsequent history of the palace and the birth of the Art Gallery. Bossi devoted himself to the renovation programme of the Academy, sponsoring the creation (1806) of a gallery of pictures, plaster casts and engravings for educational purposes. Appiani, on the other hand, brought a huge quantity of pictures to Brera from suppressed churches and monasteries, so that in 1808, to house the new picture gallery, it was decided to rebuild the church of Santa Maria di Brera, dividing the structure into two floors, the upper one for the Museo delle Antichità Lombarde (sculptures) and the lower one for the gallery. The Gothic façade of the church was demolished so as to bring the building forward a few metres and modify its plan. The Gallery was divided into four large square rooms; known as the Napoleonic rooms, they were illuminated both by windows and skylights in the centres of the ceilings, while the doorways from one room to another were flanked by columns. Throughout the 19th century, building work was limited to internal alterations. However, the most notable development took place in 1859, after the triumphal entry of Vittorio Emanuele II and Napoleon III into Milan: a colossal bronze statue of Napoleon I, in the guise of Mars the peacemaker, which had been commissioned by the viceroy Eugène de Beauharnais in 1807 and cast in Rome in 1811-12 from a modello by Antonio Canova, was finally erected on a pedestal designed by Luigi Bisi. Equally significant was the decision to display sculptural works in the loggias, courtyards, lobbies and corridors to commemorate artists, benefactors, cultural figures and scientists associated with the Brera institutions. The most outstanding works of this rich collection of sculptures have remained – for instance, two monuments of 1838, one to the legal theorist and economist Cesare Beccaria by Pompeo Marchesi and the other to the poet Giuseppe Parini by Gaetano Monti, each located on the intermediate landing of one of the two flights of the main staircase.

During the 20th century, the institutions in the palace have adapted their internal spaces to new functions. Nonetheless, the building, with its various wings, courtyards and lofty corridors, often darkened by the closure of the original Venetian windows, has maintained its austere magnificence.

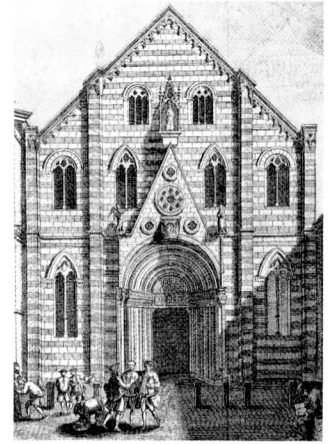

The elegant Gothic façade of the church of Santa Maria di Brera, demolished at the beginning of the 19th century, in an old print.

The Brera Gallery and its collections

One of the leading public galleries in Italy, the Brera differs from those in Florence, Rome, Naples, Turin, Modena and Parma in that its origins do not lie in the collections of the nobility, princes or courts, but rather in the cultural politics of the state in the Napoleonic era, reflecting the democratic concepts of the French Revolution. Like the Gallerie dell'Accademia in Venice and the Pinacoteca in Bologna, the Brera was originally founded as an appendage, for didactic ends, to an academy of fine arts. However, the Milanese gallery soon differentiated itself from the other two and, to meet the political requirements of the capital city of the Kingdom of Italy, was transformed into a large modern national museum in which works of all the schools of painting of the conquered territories could be safely preserved to be studied and compared, and to be seen by the public at large. The first paintings reaching the Brera were, in 1799, a number of large canvases by Pierre Subleyras, Giuseppe Bottani, Pompeo Batoni, Carlo Francesco Nuvolone and Stefano Maria Legnani, which came from the church of Santi Cosma e Damiano alla Scala in Milan; four of them are now displayed in room XXXIV. Under Giuseppe Bossi, who had been appointed secretary of the Academy in 1801, numerous other paintings were added to the collection. By this date, in the four rooms on the first floor, in addition to about thirty portraits and self-portraits by painters who were mainly Lombard, the paintings on display already included the *Crucifixion* by Bramantino, the *Virgin and Child with St John the Evangelist and St Michael* by Figino, *St Jerome* and *St Cecilia* by G. C. Procaccini, *St Helen, St Barbara, St Andrew, St Macarius, Another Saint and a Donor Adoring the Cross* by Tintoretto and *The Martyrs Valerian, Tiburtius and Cecilia Visited by an Angel* by Orazio Gentileschi. Other important paintings included the triptych of *St Helen and Constantine* by Palma Vecchio, the *Marriage of the Virgin* by Raphael, the *Virgin and Child* of 1510 by Giovanni Bellini and the *Portrait of Lucio Foppa* by Figino.

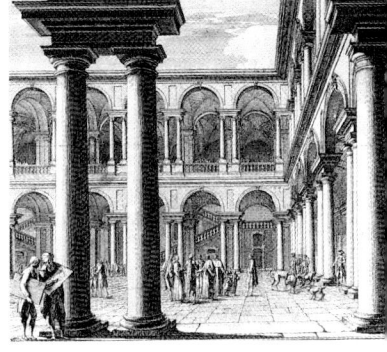

The courtyard of the Palazzo di Brera at the end of the 18th century, at the time when the Academy of Fine Arts was founded, in an old print.

Already in 1805, when Napoleon was crowned king of Italy, it was decreed that the works of art requisitioned in the departments of the kingdom should be brought to the Academy in Milan, where those by the most famous artists would be displayed in the gallery. When, in 1807, Bossi resigned due to differences with the minister of the interior, the appointment of Andrea Appiani as keeper of the gallery permitted the collections to grow rapidly thanks to his dedication to the task of selecting the works and organizing consignments. To this

end, he frequently made journeys to reconnoitre the various areas, then drew up lists of works worthy of attention.

After the paintings removed from churches and monasteries in Lombardy, hundreds more came to the Brera from the various departments, especially in the Veneto, chosen discerningly by Pietro Edwards, and soon one of the largest picture galleries in Italy had been created. Although, until 1811, almost all of the confiscated works had been large altarpieces, which from then onwards conferred a solemn air on the Brera, in that year additions to the collections included the *Pietà* by Giovanni Bellini and a number of paintings acquired from the famous Galleria Sampieri of Bologna. In the same year, in order to make up for the total lack of works by followers of Leonardo and Raphael, twenty-three paintings and drawings were requisitioned – although officially it was an exchange – from the picture gallery of the Archbishop of Milan. Forming part of the bequest made in 1650 by Cardinal Cesare Monti, these works included *Christ and the Woman Taken in Adultery* and the *Finding of Moses* by Bonifazio de' Pitati (at that time they were believed to be by Palma Vecchio and Giorgione respectively), *St Mary Magdalen* by Giulio Cesare Procaccini, and the *Baptism of Christ* by Paris Bordone.

In 1813, as the result of an agreement with the Louvre, five paintings were exchanged for the same number of works by Rubens, Jacob Jordaens, van Dyck and Rembrandt. The best paintings were hung in the Napoleonic rooms, since then the hub of the gallery. The other works were sent to the storerooms, ready to be exchanged (not always on favourable terms) or, more frequently, to be allocated to the parish churches that had requested them. Between 1811 and 1824 almost a third of the works recorded in the *Inventario Napoleonico* (in this, from 1808 to 1842, all the works coming to the Brera were listed in chronological order) had been loaned to other institutions in a new dispersal that meant that the confiscated paintings were even further removed from their origins. In the same period numerous detached frescoes arrived in the gallery from various churches and the Gallery, which has today what is possibly the largest collection of this type, began to specialize in the activity of restoration and conservation that, since then, has continued to be one of its most important functions. From 1815 onwards, with the restoration of Austrian rule and after the restitution of a number of works to the Papal States, the collection continued to grow, although at a slower rate, thanks to bequests, gifts, purchases and exchanges. Works that were acquired by the Gallery before the unification of Italy include the *Adoration*

The false ceiling, designed by Vittorio Gregotti (1996), illuminates the Venetian paintings of the 15th and 16th centuries in rooms VI and VII.

of the Magi by Stefano da Verona (also known as Stefano da Zevio); *Christ and the Samaritan Woman* by Giovanni Battista Caracciolo; the *Dead Christ* by Mantegna; the *Madonna of the Rose Garden* by Luini; the two views of Gazzada by Bernardo Bellotto; the large picture gallery, comprising eighty Italian and Flemish paintings, belonging to Pietro Oggioni; and three portraits by Lorenzo Lotto, donated by Vittorio Emanuele II after his entry into Milan with Napoleon III.

In 1882 the Gallery became independent of the Academy of Fine Arts, which, because it was principally concerned with teaching, continued to be the owner of a large part of the contemporary paintings, although they were still displayed in the last rooms of the Brera Gallery. The Gallery, in fact, took over the vast majority of older works and, under Giuseppe Bertini – a painter, designer of stained-glass windows and restorer, renowned for the wide variety of his cultural interests, who was director from 1882 to 1898 – it was entirely reorganized, refurbished and extended. He was responsible for purchasing such outstanding works as the *Two Lovers* by Paris Bordone, two panels of the Grifoni polyptych by Francesco del Cossa and the *Portrait of Andrea Doria as Neptune* by Bronzino. In addition, another selection of works from the Monti Collection of the Archbishopric entered the Gallery; these comprised drawings and paintings that are, for various reasons, remarkable, such as the *Adoration of the Magi* by Correggio, the *Martyrdom of St Rufina and St Secunda* by Procaccini, Morazzone and Cerano, and the *Holy Family* by Bramantino. In the same period a survey of the pictures loaned to various churches was carried out, and, as a result of this, a number of masterpieces, including Tintoretto's *Finding of the Body of St Mark*, were returned to the Brera.

In the period from 1898 to 1903, when Corrado Ricci, an eminent art historian, was director of the gallery, important changes were made. The Gallery was extended with the addition of rooms and an access corridor (room I), so it now completely encircled the main courtyard. For the first time, the paintings were divided into the different regional schools, each in chronological order, and were displayed in a less confusing manner. A very precise account of the history of the Gallery, based on documents from the archives and yet to be surpassed, was published in 1907. Acquisitions continued with Bramante's *Men-at-Arms*, four small panels from the predella of *Valle Romita Polyptych* by Gentile da Fabriano (which allowed it to be reconstructed), and sixty-three paintings donated by the collector and art dealer Casimiro Sipriot. Under Francesco Malaguzzi Valeri (1903-1908), Ettore

Modigliani (1908-1934 and 1946-1947), and Antonio Morassi (1934-1939) as directors, a very active policy of purchases and frequent gifts brought important works to the Brera, such as two genre scenes by Pietro Longhi, two still lifes by Evaristo Baschenis, the *Nativity* by Correggio, *Rebecca at the Well* by Piazzetta, the *Madonna del Carmelo* by Tiepolo, two views of Venice by Canaletto and the *Red Wagon* by Giovanni Fattori. Since 1926 many purchases and gifts have been made under the auspices of the Associazione Amici di Brera, a cultural organization that also promotes educational activities, and thanks to which the Gallery acquired such outstanding works as Caravaggio's *Supper at Emmaus*, Silvestro Lega's *Pergola* and Giovanni Segantini's *Spring Pastures*.

After the Second World War, in 1946, the task of rebuilding was begun under the supervision of Piero Portaluppi, and, for one wing of the Gallery, of Franco Albini, while the pictures were rehung by the new director Fernanda Wittgens (1947-1957), assisted by Gian Alberto dell'Acqua, who then succeeded her (1957-1973). The splendid dècor of the renovated Gallery, which was partially reopened in 1950, was the result of a complex process of restoration, carefully designed settings (particularly outstanding was the "sanctuary" containing the masterpieces by Piero della Francesca and Raphael) and the use of up-to-date technology. Between 1950 and 1970 other paintings were added to the collections, including the *Coronation of the Virgin* by Nicolò di Pietro, the *Resurrection* by Cariani, the *Three Scenes from the Life of St Columba* by Baronzio and the two pictures of porters by Ceruti.

In the 1970s a series of events took place that left their mark on the recent history of the Gallery with periods of crisis and important new departures. When Franco Russoli became director in 1973, he was confronted with a Gallery that felt the effects of twenty years of inadequate funding, poor maintenance and lack of space. After he had brought this dramatic situation to the attention of the public by closing the Gallery in 1974, there was a positive outcome, with the launching of the "Grande Brera" project, which aimed to enlarge the Gallery by making use of the 18th-century Palazzo Citterio (at 12-14 Via Brera, it had been purchased in 1972), together with some rebuilding of the Brera itself. This would allow the provision of all the facilities now regarded as essential for a modern museum to function efficiently, such as an educational service and a reception area. Russoli's death in 1977 meant this project was suspended at an early stage. Under Carlo Bertelli (1977-1984), the Gallery was reopened and new spaces were acquired by incorporating the 18th-century

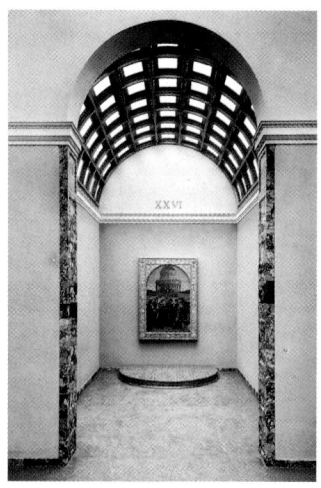

The room – virtually a "sanctuary" – that housed Raphael's *Marriage of the Virgin* in the mid-1950s: the painting has become a symbol of the Brera.

astronomer's apartment facing the Botanical Gardens. With installation design by Ignazio Gardella, this was used to display (1982) the gift by Emilio and Maria Jesi of paintings and sculptures by leading Italian artists of the early 20th century, and the loan of outstanding Futurist works from the Riccardo and Magda Jucker Collection, subsequently acquired by the municipality of Milan and now exhibited at the Civico Museo d'Arte Contemporanea (CIMAC) in the Palazzo Reale. In this period, although an overall project seemed by then impossible, many innovations were made, such as the opening of a bookshop – the first in an Italian museum – and a cafeteria. The storerooms were moved to the same floor as the Gallery, thus allowing them to be visible, easily accessible and in a suitable climate; in the entrance corridor, Giuseppe Bossi's Gabinetto dei Ritratti dei Pittori (collection of portraits of painters) was partially reconstructed; the small rooms created in 1950 to house the paintings by Piero della Francesca, Bramante and Raphael once again became a single large room that the architects Vittorio Gregotti and Antonio Citterio embellished with materials that had never before been used in the Brera; the Palazzo Citterio, known as "Brera 2", was used as an exhibition space.

Since 1989, after closures and the removal of works due to the recurrence of old problems, and while the Palazzo Citterio was being redesigned by the British architect James Stirling, a complex new scheme was devised for the rebuilding and rationalization of the rooms in the Gallery. The plan for the reorganization of the Gallery, which was promoted by the director Rosalba Tardito (1984-1891), was drawn up by Vittorio Gregotti, and has so far been realized in the Napoleonic rooms and in a series of smaller rooms (rooms II-VII), and in room XXI. At the same time, the paintings in the Gallery were rearranged (all those currently on display are described in this guide), with the addition of numerous works that had formerly been on loan to other institutions, such as *St Francis* by Ubaldo Gandolfi, the *Holy Family with St Anthony of Padua* by Luca Giordano, the *Victory of the Inhabitants of Chartres over the Normans* by Padovanino, the *Lamentation over the Dead Christ* by Francesco Salviati, the *Crossing of the Red Sea* by Perin del Vaga and *The Sermon of St Anthony Abbot to the Hermits* by Ludovico Carracci. Besides these, there are also various recently acquired works, including the *Human Flood* by Pellizza da Volpedo, the *Crucifixion* by Gentile da Fabriano, *Christ Carrying the Cross* by Romanino, *Venus and Cupid* by Simone Peterzano and *St John the Baptist* by Donato de' Bardi, to mention just a few.

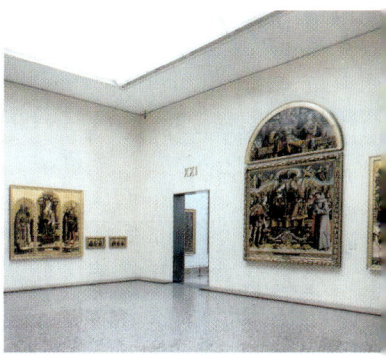

Crivelli's works reign supreme amidst the other Marchigian polyptychs of the 15th century bathed in the newly improved lighting of room XXI.

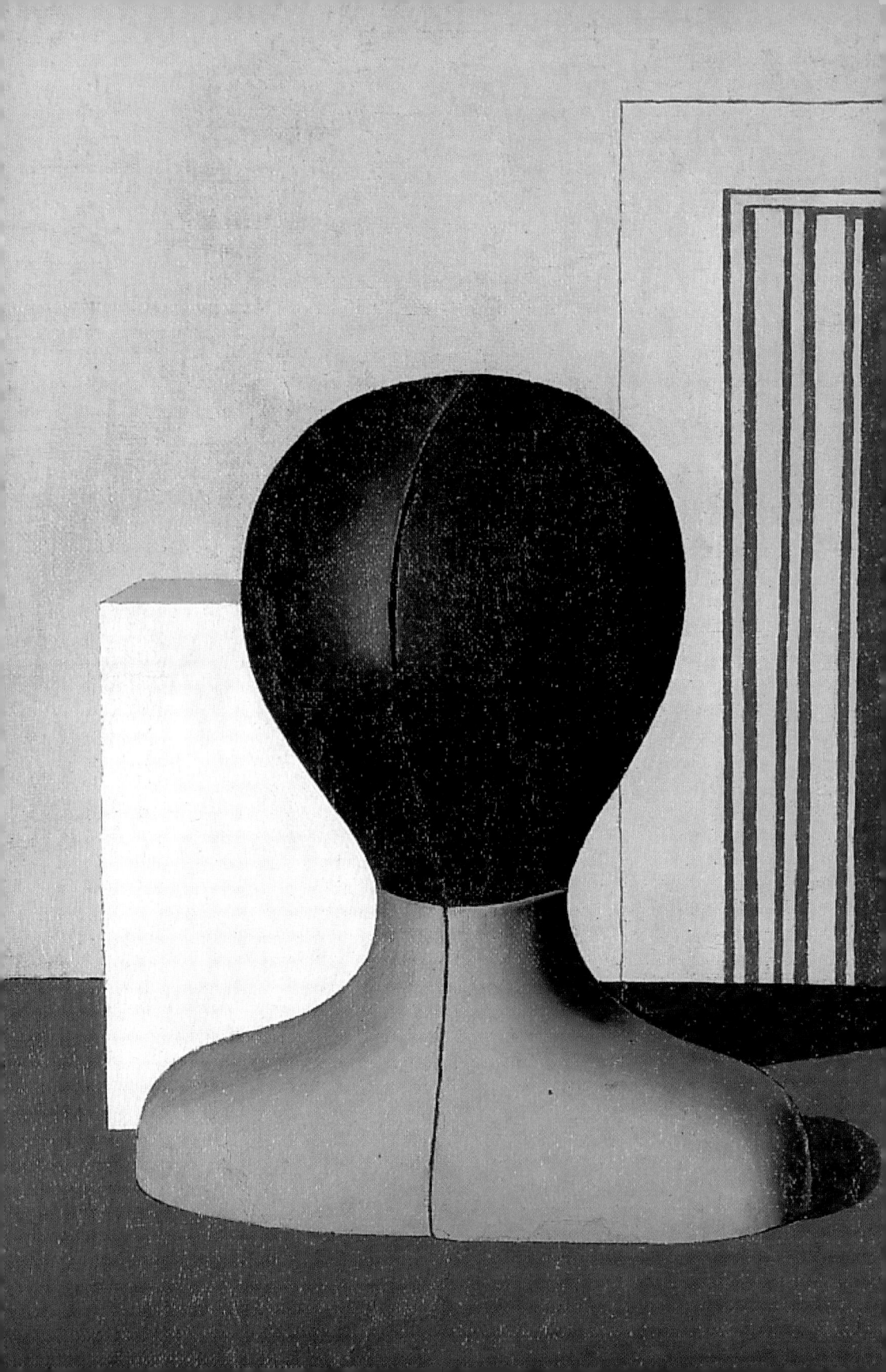

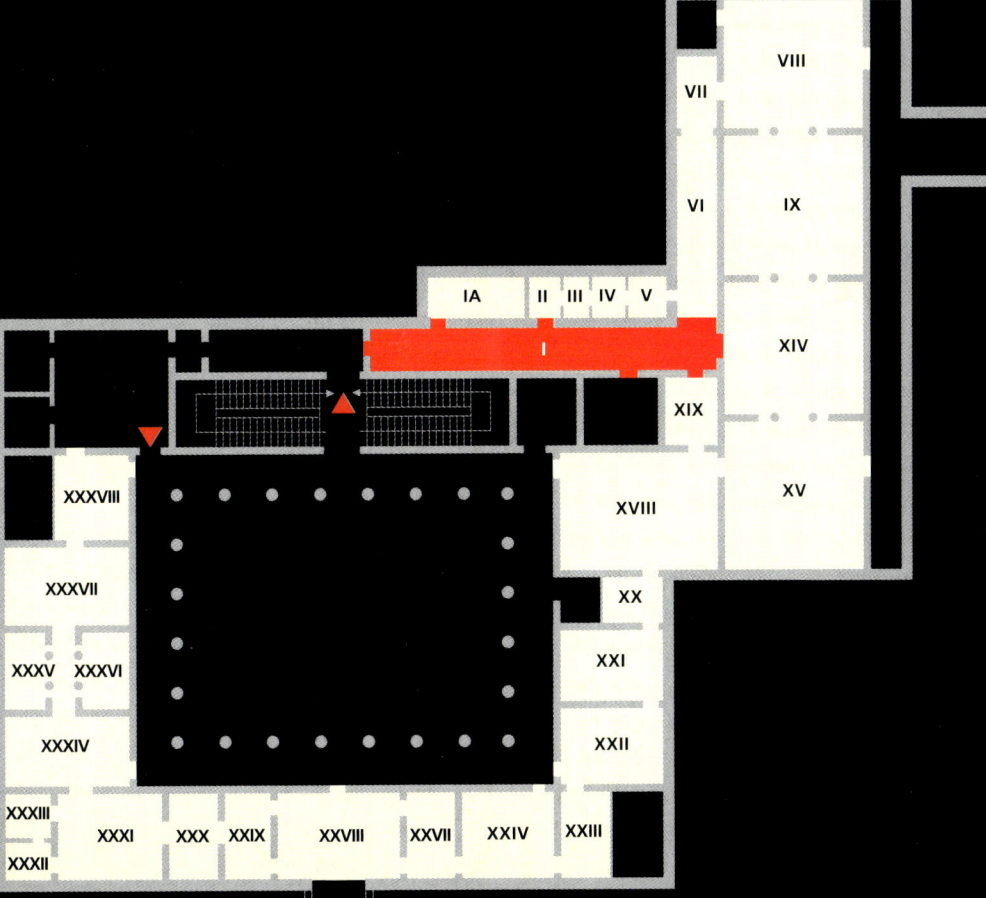

Room I

Afro Basaldella
1
Umberto Boccioni
2 3
Pierre Bonnard
4
Georges Braque
5
Massimo Campigli
6 80
Carlo Carrà
7 8 9 10 11 12
Filippo de Pisis (Filippo Tibertelli)
13 14 15 16 17 18 19 20 21 22
23 24 25 26 27
Maurice Estève
28
Osvaldo Licini
29 30
Mario Mafai
31 32
Marino Marini
33 34 35 36 37 38
Arturo Martini
39 40
Amedeo Modigliani
41 42
Giorgio Morandi
43 44 45 46 47 48 49 50 51
52 53 54 55
Pablo Picasso
56
Serge Poliakoff
57
Antonietta Raphaël
58
Ottone Rosai
59 60 61
Medardo Rosso
62 63 64
Scipione (Gino Bonichi)
65 66 67
Gino Severini
68 69 70
Mario Sironi
71 72 73 74 75 76
Ardengo Soffici
77 78
Wols (Otto Wolfgang Schulze)
79

The gift of paintings and sculptures made by Maria Jesi in 1976, which was enlarged in 1984 and bore the name of her husband Emilio (1902-1974), one of the greatest collectors of Italian modern art, marked a radical change in the policy of the Brera Gallery. By accepting the art of the 20th century, until then excluded from its collections, the gallery made a totally new departure, filling a gap that here, as in other Italian museums, was created by the delays in recognizing the value of the works of art and the lack of new acquisitions by the public institutions, which not only failed to keep up to date with the latest tendencies but were also often extremely conservative in their choices. The paintings and sculptures, which at the request of the donors are exhibited in the gallery, are displayed together, highlighting their historical and artistic importance. This is, in fact, one of the largest, most coherent and carefully selected collections of Italian art of the first half of the 20th century, and there are also outstanding works from other European countries.

The need to reconcile artistic quality with cultural representativeness is the criterion that has governed the formation and organization of the collection – in fact, the works in the gift are only part of those forming the complete collection – so that it illustrates not only the development of Italian modern art as a whole but also that of many of its protagonists. Emilio Jesi's remarkable critical faculty is evident in the farsighted and timely nature of his purchases and his capacity to choose historically significant works. This was a result of his intelligent and impassioned participation in the cultural events of his day and his relationships with the artists themselves, the most open-minded critics and the most enterprising art dealers.

Works by exponents of the leading movements in Italian art from 1910 to 1950 are displayed in the long space of the first room, including the rebellious and polemical modernity of Futurism, with its shock effect on contemporary society; the calm, dreamlike Metaphysical Painting with its theatrical overtones; the classical reaction and the "recall to order" of the Valori Plastici and Novecento Italiano movements; the expressionist spontaneity of the Roman School; and the great masters – Medardo Rosso, Amedeo Modigliani, Carlo Carrà, Giorgio Morandi, Filippo de Pisis, Mario Sironi, Arturo Martini and Marino Marini.

Although it does not belong to the collection, a rare and splendid work by Campigli (no. 80), painted in Paris in 1927 and recently acquired (1995), is displayed at the very end of this room. (L.A.)

Afro Basaldella
(Udine 1912-Zurich 1976)

1 *Silver dollar club*
Oil on canvas
109.5 x 202.5 cm
Signed and dated
lower right "Afro 1956"

This painting was purchased by Emilio Jesi – who was particularly fond of visiting artists' studios and was in contact with Afro from the early fifties onwards – shortly after its execution in 1956. In the same year, the artist participated in the Venice Biennale for the first time with a wide range of works that, while the controversy regarding abstract painting was raging, earned him the prize as "the best Italian painter", bringing him to the attention of critics and public alike.

According to one very convincing interpretation, the title refers to the milieu of American jazz, much loved by the "middle generation" to which the artist belonged. Syncopated musical echoes may be discerned in the modulations of light and colour and in the rhythm of the composition forming the basis of the painting, which is the impalpable, wholly pictorial equivalent of Alberto Burri's *Sacchi* (*Sacks*) that caused a great scandal when they were exhibited at the Rome Quadriennale the previous year.

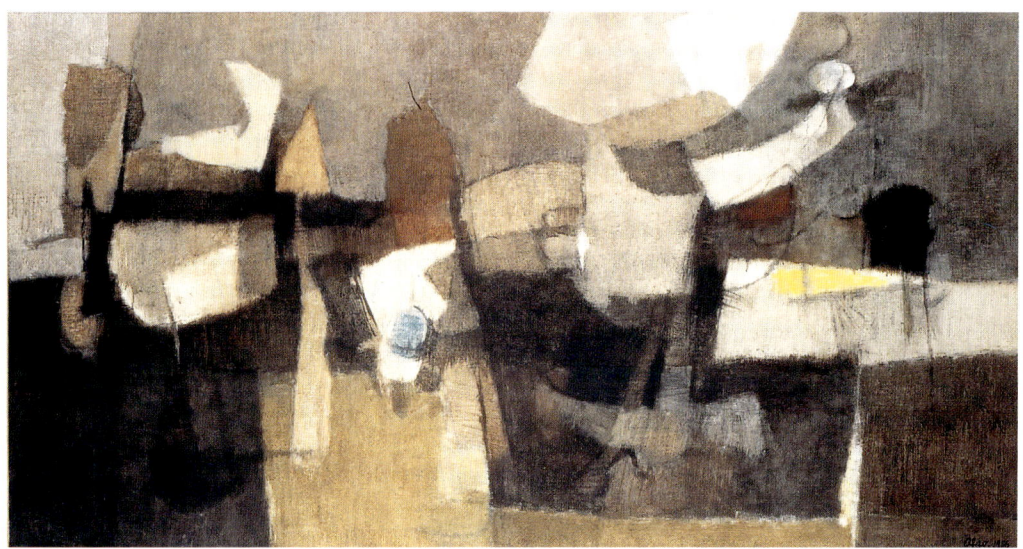

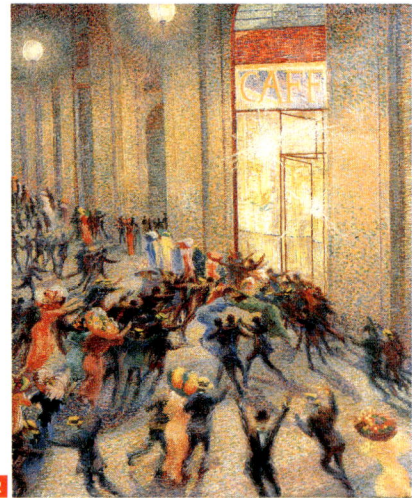
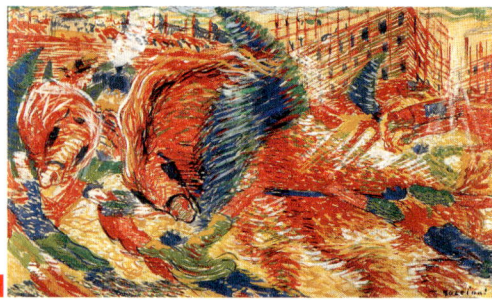

Umberto Boccioni
(Reggio Calabria 1882-Verona 1916)

2 *Riot in the Galleria*
Oil on canvas
76 x 64 cm
Signed upper right "U. BOCCIONI"

3 *The City Rises*
Tempera on paper mounted on canvas
36 x 60 cm
Signed lower right "Boccioni"

The two paintings, executed after Boccioni had signed the *Manifesto of Futurist Painters* on 11 February 1910, a "cry of rebellion" addressed "to the young artists of Italy... to destroy the cult of the past, the obsession with antiquity" and "extol modern life as it is incessantly and tumultuously transformed by triumphant science", are the first stages of the artist's career as a Futurist. They give pictorial form to the words of Filippo Tommaso Marinetti, who, in his *Futurist Manifesto* of 1909 had announced that "we shall sing the great crowds roused by work, pleasure and rebellion, we shall sing the multicoloured and polyphonic masses of the revolutions in the modern capitals, we shall sing the vibrant nocturnal fervour of the shipyards and building sites set alight by violent electric moons".
While the first painting is a study of the movement of the crowd and the effects of artificial light, the second one is a celebration of work and the progress of the industrial civilization. Employing the Divisionist technique of complementary colours, the paintings are representations of Henri Bergson's concepts of simultaneity and dynamism, and the rebelliousness and social aspirations of Georges Sorel.

Pierre Bonnard
(Fontenay-aux-Roses 1867-
Le Cannet 1947)

4 *Portrait of Marthe Bonnard*
Oil on canvas
79 x 50 cm
Signed lower right "Bonnard"

The painting, which is dated between 1917 and 1925, represents Marthe (Marie Boursin), the model, lover and, later, wife of the artist, who was closely attached to her for the whole of his life. Portraying her in an infinity of poses in interiors and landscapes, he made her the most important subject of his art.

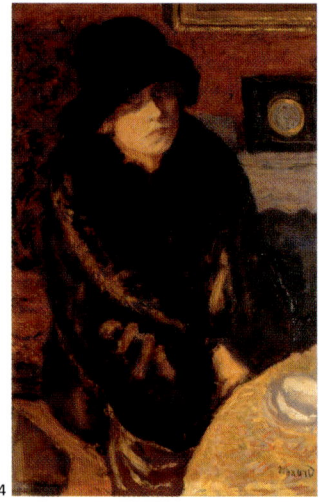

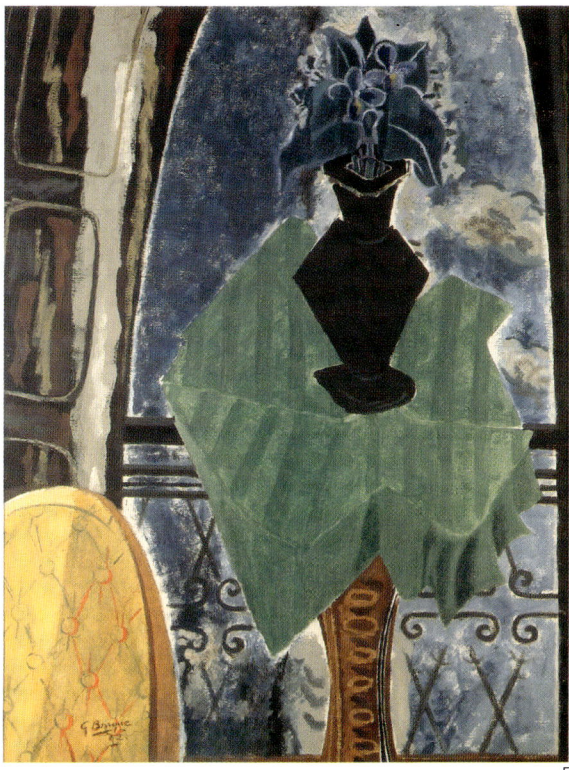

Georges Braque
(Argenteuil 1882-Paris 1963)

5 *The Green Pedestal Table in front of the Window*
Oil on canvas
116 x 89 cm
Signed and dated lower left
"G. Braque/42"

Emilio Jesi's interest in Braque, a great artist who is, however, rarely found in Italian collections, probably originated not only from the 1948 Venice Biennale, where an outstanding selection of the painter's recent works were on show, but also from the frequent reproductions of his paintings in *Cahiers d'Art*, Christian Zervos's journal that circulated widely in Italy and was backed by a Milanese industrialist resident in Paris, Carlo Frua, who was also a collector. The painting, in which the round table, frequently depicted in Braque's paintings since the dawn of Cubism in 1911, belongs to a series of still lifes and interiors executed in 1941 and 1942, all of high quality and characterized by compressed spatiality constituted by an intense relationship between the objects represented and pure, bright colours.

Massimo Campigli
(Berlin 1895-St. Tropez 1971)

6 *The Garden*
Oil on canvas
73 x 92 cm
Signed and dated lower left
"M. CAMPIGLI 1936"

One of Campigli's best-known early works, this painting was executed in Milan, where the artist lived from 1931 to 1937 after he had left Paris, where he was a member of the Italiens de Paris group (including Alberto Savinio, Giorgio de Chirico, Filippo de Pisis, Mario Tozzi and Renato Paresce). With its immobile, archaic aspect, simple geometric forms and enchanted atmosphere this picture seems to represent a return to a mythical childhood, a happy island populated with women.

Carlo Carrà
(Quargnento, Alessandria 1881-
Milan 1966)

7 *Rhythms of Objects*
Oil on canvas
53 x 67 cm
Signed and dated lower left
"C. CARRÀ 911"

8 *The Metaphysical Muse*
Oil on canvas
90 x 66 cm
Signed and dated lower right
"C. Carrà/917"

9 *The Enchanted Room*
Oil on canvas
68 x 52 cm
Signed and dated upper right "C. Carrà/917"

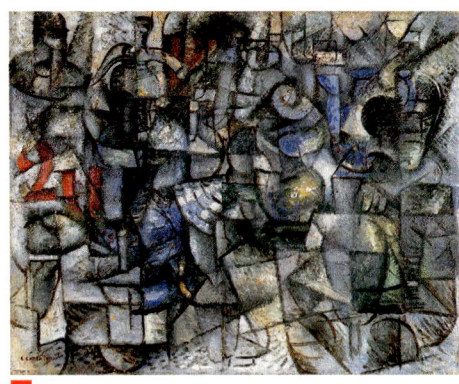

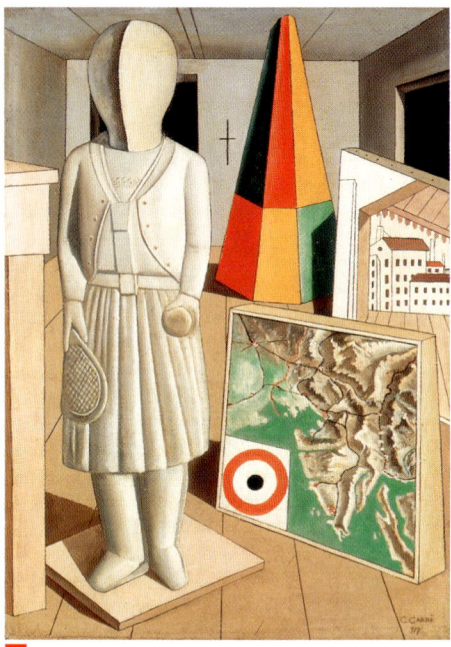

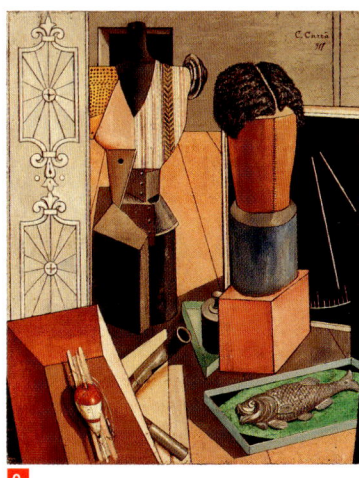

Each of this group of six paintings by Carrà marks a fundamental stage in the artist's career: his adherence to Futurism; his forsaking this for Metaphysical Painting; his "return to order" in the period of the Valori Plastici group; the choice, destined to last for the rest of his life, of a naturalism filtered by memory and interpreted in accordance with an inner idea, which was to play an important role in the "Novecento" art of the Gruppo dei Sette and in that of Magic Realism, a term first used by the German critic Franz Roh and then by the writer Massimo Bontempelli.

In *Rhythms of Objects* – which Carrà painted after his journey, in the autumn of 1911, with Boccioni and Russolo to Paris, where he met Picasso and Braque – Cubist rigour is used to govern the principles of dynamism, simultaneity of vision and the interpenetration of planes that are the fundamental tenets of Futurist art. The splendid trio *The Metaphysical Muse*, *The Enchanted Room* and *Mother and Child*, painted in 1917 when Carrà was in the military hospital at Ferrara, after he had met de Chirico, Savinio and de Pisis, marked the beginning of the artist's brief Metaphysical period. Borrowing de Chirico's bizarre range of props, which so attracted the surrealists – mannequins, children's toys, flotsam and jetsam from secondhand shops – he used them to form his

Room I

10 *Mother and Child*
Oil on canvas
90 x 59.5 cm
Signed and dated lower left
"C. Carrà 917"

11 *The House of Love*
Oil on canvas
90 x 70 cm
Signed and dated upper left
"CARRÀ 922"

12 *The Marble Cutting Shop*
Oil on canvas
69 x 89.5 cm
Signed and dated lower left
"C. CARRÀ 928"

own personal compositions, devoid of any parodistic intention, simply aiming to resolve formal problems of the balance between the spaces and objects, and between colours, light and plastic structures. *The House of Love*, unsuccessfully exhibited at the 1922 Venice Biennale, is a bold, innovative work that Carrà considered at length before he painted it. This work marks the conclusion of the artist's Metaphysical period and the beginning of a style "that aimed to discover new mysticism... a new version of the Middle Ages" in parallel with his theoretico-critical reflections on Giotto and Paolo Uccello in the articles published in *Valori Plastici*. This was the journal that launched the classicistic reaction that gave birth to the Novecento movement; its atmosphere is well reflected by *The Marble Cutting Shop* of 1928, which Carrà selected for the second Mostra del Novecento Italiano, held in Milan in 1929.

Filippo de Pisis
(Filippo Tibertelli)
(Ferrara 1896-Milan 1956)

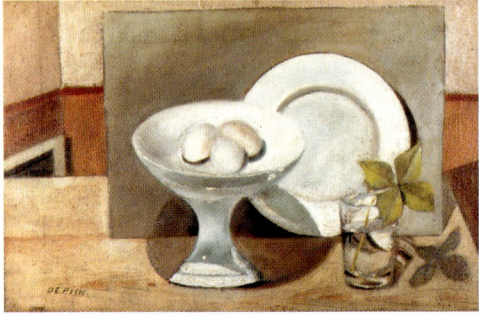

13

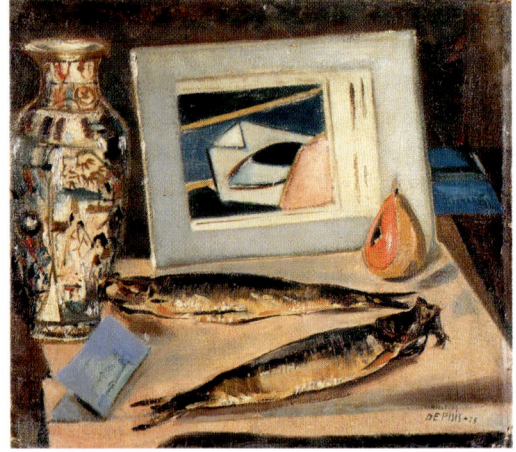

14

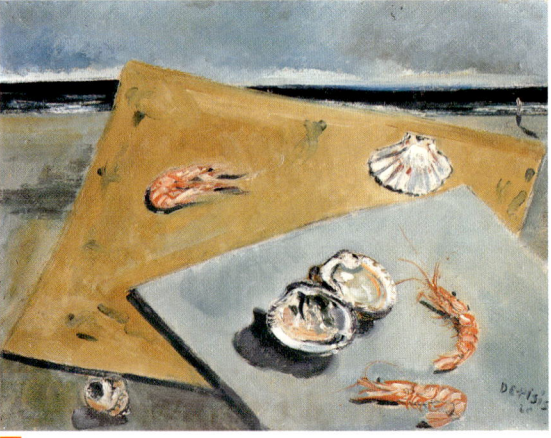

15

13 *Still Life with Eggs*
Oil on canvas
38 x 59.5 cm
Signed lower left "DE PISIS"

14 *The Sacred Fish*
Oil on canvas
55 x 62.5 cm
Signed and dated lower right
"DE PISIS-25"

15 *Marine Still Life
with Scampi*
Oil on canvas
52 x 68 cm
Signed and dated lower right
"DE.PISIS/26"

16 *Marine Still Life
with a Lapwing*
Oil on canvas
65 x 82 cm
Signed and dated lower right
"De Pisis/27"

17 *Paris with a Factory*
Oil on canvas
55 x 46 cm
Signed and dated lower left
"DE/PISIS/27"

Room I 25

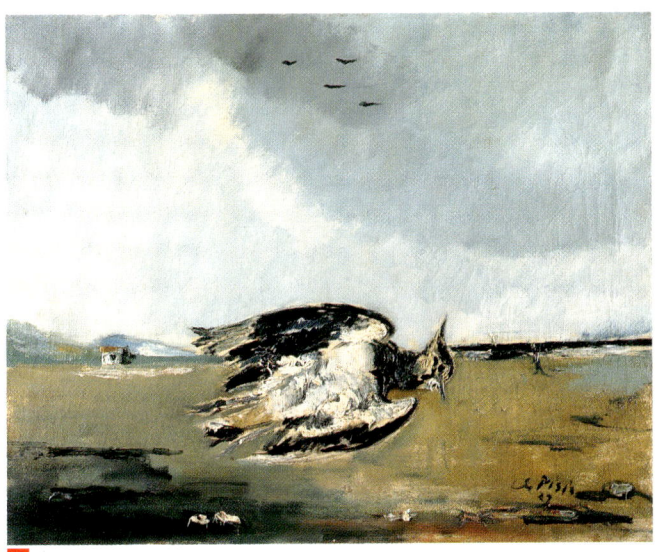

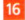

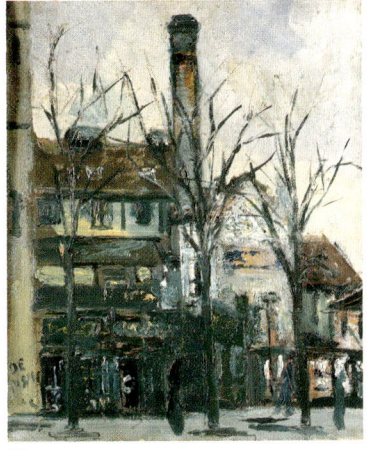

17

The fascinating series of fifteen paintings by de Pisis in the Jesi Collection reveals the most felicitous aspects of the artist's output over the central thirty-year period of his career. Originally a poet and man of letters, then a self-taught painter noted for his independence and creativity, de Pisis must be judged bearing in mind that he was an all-round artist gifted with great sensibility and imagination and extraordinary vitality, yet he was both lyrical and subtle.
Still Life with Eggs of 1924 and *Sacred Fish* of 1925, painted in Rome after a sojourn in Assisi in 1923 during which he decided to devote himself entirely to painting, are an early reflection on his inner world. Images derived from the metaphysical paintings by de Chirico (sacred fish, an enormous eye) and Morandi (a fruit dish), known and appreciated since 1916, are placed beside beloved objects remembered from his past: a glass with four-leaved clover, which took him back to his youthful passion for botany; a Chinese vase in his Ferarra house; metal fruit and a folded sheet of paper depicted in his earliest pictures.
De Pisis was restless, curious and itinerant for the whole of his life: after leaving Ferrara for Rome, he lived in Paris from 1925 to 1939, then he moved to

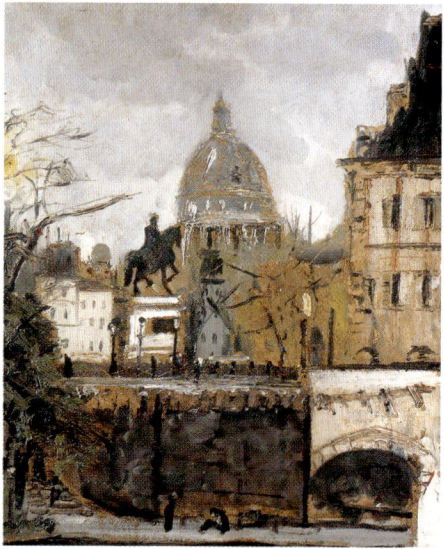
18

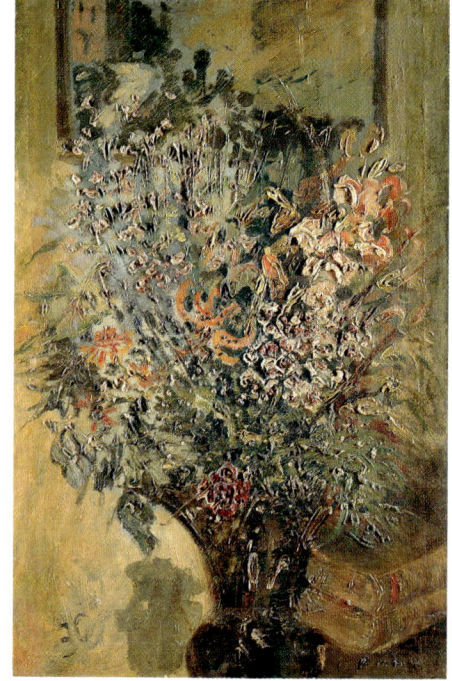
19

20

18 *The Seine Embankment at Les Invalides*
Oil on canvas
65 x 54 cm
Signed and dated lower right
"dePisis/27"

19 *Large Flowers*
Oil on canvas
81 x 53 cm
Signed lower right "de Pisis", dated lower left "30"

20 *San Moisè*
Oil on canvas
81 x 67 cm
Signed lower right "de Pisis"

21 *Still Life with a Basket of Fruit*
Oil on canvas
60 x 73 cm
Signed and dated lower right
"de Pisis 35"

22 *The Peonies*
Oil on canvas
65 x 80 cm
Signed and dated lower right "de Pisis/36", in the centre "Milano"

Room I

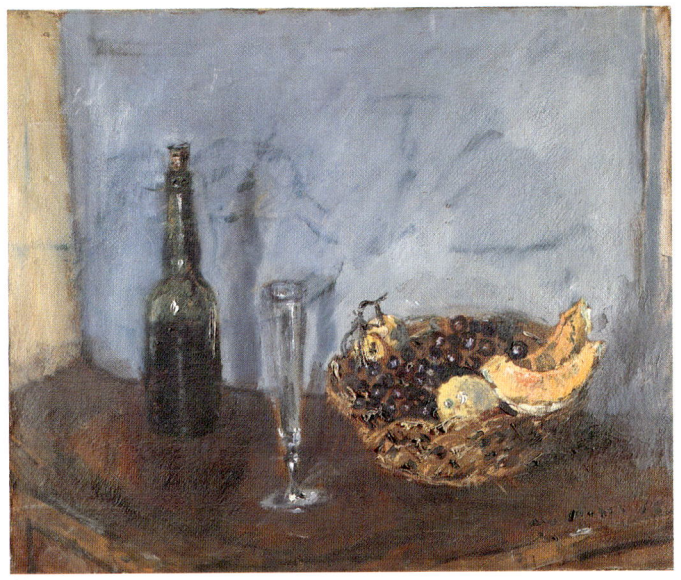

21

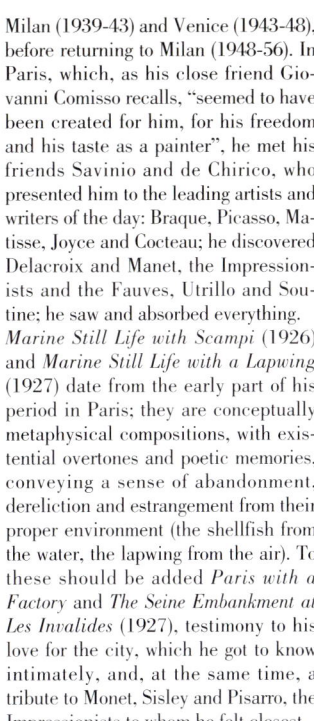

Milan (1939-43) and Venice (1943-48), before returning to Milan (1948-56). In Paris, which, as his close friend Giovanni Comisso recalls, "seemed to have been created for him, for his freedom and his taste as a painter", he met his friends Savinio and de Chirico, who presented him to the leading artists and writers of the day: Braque, Picasso, Matisse, Joyce and Cocteau; he discovered Delacroix and Manet, the Impressionists and the Fauves, Utrillo and Soutine; he saw and absorbed everything.
Marine Still Life with Scampi (1926) and *Marine Still Life with a Lapwing* (1927) date from the early part of his period in Paris; they are conceptually metaphysical compositions, with existential overtones and poetic memories, conveying a sense of abandonment, dereliction and estrangement from their proper environment (the shellfish from the water, the lapwing from the air). To these should be added *Paris with a Factory* and *The Seine Embankment at Les Invalides* (1927), testimony to his love for the city, which he got to know intimately, and, at the same time, a tribute to Monet, Sisley and Pisarro, the Impressionists to whom he felt closest.

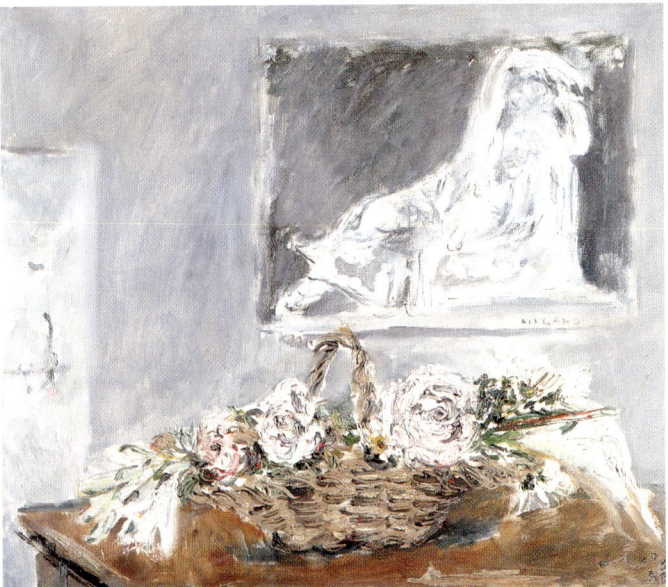

22

23 *Still Life with Flowers and a Bottle*
Oil on canvas
62 x 75 cm
Signed lower left "De Pisis";
signed and dated lower right
"38/Gers Pisis"

24 *Flowers at the Window*
Oil on canvas
76 x 63 cm
Signed and dated lower right
"de/Pisis/38"

23

24

Also associated with Impressionism and the explosions of colour of the Fauves is the enormous bunch of flowers in *Large Flowers* of 1930, a year of frenetic activity in which he gave full play to his joyful relationship with his favourite genres – still lifes, landscapes and flowers – that he managed to maintain unaltered until the end of his career, combining memories with impressions and emotions. Thus *San Moisè* (1931), dominated by the Baroque façade of the Venetian church, is inspired by Guardi, Soutine and Monet's cathedrals. *The Peonies* (1936), one of his masterpieces, treats the themes of abandonment, expectation and melancholy that were so dear to de Chirico and are evoked in the ancient bas-relief with the figure of Ariadne. *Still Life with Flowers and a Bottle* and *Flowers at the Window* (1938), painted in the artist's country house in the department of Gers, south-west France, and *Flowers in a Glass and a Book* (1945) are records of happy visions imbued with a sense of inner unease. *Marine Still Life with a Feather* (1953) is the most outstanding work of de Pisis's last period, when the artist – who was in the Villa Fiorita clinic (the initials V.F. in the painting) on the outskirts of Milan, due to the worsening of the mental illness that from 1954 onwards prevented him from working – created, by means of metaphors and allusions, a poignant and lucid representation of his own life.

Room I

25

26

27

25 *Flowers in a Glass and a Book*
Oil on canvas
63.5 x 49 cm
Signed and dated lower right
"Pisis/45"

26 *Portrait of a Woman*
Oil on canvas
55 x 44 cm
Signed and dated lower right
"F. Pisis/50"

27 *Marine Still Life
with a Feather*
Oil on canvas
50 x 64 cm
Signed lower right "PISIS",
on the left "V.F."

Maurice Estève
(b. Culan 1904)

28 *Interior at the Bay*
Oil on canvas
120 x 88 cm
Signed and dated lower right
"Estève/47"

Influenced by Cézanne, the Cubists and Léger, Estève had his first exhibition in the thirties, when, with Fougeron and Pignon, he formed the group of the "Indélicats". He became well known after the mid-forties thanks to the critics P. Courthion and B. Dorival. His painting, based on a form of abstraction that exalted the colours, bore excellent fruit in the applied arts: stained glass, cartoons for carpets and tapestries, and graphics. This painting dates from 1947, the year when he abandoned Neo-Cubism for "non-figurative art", a term he used to describe his own painting and that of his friends Bazaine and Lapicque, which had its origins in the pulsation of nature that was never forgotten.

28

Osvaldo Licini
(Monte Vidon Corrado, Ascoli Piceno 1894-1958)

29 *Balance*
Oil on canvas
90 x 68 cm
Signed lower right "Licini"

30 *Rebel Angel with White Moon*
Oil on canvas
57 x 90 cm

Around 1930, when Licini came into contact with the Cercle et Carré and Abstraction-Création groups in Paris, and with the abstractionists of the Galleria del Milione in Milan, he abandoned the figurative, Post-Impressionist style of which he had been an exponent – together with Morandi, a friend of his, and Modigliani and Matisse, whom he met in Paris – in favour of abstraction. One of the fruits of this development was *Balance* (1934), which played a fundamental role in the history of Italian abstract art. Suspended between feeling and reason, and between creation and modulation, it shows, as the artist wrote, that "geometry can become feeling and true repose for the spirit". In a different climate, much later on (in 1955), he painted the *Rebel Angel with White Moon*, which depicts a dreamlike apparition reflecting his rejection of abstract art at the time of the 1949 Venice Biennale, where he exhibited nine works entitled *Amalasunta*, closely related to the *Rebel Angel*.

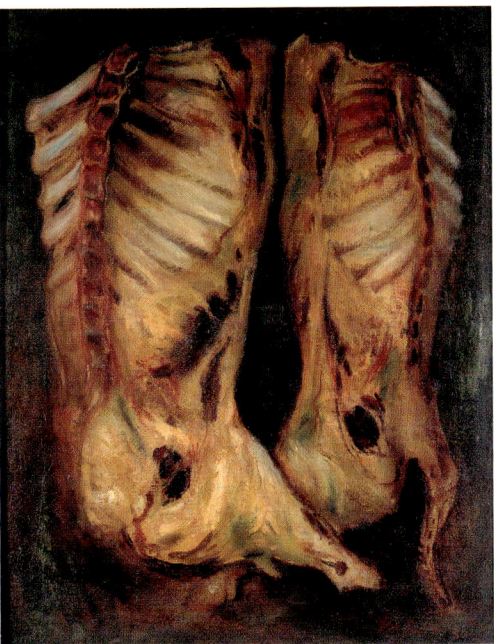

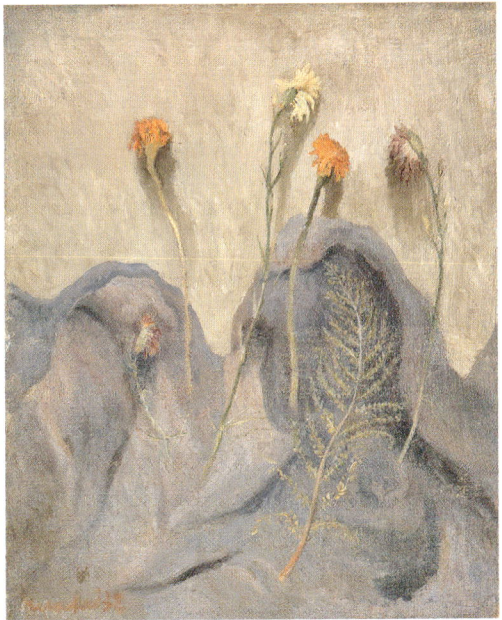

Mario Mafai
(Rome 1902-1965)

31 *Slaughtered Ox*
Oil on canvas
116 x 93.5 cm
Signed and dated lower right
"Mafai 30"

32 *Dried Flowers*
Oil on canvas
61.5 x 50 cm
Signed and dated lower left "Mafai 32"

Over and above their purely artistic relationship, Mafai and his wife Antonietta Raphaël were on friendly terms with Emilio Jesi for all their lives and a large number of their works were present in his collection. However, it is significant that only two paintings by Mafai, considered to be of central importance in his output, were included in the gift to the Brera. The first is the *Slaughtered Ox* of 1930, executed in Paris, "a metropolis of meat, concrete and iron" as the artist, who lived there for about two years, wrote. It pays homage not only to Rembrandt and his small picture in the Louvre but also to Chaïm Soutine and his butcher's shops with their dark reddish browns. The other is *Dried Flowers* of 1932, remarkable for its enchanting range of lilacs, blue-greys, yellow-oranges and greens, indicative of what was now the contemplative and lyrical – and also subtly theatrical – nature of his expressionist style.

Marino Marini
(Pistoia 1901-Viareggio,
Lucca 1980)

33 *Reclining Pomona*
Bronze
48 x 158 x 78 cm
Numbered on the base "3/3"

34 *Girl*
(*Female Nude*)
Terracotta
28 x 38 x 148 cm
Base 10 x 30 x 25 cm

35 *The Miracle*
(*Gothic Cathedral*)
Polychrome plaster and collage
Height 70 cm

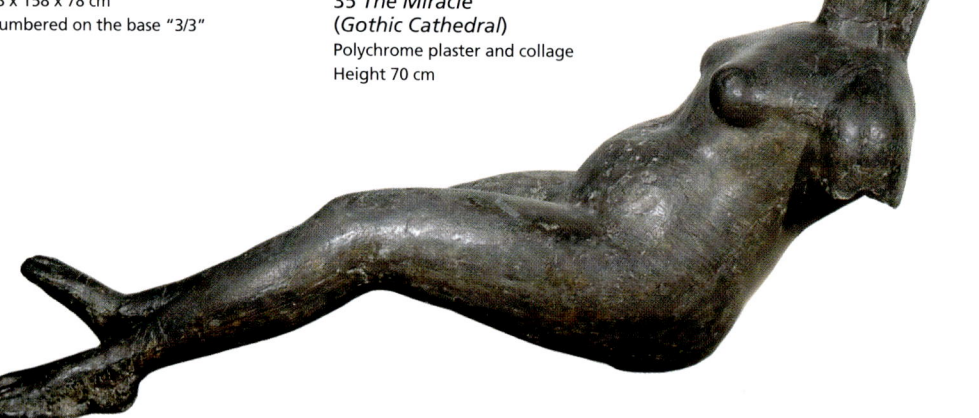
33

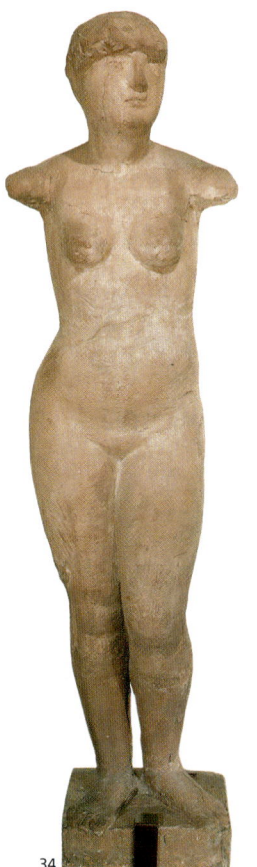
34

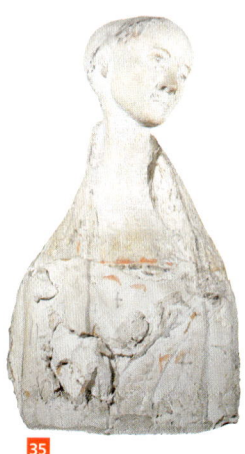
35

Apart from being a client of his, Emilio Jesi was a close friend of Marino Marini's, owning a large number of his bronzes, terracottas, paintings and engravings. The series of sculptures at the Brera includes some notable examples of the artist's output. Thus *Reclining Pomona* of 1935, the year in which he was awarded the sculpture prize at the Rome Quadriennale, initiates the theme of the mythical female figure – which, as Marini himself wrote, was one "of ineluctable necessity, immovable inertia, primitive and unconscious fecundity" – that engaged him for the rest of his life; whereas, with its solid, confident harmony, the terracotta *Girl* of 1938 is classical and timeless. The plaster sculpture entitled *The Miracle*, an ascetic and sorrowful figure, reminds us of the tragedy of war and recalls Donatello's statues; it has minimal touches of colour as if it were a relic, and was executed in 1944 when the artist had taken refuge in Switzerland; the large *Pomona* of 1948, with its barbaric dignity; the tense and inspired

Room I

36

36 *Portrait of Emilio Jesi*
Bronze
20 x 25 x 24 cm
On the back are the initials
"MM" and "Fonderia MAF"

37 *Pomona*
Bronze
62 x 50 x 158 cm
On the pedestal are the initials
"MM" and "Fonderia MAF"

37

38

Portrait of Emilio Jesi of the same year; and the monumental *Miracle* of 1959-60, a final version of the horse and rider subject that he had begun in 1951-52 and continued for fifteen years. In the latter work, according to Marini, there was "no longer any intention of celebrating the victory of a hero", but rather "that of expressing something tragic..., a defeat rather than a victory" and of giving substance to the "anguish caused by the events of an epoch".

38 *Miracle*
(*Horse and Rider*)
Bronze
125 x 280 x 170 cm
Base 57 x 214 x 101 mm
The base is engraved, to the left,
"MM/Fonderia artistica/Battaglia
e C./Milano"; at both ends, "MM"

Arturo Martini
(Treviso 1889-Milan 1947)

39 *Drinker*
Terracotta
150.5 x 54 x 70 cm
Signed on the base "MARTINI"

40 *Ophelia*
Terracotta
72 x 179 x 23 cm
Signed and dated lower right
"XI Martini-A."

The date of the first of these two sculptures is a matter for debate, since, although it is nearly always assigned to 1926, it was probably executed in 1928 or 1929, while the second is dated 1933 (the eleventh year of the Fascist regime). This was the period in which Martini, the most outstanding Italian artist of the interwar years, was widely acclaimed for his output. In these two works, the compositions, techniques and themes are considerably different, despite the fact that he is using the same material, clay; in fact, of all the media used by Martini – they also included plaster, marble and other types of stone, bronze and wood – this was the one most suited to his lively imagination. The drinker, the typical subject of the painting of the second half of the 19th and early 20th centuries, is depicted in a neo-primitive manner, with a particular taste for soft, velvety surfaces, while, in the case of the Shakespearian heroine, the iciness of the Pre-Raphaelite theme melts into timorous pathos and psychological subtlety emphasized by the rough, granular material that forms numerous shadows.

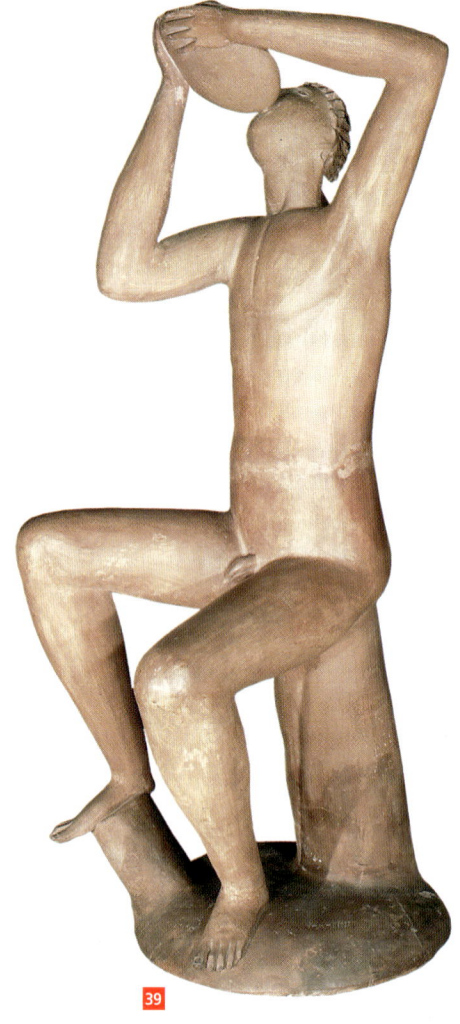

Room I

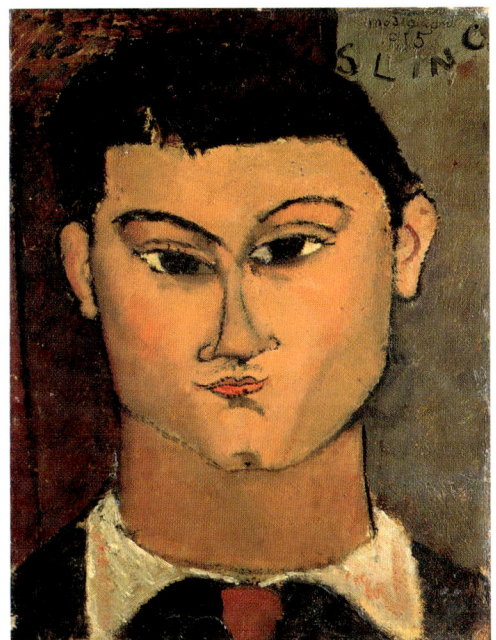

Amedeo Modigliani
(Leghorn 1884-Paris 1920)

41 *Portrait of the painter Moïse Kisling*
Oil on canvas
37 x 29 cm
Signed and dated upper right
"Modigliani 1915 Kisling"

42 *Portrait of a Young Woman*
Oil on canvas
46 x 38 cm
Signed lower right "modigliani"

These paintings, purchased in the 1930s by the Galleria del Milione in Milan, in the wake of the enormous success of the retrospective held at the Venice Biennale of 1930, and sold to Emilio Jesi immediately after the Second World War, originally belonged to Paul Guillaume. An art critic, dealer and, together with Apollinaire, discoverer of Negro art, the latter was an enthusiastic collector of works by Modigliani, of whom he was initially the only client.

The first portrait, which is very well known, is of Moïse Kisling, a Polish Jew who was a naturalized Frenchman. A fellow artist and friend of Modigliani, he was close to him until the last. Square and angular, with its intrusive frontality and brutal elegance, the portrait resembles those of his other artist friends – Pablo Picasso, Juan Gris, Chaïm Soutine, Henry Laurens and Jacques Lipschitz – painted in the same period.

The much blander portrait of a young woman (possibly Beatrice Hastings), with its gentle contours, the perfection of the sitter's oval face and her engrossed expressiveness, confirms the great refinement of Modigliani's obstinately unvaried style and attests to the artist's sources of inspiration, ranging from Cézanne to Gauguin, Picasso and Brancusi.

Giorgio Morandi
(Bologna 1890-1964)

43 *Landscape (The Wood)*
Oil on canvas
60 x 45 cm
Signed and dated lower left
"Morandi/1914"

44 *Landscape (Pink Landscape)*
Oil on canvas
39 x 54 cm
Signed lower right "Morandi"

45 *Flowers*
Tempera on cardboard
60 x 50 cm

43

44

45

Together with de Pisis, Morandi is the artist who is best represented in the Jesi Collection, where there is a splendid series of his landscapes and still lifes, the only subjects he treated, and a rare self-portrait, examples of artistic creation marked by meditation, purity, great concentration and formal rigour, in which the initial stimuli – Futurism, Metaphysical Painting, Valori Plastici, Novecento Italiano and the Strapaese group – are absorbed into a dimension in which the artist's inner nature is expressed thanks to his total command of the techniques of painting. Morandi's sources of inspiration at the outset of his career – Cézanne, Rousseau and early Cubism, with which he was acquainted through books, and also Giot-

Room I

46 *Still Life*
(*Large Metaphysical Still Life*)
Oil on canvas
68.5 x 72 cm

47 *Still Life*
Oil on canvas
59.5 x 60 cm
Signed and dated lower right
"Morandi 919"

48 *Still Life*
Oil on canvas
56.5 x 47 cm
Signed and dated upper right
"Morandi 919"

to, Masaccio, Paolo Uccello and Piero della Francesca – form the basis of the *Landscape* with trees of 1914, the "pink" one of 1916 and the *Flowers* of the same year. These extremely unusual works, small poems dedicated to nature full of distant splendour and resonances, derive from his memory of the real world, their tonal spatiality being obtained purely through the use of colour. The pictorial climate of the three metaphysical still lifes of 1918 and 1919 is apparently different. Morandi was remote from de Chirico's poetic devices of the enigma and spectrality and his penchant for parody,

49 *Still Life*
Oil on canvas
50 x 60 cm
Signed lower left "Morandi"

50 *Self-Portrait*
Oil on canvas
48.5 x 40 cm
Signed upper centre "Morandi"

51 *Landscape* (*The Pink House*)
Oil on canvas
46 x 42 cm
Signed lower right "Morandi"

52 *Still Life*
(*Still Life with the Round Table*)
Oil on canvas
55 x 58 cm
Signed and dated on the back
"Morandi/1929"

53 *Still Life*
Oil on canvas
50 x 60 cm
Signed and dated upper right
"Morandi 929"

54 *Landscape (Ploughed Fields)*
Oil on canvas
54 x 65 cm
Signed and dated on the back
"Morandi/1932"

55 *Landscape*
Oil on canvas
60 x 55 cm
Signed and dated on the back
"Morandi/1936"

but he was, nonetheless, open to the contemplative, timeless and classical elements of his art. Thus, in the words of de Chirico, an early admirer, he expressed "the great lyricism created by the metaphysics of everyday objects – those objects that habit has made familiar and that, however conversant with the mysteries of appearances we may be, we often observe through the eyes of those who see but do not know"; in other words, they are objects purified of every element that can disturb their clean-cut volumes and eternal geometry. Coherence, rigour and continuity of the inner dialogue are all to be found in the still life of 1921 (49) – which is reminiscent of Corot and Chardin – and also in the self-portrait of 1924, the landscape with a pink house of the following year and in the still life with a round table, an unusually opulent and monumental composition with its perfect centrality. They contrast with the other still life, also of 1929, modest and experimental due to the artist's choice of asymmetry, and the severe landscapes of 1932 and 1936, described by the critic Roberto Longhi as "desolate".

Pablo Picasso
(Málaga 1881-Mougins 1973)

56 *Head of a Bull*
Oil on canvas
116 x 89 cm
Signed upper right "Picasso", dated lower right "6.4.42"

The picture was purchased by Louise Leiris, the owner, together with her poet husband, Michel, of the Galerie Leiris in Paris, which handled almost all the works executed by Picasso during the Second World War and had a near monopoly of the artist's output in the following years. Before its acquisition by the Jesi Collection, it belonged to another private collector. Together with the version dated "5.4.42" in the Kunstsammlung Nordrhein-Westfalen, Düsseldorf, it is a fundamental work of the war years, when Picasso filled his studio with austere and dramatic still lifes. A symbol of the horrors of this period and the brutality of the Nazis and Fascists, it was a major influence on European painting in the late forties and the fifties.

Serge Poliakoff
(Moscow 1906-Paris 1969)

57 *Composition*
Oil on canvas
121 x 85 cm
Signed lower right "Serge Poliakoff"

This painting by Poliakoff, an exponent of the École de Paris and, even more so, of the expressive abstraction that also involved Nicolas de Staël, Maria Elena Vieira da Silva, Alfred Manessier and Hans Hartung, was purchased in the late fifties or early sixties when, thanks to a series of exhibitions held at the Galleria del Naviglio in Milan, Italian collectors began to buy the painter's works. From a visual point of view, Poliakoff's abstraction has its roots in Beato Angelico, Giotto and Cimabue, to whom he often referred; his painting was influenced by the work of Braque and Picasso, as well as that of Kandinsky and Malevich. Thanks to this line of development Emilio Jesi could juxtapose this work with the other very different ones of his collection without creating a jarring contrast.

Room I

Antonietta Raphaël
(Kovno, Lithuania 1895-Rome 1975)

58 *Archaeological Walk*
Oil on canvas
46.5 x 43.5 cm
Signed and dated lower left
"Raphaël/1928"

Displaying her skilful use of colour, her taste for decoration and sensual participation in reality, and her visionary and naive modes, this painting – which can be seen as a pendant to *The Street with a Red House* by her husband, Mario Mafai – summarizes Raphaël's artistic tenets. After a Bohemian period in London and Paris, in 1924 she moved to Rome; here she met Mafai, with whom she set up house and studio in Via Cavour, thereby starting the Roman School –or School of Via Cavour, as the critic Roberto Longhi dubbed it – a spontaneous and wholly Italian variant of European Expressionism.

Ottone Rosai
(Florence 1895-Ivrea 1957)

59 *Still Life: the Carpenter's Bench*
Oil and collage on cardboard
47.5 x 70 cm
Signed and dated lower right
"O. ROSAI 1914"

60 *Tuscan House*
Oil on canvas
58 x 45.5 cm
Signed lower right "O. ROSAI",
dated lower left "1919"

61 *Concertino*
Oil on canvas
64.5 x 58.5 cm
Signed lower right "O. ROSAI"

This brief series of paintings by Rosai illustrates important stages in the artist's career, which, beginning with Futurism, proceeded towards a rarefied and almost metaphysical adhesion to the Novecento Italiano movement, culminating in an intensely emotional, but visually moderate, form of Expressionism, imbued with a naive manner inspired by Masaccio, Cézanne, the Tuscan Macchiaioli and Henri Rousseau.
The autobiographical *Carpenter's Bench* of 1914 (the artist's father was a frame- and cabinet-maker) was inspired by Ardengo Soffici, from whom the use of collage and the Cézannesque mode of representing objects were derived. *The Tuscan House*, on the other hand, is metaphysical, succinct and primitive in style, a landscape expressing painful solitude that the artist repeated with variations for the rest of his life, while the *Concertino* – also known by the title *The Orchestra of the Paszkowski Café* (a well-known Florentine café) – with the figures dressed in funereal colours, forerunners of his characteristic "little men", belongs to the folkloristic (and populist) Strapaese current, as did a large part of his painting.

Medardo Rosso
(Turin 1858-Milan 1928)

62 *The Little Laughing Girl*
Wax
Height 28 cm
Signed on the centre of the base
"M. Rosso"

63 *The Jewish Child*
Wax
Height 25 cm
Signed on the right shoulder "M. Rosso"

64 *The Veiled Lady*
Wax
Height 61.5 cm

Medardo Rosso took the rebelliousness and the luminism of the Lombard Scapigliatura movement, within which he had been formed, to extremes, linking Impressionism to Divisionism and creating works that heralded Futurism. Thus his modernity justifies the presence of his wax sculptures – all dating from the 19th century – in the Jesi Collection.
Dating from December 1889, when Rosso had been living in for Paris for five years, *The Little Laughing Girl*, a portrait made for a very unusual commission that was virtually a "snapshot" of the daughter of the treasurer of the Laborisière hospital, where the artist was a patient and where he completed the *Sick Child* and the *Patient in Hospital*. *The Jewish Child* (the supposed portrait of a child of the Rothschild family) was executed a few years later, in 1892 or 1893, and is very innovatory due to its ephemeral aspect, the result of the almost pictorial modelling of the volumes; various examples of this successful work exist in both wax and bronze. *The Veiled Lady*, made in 1893, was initially entitled *Impression* or *Impression de boulevard*, a fleeting vision that begins the series of sculptures devoted to "modern life" in which the theme of the figure and its surroundings is treated once again; here it is resolved with an osmotic relationship between the veiled face of the woman and the atmosphere surrounding it.

Scipione (Gino Bonichi)
(Macerata 1904-Arco, Trento 1933)

65 *Cardinal Vannutelli on his Deathbed*
Oil on panel
34.5 x 43 cm

66 *Still Life with Sole and a Coin*
Oil on panel
50 x 63 cm
Signed and dated lower right
"Scipione/30"

67 *Portait of the Artist's Mother*
Oil on panel
40.5 x 33 cm
Signed lower left "Scipione"

Room I

68

Gino Severini
(Cortona, Arezzo 1883-Paris 1966)

68 *The North-South Train*
Oil on canvas
49 x 64 cm
Signed and dated bottom centre
"1912. G. Severini"

69 *Large Still Life with a Pumpkin*
Oil and collage on panel
92 x 65 cm
Signed lower right "G. Severini"

70 *Still Life with a Fruit Bowl*
Oil and collage on canvas
61 x 72 cm
Signed top centre "G. Severini"

After meeting Boccioni and Giacomo Balla in Rome in 1901, Severini learnt the Divisionist technique from them, but not content with this, in 1906 he left for Paris where he not only furthered his knowledge of the Impressionists and the Pointillism of Seurat, but also met Modigliani, Braque, Picasso and Dufy, and the critic Félix Fénéon. In 1910 he adhered to Futurism, but he gradually rejected this in favour of Cubism and then the Classicism that, in various forms, invaded Europe at the end of the First World War. The *North-South Train* of 1912, a simultaneous and dynamic view of a carriage of the Paris underground at the station of Pigalle on the North-South line, is one of the best-known Futurist works, centring on the rhythmicity of the movement and the alternation of the colours repeated in rapid succession. The still lifes with a pumpkin (1917) and with a fruit bowl (1918) are in the Synthetic Cubist style, which is interpreted with an essentially decorative taste and classical composure.

The production of Scipione, limited to a brief period due to the tuberculosis that brought about his death at the age of twenty-nine, was of central importance for the Roman School with which he was associated – as well as Mario Mafai, Antonietta Raphaël and Marino Mazzacurati – and had the merit of going against the tide of the official culture of the Fascist regime, attracting the attention of poets and writers informed by the same nonconformist spirit, such as Libero de Libero, Leonardo Sinisgalli and, above all, Giuseppe Ungaretti. Cultured, very fond of literature and eccentric, Scipione was obsessed by the decrepit greatness of papal and Baroque Rome, with the architecture of Bernini and Borromini. This decadent, visionary mode, full of fervour and Goyaesque sensuality, gave rise not only to the tenebrous funeral image of *Cardinal Vannutelli* of 1930 but also the calm, luminous, only slightly decomposed *Still Life with Sole and a Coin*, in which the theme of death and the decay of the flesh is symbolized by the skull depicted on the coin. A very different case is the *Portrait of the Artist's Mother*, also painted in 1930, but tender and affectionate and unusually objective.

Mario Sironi
(Sassari 1885-Milan 1961)

71 *The Lorry*
Oil on cardboard
90 x 80 cm

72 *The Studio of Wonders*
Oil on canvas
67.5 x 61 cm
Signed lower left "Sironi"

73 *The Lamp*
Oil on paper mounted on canvas
78 x 56 cm

The six paintings by Mario Sironi were all executed during his early period and precede – or are, at any rate, conceptually extraneous to – his adhesion to the "Fascist revolution" and his participation, with frescoes, mosaics and bas-reliefs, in the great architectural undertakings of the regime characterizing the central part of his career, which Emilio Jesi, of Jewish origin and a convinced anti-Fascist, certainly did not find acceptable. Sironi, who was enrolled in the faculty of engineering at the univer-

Room I

74

75

76

sity of Rome, abandoned his studies in order to attend the Accademia di Belle Arti, also frequenting Giacomo Balla's studio, where he met Boccioni and Severini. In 1914 he moved to Milan, where he adhered to Futurism and, with Boccioni, volunteered for military service in the First World War. The first signs of a change are visible in a number of his archaistic and Metaphysical works, especially his first urban landscapes of 1920, which are interpretations in a "Quattrocento" style of the present-day industrial suburbs, where the Futurist myth of the progress of modern civilization is transformed into the solitude and desolation of a gloomy, pessimistic world. In 1922 he joined the group created by the critic Margherita Sarfatti and initially known as the "Sette pittori del Novecento Italiano", of which he became a leading exponent. *The Lorry* is variously dated 1914 and 1917, and is notable for its sombre colours and geometric simplification, while *The Studio of Wonders*, which may be dated 1917 or 1918, is an eccentric and *retardataire* revival of the Cubo-Futurist decompositions, including borrowings from Carrà's Metaphysical paintings (set squares, cylinders, perhaps the title itself). *The Lamp* of 1919 is generally considered to be influenced by Metaphysical Painting, although it already expresses the sense of solitude and existential anguish of contemporary urban life that Sironi – the first and most outstanding artist to do so – made the subject of his painting. The urban landscape with a lorry of 1920, the one with a wayfarer, usually dated 1922-23, but now ascribed to 1929, and the one with a chimney, for which the dates of 1930 and 1942-43 have been proposed (in contrast with that of the early twenties recorded by the Jesi), mark the approach of the artist's mature period: the first is a simple, yet majestic, metaphysical vision of the urban environment dominated by an unforgettable emerald green sky; the second is thick with paint and dramatically expressionist, with the Donatellesque figure of the wayfarer (a recurrent theme in Sironi's work); in the third there is compressed and brutal monumentality accentuated by its execution in monochrome.

74 *Urban Landscape with Lorry*
Oil on canvas
44 x 60 cm

75 *Urban Landscape with Wayfarer*
Oil on canvas
70 x 67 cm
Signed lower left "Sironi"

76 *Urban Landscape with Chimney*
Oil on canvas
62.5 x 79 cm
Signed lower right "Sironi"

Ardengo Soffici
(Rignano sull'Arno, Florence 1879-
Poggio a Caiano, Prato 1964)

77 *Santa Cristina*
Oil on cardboard
64 x 49.5 cm

78 *Watermelon and Liqueurs*
Oil and collage on cardboard
65 x 54 cm
Signed and dated upper left "SOFFICI 14"

From 1900 to 1907, Soffici, who was also a critic and writer, spent his formative years as an artist in Paris, where he came into contact with Fauvism and Cubism, contributed to the journal *Mercure de France* and associated with Apollinaire, Blaise Cendrars and Max Jacob. On his return to Florence in 1910, together with the writers Giovanni Papini and Giuseppe Prezzolini, he founded the periodical *La Voce* and, in 1913, *Lacerba*, the house journal of the Futurist movement, to which, in the meantime, he had adhered. The latter publication had the typical style of an avant-garde magazine in its texts, layout and typeface. In 1915, the artist's break with Boccioni and Marinetti marked a gradual return to naturalistic figurative painting, in advance of the Novecento Italiano movement.
Linked to these events are *Santa Cristina* of 1908 (the original title was *The Straw Ricks*), a landscape inspired by Cézanne, and, above all, the Fauves, and *Watermelon and Liqueurs* of 1914, a typical Futurist still life in which collage, painting and fragments of writing harmonize perfectly, giving rise to a composition that is, as Soffici himself put it, rich in a "plastic sense of reality".

77

78

Room I

Wols
(Otto Wolfgang Schulze)
(Berlin 1913-Paris 1951)

79 *Composition IV*
Oil on canvas
65 x 54 cm
Signed lower right "Wols"

This painting, originally known as *January*, appeared for the first time in the exhibition organized in 1947 in Paris by the Galerie Drouin, which revealed Wols – a pupil of Paul Klee at the Bauhaus in Dessau, who had also been a violinist and a photographer influenced by the Surrealists – to be one of the most precocious and intense artists in the Art Informel movement. After the Second World War his encounter with Sartre and discovery of existentialism consoled the artist, an anti-Nazi German, giving him a dramatic insight into the human condition with its absurdity and grief. This painting, one of the artist's most successful and complete works, was acquired by the Jesi Collection immediately after 1958, the year of an important retrospective at the Venice Biennale that posthumously established his reputation as the leading European exponent of "Lyrical Abstraction", which was a mixture of Surrealism and Expressionism.

Massimo Campigli
(Berlin 1895-Saint-Tropez 1971)

80 *Women with Guitars*
Oil on canvas
95 x 73 cm
Signed and dated lower right
"MASSIMO/CAMPIGLI/1927"
Acquired: 1995

This painting, with its earthy colours, like those of a fresco, and the imposing, immobile presence of the two female figures facing each other with specular symmetry, is a rare work from the period 1924-27. This was when the artist, who had been living in Paris since 1919 as a correspondent of the *Corriere della Sera*, after gaining experience with the Purism of Ozenfant and Le Corbusier, switched his attention to Picasso, Léger and Juan Gris, interpreting their styles in an original manner, falling under the spell of the ancient Mediterranean civilizations.

Room IA
The Chapel of Mocchirolo

Room IA
Master of Mocchirolo
1
Simone da Corbetta
2

The presence of Giotto in Lombardy was recorded by Giovanni Villani: according to this Florentine writer, after the foundation of the campanile of Florence cathedral in 1334, Giotto was sent by the commune of the city to Milan to serve the Visconti, who had recently obtained the signoria of Milan. Patrons of the arts, they turned the city into one of the commercial and cultural centres of 14th-century Europe. At the end of the century the foundation of the cathedral fittingly reflected the ambitions of the Visconti and the climate of strong internationalism prevailing in Milan since the beginning of the century.

In the 1430s, under Azzone and in the presence of Giotto, the Visconti palace, next to the cathedral, became a vehicle for promoting the family's prestige thanks to the profusion of paintings and frescoes adorning it: in one of the courtyards, in what was clearly a political allusion, the Carthaginian wars were depicted; in a room there was a representation of Vainglory with the pagan heroes as well as Charlemagne and Azzone Visconti himself, painted with a predominance of blue (a very expensive colour) and gold. The chapel of the palace, which later became the church of San Gottardo, was also decorated in blue and gold with furnishings in ivory. Here, in the church of San Gottardo in Corte, a Crucifixion is the only surviving decoration by a follower of Giotto. The Florentine artist's influence in Lombardy is also evident in the frescoes in Viboldone Abbey, outside Milan, (a lunette frescoed in 1349) and the Archbishop's palace in the city, and then it spread, particularly as a result of the journeys of artists such as Giovanni da Milano, who had already worked with Giotto in the church of Santa Croce in Florence and to whom the frescoes of the chapel of Mocchirolo are attributed. In these frescoes some of the characteristics of Giotto's art are apparent: a strong sense of form and volume; attention to realistic details and expressions; clarity of description and narrative coherence. A monument of particular importance for the development of Lombard art shortly after the middle of the 14th century, the chapel of Mocchirolo also bears witness – together with the frescoes of other well-known Lombard oratories, such as the oratory of Albizzate and the one at Lentate – to the incipient evolution of Giottesque realism towards the modes of International Gothic, as may be observed in the representation of the donor and his family on the right side of the chapel, in close correspondence with the artistic trends under the Visconti that were to culminate in what was known in France as the "ouvraige de Lombardie" – that is, the art of illumination – for which the region was universally known. (P.C.M.)

Master of Mocchirolo
(active in Lombardy
in the second half
of the 14th century)

1 *Porro oratory at Mocchirolo*
Frescoes transferred to canvas

Crucifixion
End wall 378 x 277 cm

*Count Porro with Members
of his Family Offering
the Virgin a Model of the Church*
Right wall 323 x 217 cm

*St Ambrose Enthroned
Scourging Two Heretics;
Mystic Marriage
of St Catherine*
Left wall 323 x 217 cm

Christ and the Four Evangelists
Vault 323 x 323 cm

Equestrian Saint
Triumphal arch 106 x 61 cm

Risen Christ Blessing
Triumphal arch 106 x 61 cm
Acquired: 1950

The frescoes of the Porro oratory at Mocchirolo (near Lentate sul Seveso, to the north of Milan, where there is another oratory built by the same family) were detached from their original wall in 1949 and then recomposed at the Brera in the 1950s. As far as possible, the reconstruction was as faithful as possible to the original location, with an attempt being made to maintain the direction of the light. These important frescoes, commissioned by a member of the Porro family, possibly Stefano, were previously attributed to Giovanni da Milano, who was thought to have executed them between 1360 and 1367. Another hypothesis is that they are by Pietro da Nova, an artist who is known to have worked in Santa Maria Maggiore in Bergamo from 1373 onwards, but who was absent in 1378 in order to paint at "Moncayrolum". In this case the true patron would have been a relative of Stefano Porro, Lanfranco, who was referendary of Regina della Scala in Bergamo in 1377. This attribution presupposes, however, a dating that is too advanced for the cycle and is, in fact, rejected by other scholars. It is, therefore, better to stick to an earlier date, around, or shortly after, the middle of the century, and leave the artist who painted the oratory in his anonymity. Stylistically, this artist seems to interpret Giotto's art in a manner similar to that found in the works of Giusto de' Menabuoi and Tommaso da Modena, influenced by the chivalrous, Gothic atmosphere prevailing in the Visconti court towards the middle of the 14th century. Some figures on the left wall are particularly Giottesque in their realism, while others, on the right wall, are inspired by International Gothic.

Simone da Corbetta
(active in Lombardy after 1382)

2 *Virgin and Child, Saints and
the Donor, Teodorico da Coira*
Detached fresco
235 x 297 cm
Acquired: 1847

Because of its apparent chronological and stylistic similarities, this fresco, which was originally in the church of Santa Maria dei Servi in Milan, is housed in the same room as the oratory of Mocchirolo. The artist who executed this painting is, however, much less cultured and skilful than the Master of Mocchirolo, and the way the Virgin and saints are disposed is both weak and banal, although the fresco reflects the practice in the illuminations of the period. It has been noted, however, that the facture is similar to that of the fresco in the oratory of Lentate portraying the Porro family before St Stephen. It is likely that the work was executed before the end of the 1380s, after the death of Teodorico da Coira in 1382.

gentilis de fabriano pinxit

			VII	VIII
			VI	IX
	IA	**II** **III** **IV**	V	
		I		XIV
			XIX	
XXXVIII			XVIII	XV
XXXVII			XX	
XXXV	XXXVI		XXI	
XXXIV			XXII	
XXXIII XXXII	XXXI	XXX XXIX XXVIII XXVII XXIV	XXIII	

Room II
Pisan painter
1
Giovanni Baronzio
2
Barnaba da Modena
3
Master of the Pesaro Crucifix
4
Ambrogio Lorenzetti
5
Giovanni da Milano
6
Bernardo Daddi
7
Bartolomeo and Jacopino da Reggio
8
Lorenzo Veneziano
9

Room III
Paolo di Giovanni Fei
1
Pere Serra
2
Jacopo Bellini
3
Giovanni da Bologna
4
Nicolò di Pietro
5
**Andrea di Bartolo
and Giorgio di Andrea**
6
Andrea di Bartolo
7

Room IV
Gentile da Fabriano
1 2
**Stefano da Verona
(Stefano da Zevio)**
3
Bonifacio Bembo
4
Zavattari
5
Francesco di Gentile
6 7

These three rooms illustrate in an incomplete but nonetheless significant manner the development of Italian painting – especially in the northern part of the country – from the end of the 13th century to the spread of International Gothic. On display are religious pictures, mainly fragments of larger works, that adorned the altars in the churches of that period: architecture glittering with gold and bright with colours enclosed or presented the sacred images for the adoration of the faithful, or narrated the lives of the holy personages in pictorial form. Due to the very different origins of these works, it is difficult to suggest a particular order in which they should be seen, but a continuous thread may be identified in the progressive conquest and representation of the natural world, beginning with the refined stylization that was still Byzantine in character (room II, no. 1). The keystone of this process, responsible for the rapid transformation to a more convincing representation of reality, was the output of the Florentine Giotto, whose influence is only seen in the Brera through the effect he had on the various Italian schools (room IA, no. 1; room II, nos. 2, 6, 7).

Examples of what were special situations are found in these rooms – for instance, that of Siena (room II, no. 5), characterized by close contacts with French Gothic; Bologna, where the presence of a major university favoured the development of a cosmopolitan style; and, above all, Venice, which maintained close links with the culture of the East, until the second half of the 14th century (room II, no. 9). At the end of the 14th century the whole of Italy – albeit to different degrees in the various cities – was involved in the creation and diffusion of International Gothic. This term refers to the formation, especially at leading courts of Europe (Paris, Milan, Prague, Avignon, Burgundy) and in such centres as the small signorie of the Marches, of a style that had common characteristics.

In the works of Gentile da Fabriano, one of the greatest exponents of the International Gothic style (room IV, nos. 1 and 2), as in those of Pere Serra, Nicolò di Pietro (room III, nos. 2 and 5), Stefano da Verona or Bonifacio Bembo (room IV, nos. 3 and 4), there is the same precise realism that investigates and renders, one by one, the most hidden aspects of reality; a passion for naturalistic detail and the precious object in which both the craftsmanship and materials are extremely refined; the transformation of sacred scenes into occasions of profane luxury; and, from a stylistic point of view, the prevalence of contours, formed by lines varying from soft to nimble, and elegant colours creating an almost abstract effect.

Not only was this style very successful, but it also lasted right through the 15th century, as is readily apparent from the comparison of the dates on the paintings displayed here by Bonifacio Bembo and the Zavattari (room IV, nos. 4 and 5). (E.D.)

Pisan painter
(active in Pisa? c. 1270–1275)

1 *St Veranus between Two Angels and Six Scenes from his Life*
Tempera on panel
152 x 97 cm
Acquired: 1982

This painting, which may be dated about 1275 and was donated to the gallery by the heirs of Paolo Gerli – a collector and long-time chairman of the Associazione Amici di Brera (Friends of the Brera Gallery) – was probably the altarpiece of the parish church, dedicated to St Veranus, at Peccioli, in the province of Pisa. The rigid saint, in accordance with a scheme common in 13th-century painting, especially in central Italy, is flanked by the most salient events of his life, from his baptism (upper left), to his burial, overseen by an angel (lower right). The anonymous artist's style combines compact monumentality – especially evident in the figure of the saint wearing a loose robe embellished with very regular gold heightening – with narrative verve, which dominates the stories acted out by figures with lively gestures.

Giovanni Baronzio
(active in Rimini before 1362)

2 *Three Scenes from the Life of St Columba*
Tempera on panel
53 x 55 cm each
Acquired: 1960

The protagonist of the three scenes is St Columba of Sens, to whom the old cathedral of Rimini was dedicated. And it is from this church that these panels probably came originally; they were certainly part of a larger work that is, however, difficult to reconstruct. In them the most outstanding events of the saint's life (her profession of faith before the emperor Aurelian, her miraculous defence by a bear that put to flight the rogue who had been commissioned to violate her in prison, her martyrdom) are narrated by a Riminese painter who is still little known. The school of painting that flourished in Rimini after Giotto's sojourn there at the beginning of the 14th century combined the sense of space and volume typical of the Florentine artist with a taste for the curious detail serving to illustrate the narrative, rich decoration and colour – bright and luminous as in the Venetian tradition – which are all to be found in this work, datable around 1350. Here the figures are solid but elongated, the gestures sweeping and elegant, and, in order to exalt their refinement, the materials are applied with notable technical skill, as in the ground and the saint's robe.

Barnaba da Modena
(active 1361–1383)

3 *Adoration of the Child*
Tempera on panel
57 x 50 cm
Acquired: 1904

This panel painting, which came to the Brera as part of the Sipriot Collection and may be dated around 1380, must also have originally formed part of an altarpiece. It can be definitely attributed to Barnaba da Modena, who trained in Bologna, but was also active in Liguria, Piedmont and Tuscany, where he had a considerable influence with his paintings characterized, like this one, by descriptive detail, crowded compositions and sumptuousness resulting from the abundant use of gold that accompanies contours with sinuous Gothic elegance.

Master of the Pesaro Crucifix
(active in Venice 1385–1400)

4 *Virgin and Child and Annunciation*
Tempera on panel
68 x 51 cm
Acquired: 1808

This is the central panel of a small triptych, possibly commissioned – at least, this is what the monogram "TS", which is repeated a number of times, seems to indicate – by the Venetian Scuola dei Tessitori di Panni di Seta (Confraternity of the Weavers of Silk Cloth). One of the most mature works by this anonymous artist working in Venice at the end of the 14th century, it is characterized by intense colours and simple curvilinear contours.

Ambrogio Lorenzetti
(Siena c.1290-1328)

5 *Virgin and Child*
Tempera on panel
85 x 57 cm
Acquired: 1947

Donated to the gallery by the collector Guido Cagnola, this painting was probably the central panel of a polyptych that it is not now possible to reconstruct, and may be dated around 1320. Although he was Sienese, Ambrogio Lorenzetti worked for a long period in Florence where he was influenced by the more mature experimentation with space of the Giottesques. Despite the poor state of preservation of this work – the gold ground is badly worn, as are the faces, which, due to excessive cleaning in the past, have lost their roseate glazes – it is still possible to appreciate the combination between the extraordinary formal elegance (the pure contours, the decorative quality of the mantle), and the exchange of glances between the Mother and the lively Child who, although wrapped in swaddling clothes, seeks to move his feet.

Giovanni da Milano
(Caversaccio, Como active 1346-1369)

6 *Enthroned Christ Adored by Angels*
Tempera on panel
152.3 x 68.5 cm
Acquired: 1970

Giovanni da Milano, who trained in Lombardy after Giotto had stayed there, worked above all in Florence, the city from which this painting probably comes. It is the central panel of a now dispersed polyptych that was executed for the Camaldolese monastery of Santa Maria degli Angeli, in Florence, around 1365.

The solemn figure of Christ seated on a faldstool and holding a volume in which are written verses from the Apocalypse emphasizing both his majesty and his role as supreme judge, may allude to the temporal power of the popes. The artist's skill in rendering the volumes and the foreshortening (note the hand raised in benediction), accompanied by graceful contours and a keen sense of reality – for example, in Christ's attentive expression and the varying ones of the angels – indicate that it is a mature work. The colour, intense and refined, but with subtle gradations, is applied with minute, dense brushstrokes that both model the surfaces and cause them to vibrate with light.

Bernardo Daddi
(Florence c. 1290-1348)

7 *St Lawrence*
Tempera on panel
43 x 24 cm
Acquired: 1903

This painting, which has been cut off at both ends, originally represented the full-length figure of the saint and was the side panel of a polyptych. It may be dated around 1340 and was produced by the very active workshop of Bernardo Daddi, who, influenced by Giotto, developed the lyrical element of the latter's art, emphasizing, above all, the expressive nature of line and colour.

Bartolomeo and Jacopino da Reggio
(active in the third quarter of the 14th century)

8 *Crucifixion, Annunciation and Thirty Figures of Saints*
Tempera on panel
67 x 92 cm overall
Signed at the foot of the cross
"HANC TABVLA(M) FECERV(N)T BARTOLOMEV(S) ET IACOPINV(S) DE REGIO"
Acquired: 1889

This work, which was found in a house in the hills near Parma and donated to the Brera Gallery by the collector Luciano d'Aragona, is a triptych serving as a reliquary, as is demonstrated by the circular hollows for the relics in the pointed arches surmounting the fictive double lancet windows in which the pairs of saints are depicted. In addition to this painting, art historians have attributed a small group of works to the two artists, about whom there is a lack of documentary evidence, but who appear to have been greatly influenced by the Bolognese school, especially the numerous workshops specializing in manuscript illumination that flourished around the university of Bologna, as may be seen from the vivacity and clarity of the composition.

Lorenzo Veneziano
(active in Venice 1356-1372)

9 Virgin and Child with Saints
Tempera on panel
Central panel 79 x 29 cm
Side panels 31 x 13 cm
On loan from the Galleria Franchetti, at the Ca' d'Oro (Venice), since 1958

This small altarpiece, which comes from the monastery of Santa Maria della Celestia in Venice, is almost intact; even the frame, although it is incomplete because it lacks the pinnacle panels and some of the pillars, is largely original. It is a late work by Lorenzo Veneziano, one of the most important Venetian artists of the 14th century.

Lorenzo, after training in Venice, went to Bologna, where he was deeply influenced by the Gothic style. This is indicated by the animated relationship between the Mother and her Son; the graceful movements and soft, curvilinear contours; the abundance of decoration, particularly in the throne; and the worldly elegance of the clothes of some of the saints.

Paolo di Giovanni Fei (attributed)
(Siena 1346-1411/12)

1 *Virgin and Child*
Tempera on panel
62.5 x 35 cm
Acquired: 1982

The splendid colour accords, supported by the undulating rhythms of the contours and, above all, the remarkable variety and refinement of the punch marks decorating the ground and haloes, accentuate the archaizing tone of this panel. For this reason, doubts have been raised as to whether this painting – donated to the gallery by the heirs of Paolo Gerli – is, in fact, an early work (c. 1375) by the Sienese artist Paolo di Giovanni Fei, who is known, in particular, for more engaging and modern compositions, rich in narrative detail.

Pere Serra
(active 1357-1408/09)

2 *Annunciation*
Tempera on panel
59 x 39 cm
Acquired: 1920

Executed by Pere Serra, a Catalan painter who was also active in Sardinia, this painting is evidently a panel of a retable. The precise naturalistic details, flowing contours of the figures and the delicate, refined colours, all characteristic of the International Gothic style, indicate that this is a product of the artist's late period.

Jacopo Bellini
(Venice c. 1400-1470/71)

3 *Virgin and Child*
Tempera on panel
45 x 50 cm
Signed inside the painted frame
"HAS DEDIT INGEN(VA)/BELINVS MENTE FIGORAS" and dated 1448
Acquired: 1912

This panel painting – unfortunately, badly damaged – comes from the church of the Visitazione at Casalfiumanese, near Imola (Bologna). Given its limited dimensions and, above all, the use of perspective suggesting that it was intended for viewing from below, it must have formed part of a larger work about which, however, nothing is known. Jacopo Bellini, the father of Gentile and Giovanni Bellini, was trained by Gentile da Fabriano, but, during the 15th century he was particularly influenced by the new developments in Florence and Padua, especially with regard to perspective and the taste for the art of antiquity. In this case his weak, but unequivocal, attempts to confer a sense of naturalness on the images, which parallel those of Antonio Vivarini (room V, no. 1), produce simplicity of contour, soft chiaroscuro that models the figures and detaches them from the background, and foreshortening of the Child's legs, allowing the depth of the space to be measured, albeit approximately.

Giovanni da Bologna
(active in Treviso 1377–1385 and Venice 1389)

4 *Virgin and Child and Angels*
Tempera on panel
91 x 61 cm
Acquired: 1910

This painting is certainly a fragment of a more complex work, although it is not possible to put forward valid hypotheses regarding its original arrangement. With its glowing colours, made more refined by the use of gold fillet, this work demonstrates, in the compact figures of the Virgin and Child, how the art of Giovanni da Bologna continued to be inspired by Giottesque models of the first half of the 14th century.

Nicolò di Pietro
(active in Venice 1394–1430)

5 *Coronation of the Virgin*
Tempera on panel
100 x 54 cm
Acquired: 1963

This painting was donated to the gallery by the Associazione Amici di Brera (Friends of the Brera Gallery). In view of its dimensions and the presence of small figures of the donors kneeling at the feet of the holy personages, it may originally have been a small altarpiece placed on a secondary altar.
Executed around 1400, it clearly illustrates the transition not only of the artist, but also of Venetian painting as a whole, to the International Gothic style. In fact, the naturalistic expressiveness of the solid figures with their sharp features are accompanied by soft contours, refined juxtapositions of colours and a profane abundance of decoration.

Andrea di Bartolo
(Siena c. 1365-1428)

Giorgio di Andrea
(active 1410-1428)

6 *Polyptych of the Coronation of the Virgin*
Oil on panel
Central panel 160 x 65 cm
Side panels (left) 142 x 37 cm
Side panels (right) 142 x 36 cm
Acquired: 1811

This polyptych comes from the church of the Benedictine convent of Santa Caterina d'Alessandria at Sant'Angelo in Vado, near Urbino. It must have been an imposing work because it formerly comprised two other panels with figures of saints, now in the Galleria Nazionale delle Marche in Urbino, and a predella, the panels of which are now in various museums. Moreover, it was surmounted by pinnacle panels, the existence of which is demonstrated by the holes in the upper part of the surviving panels. There is no documentary evidence for the name of the artist responsible for this work – which may be dated around 1415 – but the long-limbed and bemused figures, dressed in bright colours with unusual accords and the sumptuous gold decorations, seem to indicate Andrea di Bartolo, a Sienese painter who also worked in the Marches, assisted by his son Giorgio; the latter was certainly responsible for St Peter with his yellow robe.

6

Andrea di Bartolo
(Siena c. 1365-1428)

7 *Christ Blessing*
Tempera on panel
73 x 31 cm
Acquired: 1811

This small painting also came to the gallery from Sant'Angelo in Vado (Urbino), and it was conjectured that it was one of the pinnacle panels of the polyptych described above. In reality, the width of the base does not correspond to that of the panels now in the Brera, while it matches perfectly another panel by Andrea di Bartolo depicting the *Assumption of the Virgin*, now in the Virginia Museum of Fine Arts in Richmond (USA), but probably executed for Fano (Pesaro) around 1390; this is the central panel of a complex polyptych.

7

Gentile da Fabriano
(Fabriano, Ancona c. 1385-
Rome 1427)

1 *Valle Romita Polyptych*
Tempera on panel
Central panel 157.2 x 79.6 cm
Lower side panels 117.5 x 40 cm
Upper side panels 48.9 x 37.8 cm
Signed on the central panel bottom centre "gentilis de fabriano pinxit"
Acquired: 1811 and 1901

The panels comprising the polyptych, now surrounded by an early 20th-century frame, came to the gallery at two different times: the five largest ones – from the monastery of Santa Maria di Valdisasso (or Valle Romita), near Fabriano, in the Marches – arrived as a result of the Napoleonic despoliation, while the smaller ones were purchased. This masterpiece by Gentile da Fabriano, one of the greatest artists in Europe in the early 15th century, may be dated around 1410. It is an outstanding example of his style, which combines naturalistic detail (the flowery meadows on which the saints stand, Mary Magdalene's fur-lined mantle and the tunic of soft wool worn by St Jerome, and the artist's sensitivity to the effects of light) with the exquisite abstract elegance of the contours, the refinement of the materials (besides the gold ground, note the silver leaf, now oxidized, of which Christ's tunic is made) and the variety of ways in which these materials are skilfully worked – for instance, the superb tooling, worthy of a goldsmith, of the central panel.

Gentile da Fabriano
(Fabriano, Ancona c. 1385-Rome 1427)

2 Crucifixion
Tempera on panel
60 x 40.5 cm
Acquired: 1995

Although this painting was purchased from a London antique dealer, an inscription on the back states that it comes from the Marches. It is probable, therefore, that it is the pinnacle panel that, according to old sources, once crowned the polyptych Gentile da Fabriano painted for the monastery of Valle Romita (no. 1) and which – also according to the same sources – was taken away by an "oriental". Whether or not this panel formed part of the Valle Romita Polyptych, there is no doubt that it is an autograph work executed for a client in the Marches in a period close to that of the polyptych.

Stefano da Verona
(Stefano da Zevio)
(c. 1375-after 1438)

3 Adoration of the Magi
Tempera on panel
72 x 47 cm
Signed lower left "Stefanus pinxit" and dated 1435
Acquired: 1818

This painting, with an attribution to Stefano Fiorentino (an elusive follower of Giotto), was sold to the gallery by Domenico Biasioli, who, in his turn, had purchased it from a Veronese family. The painter was also identified as a Veronese, Stefano da Verona; the son of the Frenchman Jean d'Arbois and master of Pisanello, he was one of the leading exponents in Verona of International Gothic, the worldly taste of which is evident here in the clothes, materials (the profusion of gold and moulded gesso) and the emphasis given to the royal procession of the Magi. This delicate painting is fascinating for the elegant flow of the lines – the basis of the compositional structure – and the importance given to details, depicted with attention being paid to their natural appearance, but without subjecting them to the rational organization of space.

Bonifacio Bembo
(Brescia c. 1420–active until 1477)

4 *St Alexius; St Julian*
Tempera on panel
85 x 28 cm each
Acquired: 1950

These two panels, donated by Paolo Gerli, evidently formed part of a polyptych – now dispersed – executed in the 1380s by Bonifacio Bembo, a painter and illuminator who obtained numerous important commissions from the Sforza, interpreting their ideals of luxury and courtly elegance. For the whole of his career Bembo painted in the International Gothic style, one of the cradles of which was Lombardy, using thin, soft contours to outline the figures and their details; he was also influenced by the masterly naturalism of Gentile da Fabriano, as is demonstrated by the careful rendering of the meadow on which the saints are standing.

**Zavattari
(Second master of Monza)**
(active in Lombardy in the
15th century)

5 *Assumption of the Virgin*
Tempera on panel
100 x 72.5 cm
Acquired: 1982

The most well-known undertaking of the Zavattari family, the members of which worked in Lombardy right through the 15th century, is the decoration of the chapel of Teodolinda in Monza cathedral, which, significantly enough, is signed collectively. Although, within the family, there were a number of more outstanding artists, the influence of early 15th-century Milanese art was a feature common to all their works. These are characterized by two-dimensional compositions populated by figures with delicate, but impersonal, faces in which the contours become arabesques, as may be seen in this painting donated to the gallery by the heirs of Count Paolo Gerli.

Francesco di Gentile
(Fabriano, Ancona active in the second half of the 15th century)

6 *Assumption of the Virgin*
Tempera on panel
89 x 50 cm

7 *St Sebastian between St Dominic and St Anthony Abbot*
Tempera on panel
90 x 50 cm
Acquired: 1855

These two paintings, which formed part of the Oggioni bequest, constituted the two sides of a processional banner. They are rare works by the painter from Fabriano, in the Marches (he was not related to Gentile da Fabriano), and date from a period late in his career when his fondness for the richness of the materials and his craftsman's skill in treating the surfaces, typical of artists from the Marches, was combined with attempts at anatomical correctness (note the figure of St Sebastian), bearing witness to an enthusiastic, albeit superficial, adaptation to the new developments in Renaissance art.

Room V
Venetian paintings of the 15th and 16th centuries

Room V

Giovanni d'Alemagna and Antonio Vivarini
1

Pedro Berruguete
2

Girolamo da Treviso the Elder
3

Master Giorgio
4

Girolamo da Santacroce
5

Lazzaro Bastiani
6

Cima da Conegliano (Giovanni Battista Cima)
7 8 9

The difficult and varied balance between artistic innovation and tradition is the common denominator of the paintings in this room, which were executed over a seventy-year span from the middle of the 15th century onwards. In this period Venice had extended its dominion to the *terraferma* (mainland), guaranteeing, however, the preservation of the cultural distinctiveness of the individual provinces. Consequently, for the whole of the second half of the 15th until the early 16th centuries, Venetian painting varied considerably from one area to another, depending especially on the particular approach that was taken to the innovations originating from Florence at the beginning of the century that had, in the first place, been elaborated and disseminated by the artists of Padua and Venice.

In Padua, where the presence of the university had for centuries favoured a tradition of studying classical antiquity, the ten-year sojourn (1443-53) of the Florentine sculptor Donatello, who had been commissioned to execute an equestrian monument to the condottiere Gattamelata and sculptures for the high altar of the basilica of Sant'Antonio, had produced outstanding examples of the lucid organization of space governed by linear perspective and animated by a changeable chiaroscuro, original studies of antiquities and an intensity of expression that had impressed, first and foremost, the painters. In Venice, on the other hand, thanks to the Bellini family – especially Giovanni – and the presence of Antonello da Messina, an extremely original variant of humanism had developed in painting in the 1470s.

In the works displayed in this room, a conservative tendency may be noted in the persistence of the polyptych as opposed to the more modern need for a unified space, the gold ground in contrast to architectural or landscape settings, and the standardized faces, with features that are still vaguely Byzantine or Late Gothic. The remarkable *Dead Christ with Angels* (no. 2) is, however, completely extraneous to this context: it has been hung here because of its supposed provenance, the church of the Carità in Venice, although it recently transpired that this hypothesis was the result of a misunderstanding of documents. (E.D.)

Giovanni d'Alemagna
(active in Venice after 1437-Padua 1450)

Antonio Vivarini
(Venice 1418/20-1476/84)

1 *Praglia Polyptych*
Tempera on panel
Lower tier:
Central panel 67 x 33 cm
Side panels 62 x 22 cm
Upper tier:
Central panel 47 x 22 cm
Side panels 42 x 22 cm
Acquired: 1811

This polyptych, which comes from the high altar of the Benedictine abbey of Praglia, near Padua, was probably executed in 1448, the year in which the abbey joined the Congregation of Saint Justina of Padua on the initiative of the abbot Cipriano Rinaldini, who has been identified as the donor at the Virgin's feet. This painting by Antonio Vivarini – executed in collaboration with his son-in-law Giovanni d'Alemagna – is an excellent example of the output of his workshop, which, in the first half of the 15th century, was noted in Venice for its cautious renovation of the Gothic tradition and was particularly popular with clients having more conventional artistic tastes. Here, for example, the figures – particularly the solid Virgin and the sturdy Child – stand out with authority in the pictorial space, but there is still the customary division into panels and the abstract gold ground, of which only the red bole used as the underlayer for the gold leaf remains, and we can only imagine the polychrome carved frame, still in Gothic style, that must have surrounded the work.

Pedro Berruguete
(Paredes de Nava c. 1450-Avila 1504)

2 *Dead Christ with Angels*
Oil on canvas
62 x 71 cm
Acquired: 1811

The painting was requisitioned for Brera, with a very flattering attribution to Raphael, in the monastery of Sant'Agata Feltria, near Urbino. In reality, it is an outstanding work by a painter with a Flemish background – customarily identified as the Spanish artist Pedro Berruguete – who worked at the court of Urbino from about 1472 onwards.

This artist was also responsible for repainting the hands of Federico da Montefeltro in the altarpiece by Piero della Francesca (room XXIV, no. 1); this was done with the same technique, glazing, as in this small canvas and with the same naturalistic detail.

Girolamo da Treviso the Elder
(Treviso 1451-1497)

3 *Dead Christ with Angels*
Oil on panel
67 x 63 cm
Signed lower right "HIERONIMVS TARVISIO P."
Acquired: 1889

The composition of this work, which may be dated about 1480, derives from the bas-relief representing the *Pietà* sculpted by Donatello for the high altar of the basilica of Sant'Antonio in Padua, while the metallic drapery and the sharp definition of the faces or the anatomical details is evidence of the attention paid by the artist to the mildly innovatory painting of the Vivarinis' workshop, especially that of Bartolomeo.

Master Giorgio
(active in Venice in the mid-15th century)

4 *St Mark*
Tempera on panel
60 x 51 cm
Signed and dated
on the upper part of the panel
"MCCCCLIIII/georgius pinxit"
Acquired: 1811

Although this painting was originally in the Doge's Palace in Venice, it came to Brera as a gift of the viceroy, Prince Eugène de Beauharnais. No other works by this artist have been identified, so that the little that is known about him can only be gleaned from this small painting. It is evidently by an artist whose style was, by the middle of the 15th century, decidedly *retardataire* – note the schematic way in which the furrows on the saint's forehead are depicted – but he updates it through a more convincing rendering of the volumes and the characterization of the facial features, both of which reveal the influence of Mantegna's early works (room VI, no. 12).

Girolamo da Santacroce
(d. Venice 1556)

5 *St Stephen*
Oil on panel
40 x 35 cm
Acquired: 1811

This painting, which came to the gallery from the Benedictine convent of San Lorenzo in Venice, formed part of a larger work, possibly a polyptych, other parts of which have been identified. Girolamo da Santacroce, a follower of Gentile Bellini, was incapable of adapting himself to the changes brought about by the younger generation of Venetian painters, such as Giorgione and Titian, as may seen from the small, clearly outlined figure standing out against a vast animated landscape, the style of which is still very Bellinesque.

Lazzaro Bastiani
(active in Venice 1449-1512)

6 *St Jerome Leading the Lion to the Monastery; St Jerome in the Desert; The Death of St Jerome*
Tempera on panel
25 x 50 cm each
Acquired: 1900

These three paintings, which originally constituted the predella of the altarpiece of St Jerome in the cathedral at Asolo, near Treviso, in the Veneto, are the work of a mediocre artist who is, however, capable of judiciously updating his style. Although this is still basically Gothic, his training as an illuminator is evident, with the architecture drawn in perspective and solidly constructed figures.

Cima da Conegliano (Giovanni Battista Cima)
(Conegliano, Treviso 1459/60-1517/18)

9 *St Justina with St Gregory and St Augustine*
Tempera on panel
Central panel 76 x 39 cm
Side panels 76 x 20 cm
Acquired: 1811

Cima da Conegliano (Giovanni Battista Cima)
(Conegliano, Treviso 1459/60-1517/18)

7 *The Virgin with St Luke, St John the Baptist and St Mark*

8 *St Clare, St Jerome, St Nicholas and St Ursula*
Tempera on panel
30 x 25 cm each
Acquired: 1809

These small panels, part of an unidentified larger work, come from the church of San Girolamo in Venice. Attributed by some writers to the artist's workshop, they are splendidly executed works, notable above all for the remarkable light effects obtained by the tooling of the gold ground and the skilful portrayal of each saint.

Room V

These three panels, which came to the gallery together with another two now in the Gallerie dell'Accademia in Venice, were part of a polyptych intended for the church of Santa Giustina in Venice. Despite their archaic structure, which had perhaps been requested by the clients, they must be dated around 1500.

Because of some irresolution in the way the anatomies are represented and the emphatic chiaroscuro of the faces, they are believed to be the work of an assistant, although the geometric regularity of the volumes (note, in particular, St Justina's face) is typical of Cima's style.

Room VI

Liberale da Verona
[1]

Giovanni Martini da Udine
2

Vittore Carpaccio
3 4 [5]

Bartolomeo Montagna
6

**Cima da Conegliano
(Giovanni Battista Cima)**
[7] [8]

Francesco Bissolo
9

Andrea Previtali
10

Giovanni Bellini
[11] [13] 16

Andrea Mantegna
[12] 14 [15]

The works by Mantegna and Bellini in this room are some of the most outstanding paintings in the Brera and are also among the ones that are most familiar to the general public. Together with these pictures, which illustrate the nature of the forces that made Venice one of the leading artistic centres in Italy, hang works attesting to other distinctive features of Venetian art in the late 15th and early 16th centuries. Reference has already been made to the shifting of the centre of Venetian political power from the sea towards the mainland, which also implied the slow opening up of the city to the artistic currents existing in the various areas under its domination, especially that of Padua, which is represented here by its most famous exponent, Andrea Mantegna, a key figure in Italian art at the beginning of the 16th century. A pupil of Francesco Squarcione in Padua, he was court painter to the Gonzaga in Mantua and a precursor of artistic developments in northern Italy. In particular, he played a fundamental role in the evolution of Venetian painting due to his influence on his brother-in-law Giovanni Bellini, who soon freed himself from the rigidity of Mantegna's draughtsmanship and the severity of his pictorial style in order to attain a more profound representation of the emotions and a naturalistic rendering of both the figures and the landscape, availing himself of the expressive and constructive potential of colour and light. The example of the Flemish painters, who were held in high esteem in Venice, was particularly important for Bellini, as was that of Antonello da Messina, who was considerably influenced by Flemish art, but was also very familiar with the work of Piero della Francesca: together they changed the whole course of Venetian painting (nos. 1, 2, 6, 7, 8, 9, 10).

On the other hand, the works displayed here bear witness to the early adoption of oil painting in Venice. Once again, this was probably favoured by familiarity with the works of Flemish painters (the first to use this technique systematically); with its bright, transparent glazes, it permitted remarkable effects of atmospheric softness to be obtained. Moreover, the paintings by Carpaccio (nos. 3, 4, 5) attest to the popularity – linked to the uniquely Venetian patronage of the *scuole* (confraternities of lay persons with aims that, at least initially, were devotional, having their own, often monumental, premises) – of the large narrative canvases, intended to decorate the meeting halls and chapels with cycles of paintings placed around the walls. In these richly detailed works, the religious scene very often became a pretext for precise townscapes based on real views or accurate portraits of members of the confraternity scattered among the onlookers. (E.D.)

Liberale da Verona
(Verona 1445-1527/29)

1 *St Sebastian*
Oil on panel
198 x 95 cm
Acquired: 1811

In 1476 Liberale returned to his native city after a long period spent in central Italy where he had worked, above all, as an illuminator. The abundance of detail and the graphic agility with the expressionistic use of line, typical of illuminations, are particularly evident in the background – rich in curious episodes – of this work executed in the 1490s for the church of San Domenico in Ancona.
The complex perspective of this work, emphasized by the foreshortened broken column, is particularly remarkable; this is derived from the *St Sebastian* by Antonello da Messina, executed in Venice and now in the Gemäldegalerie in Dresden. Also worthy of note is the high, bright light and the monumental, nervous figure of the saint – modelled on the statue of Adam sculpted by Antonio Rizzo for the Doge's Palace in Venice – to which the light lends a stately demeanour and a marmoreal texture.

Giovanni Martini da Udine
(Udine c. 1470-1535)

2 *St Ursula amidst the Virgins*
Oil (?) on canvas
185 x 220 cm
Inscription on the pedestal bearing St Ursula: "ESSENDO CA/MERAR/ MAGISTRO/ANTONIO/ MANZIGNEL/MCCCCCVII"
Acquired: 1811

Giovanni Martini was, above all, an engraver, and he is only known to have worked as a painter until the first decade of the 16th century, the period in which he executed this painting. It formed the central panel of an altarpiece comprising a lunette, a predella and an elaborate wooden frame, commissioned by the Confraternita di Sant'Orsola for its altar in the church of San Pietro Martire in Udine. The geometrized ovals of the faces, the clear contrast between light and shade, and the paper-like folds of the iridescent robes reveal that the artist was not only influenced by the works of Cima da Conegliano, but also by those of Antonello da Messina, who worked in Venice in 1475-76.

Vittore Carpaccio
(Venice c. 1460-1525/26)

3 *Presentation
of the Virgin*
Oil on canvas
130 x 137 cm

4 *Marriage of the Virgin*
Oil on canvas
130 x 140 cm
Acquired: 1808

These paintings, executed around 1505, represent two successive episodes in a cycle devoted to the life of the Virgin that decorated the Sala dell'Albergo in the Scuola degli Albanesi in Venice. Although these are not among Carpaccio's most outstanding works, it is possible to note his skill as a narrator in the way he suggests the continuous unfolding of the story through the architectural backgrounds and records with curiosity every aspect of reality, transferring the events of the religious story to a dimension that is both human and fantastic. Here the painter's inventive vein expresses itself through the exotic buildings and the wealth of detail, both decorative and symbolic, inserted with naturalness in the scene – for example, in the *Presentation*, both the deer, held on a leash by the child, and the rabbit allude to the Virgin's purity and her sinless fertility.

Vittore Carpaccio
(Venice c. 1460-1525/26)

5 *Disputation of St Stephen*
Oil on canvas
147 x 172 cm
Signed and dated on the pedestals
of two columns:
on the left
"VICTOR/CARPATHIVS/PINXIT";
on the right "M/DXIIII"
Acquired: 1808

This painting, which comes from the Scuola di Santo Stefano in Venice, is part of a cycle depicting the most important events in the saint's life. In this canvas, which is undoubtedly of a higher standard than the previous two, it is possible to appreciate the liveliness of the artist's imagination, which, in the background, has created an Orient with fantastic monuments, the artist's gifts as a portraitist – seen in the depiction of the members of the confraternity dressed in red or black – and his confident use of perspective, evident both in the construction of the portico and the foreshortened objects, which, with their shadows, stress the depth of the space.

Bartolomeo Montagna
(Vicenza c. 1449-1523)

6 *St Jerome*
Oil on panel
51 x 58 cm
Acquired: 1925

This panel, which formerly belonged to the scholar and collector Gustavo Frizzoni, may be dated from the beginning of the 16th century. In this superb work, it is evident that the painter has been influenced by the developments in the way Venetian painting renders the landscape, which is bathed in a warm, soft light that moulds the objects and the episodes from the hermit's life thronging it.

Cima da Conegliano
(Giovanni Battista Cima)
(Conegliano, Treviso 1459/60-1517/18)

7 *St Jerome in the Desert*
Oil on panel
37 x 30 cm
Acquired: 1808

The original provenance of this small panel is unknown, but it may be identified as the one that, in the second half of the 17th century was in the reliquary room in the church of San Giorgio Maggiore, Venice. Although an old inscription on the back indicates that it is the work of Pasqualino Veneto, it can, in fact, be attributed with certainty to Cima da Conegliano and may be dated around 1495. In it, the artist avails himself of the religious subject (the hermitic retreat of St. Jerome) to depict a landscape teeming with life that is rendered with bright colours and remarkable sharpness of detail.

Cima da Conegliano
(Giovanni Battista Cima)
(Conegliano, Treviso 1459/60-1517/18)

8 *St Peter Enthroned with St John the Baptist and St Paul*
Oil on panel transferred to canvas
155 x 146 cm
Acquired: 1811

This painting comes from the refectory of the Franciscan convent of Santa Maria Mater Domini at Conegliano, although it was probably executed for the church attached to the building. Completed around 1516, the year when the artist was paid, it was one of the last works by Cima; although it remains faithful to tried and tested models, especially in the simple, symmetrical composition, framed by a loggia opening onto a landscape, it is remarkably up-to-date for the changeable, natural light that bathes the figures and softens the contours.

Francesco Bissolo
(active in Venice 1492-1554)

9 *St Stephen with St Augustine and St Nicholas of Tolentino*
Oil on panel
Central panel 115 x 58 cm
Side panels 115 x 43 cm
Acquired: 1808

Originally on the altar of the Scuola di Santo Stefano in Venice, this work was formerly attributed to Carpaccio, who, as mentioned previously, painted the canvases treating the life of St Stephen (no. 5) decorating the walls of the *scuola*. Nonetheless, the solidity and almost geometrical simplicity of the figures, the subdued but profound tones of the colours and the delicate landscape glimpsed behind the saints suggest that it should be attributed to Bissolo.

Andrea Previtali
(Berbenno, Bergamo 1470/80-Bergamo 1528)

10 *Transfiguration*
Oil on panel
147.5 x 137.7 cm
Signed and dated lower right on the book "Al nobel homo m Andrea dipintor in Bergamo MDXIII"
Acquired: 1811

Executed for the powerful Bergamasque family of the Cassotti, the painting formerly hung in their chapel in the church of Santa Maria della Grazie in Bergamo. The episode depicted is the Transfiguration, the occasion when Christ manifested himself in all his glory to the disciples Peter, James and John, recognizable as the three small figures on the left. But the iconography is somewhat unconventional, containing elements of the baptism, such as the dove hovering above Christ's head.

Previtali spent the early part of his career in Venice, where he was firstly a pupil of Giovanni Bellini then a follower of his style. This work, executed after the artist had returned to Bergamo, confirms his special aptitude for the representation of nature: apart from the meadow in the foreground, note the way the vast, bluish landscape opens up luminously beyond the thicket immediately behind Christ.

Giovanni Bellini
(Venice c. 1430-1516)

11 *Virgin and Child*
Oil on panel transferred to canvas
85 x 118 cm
Signed and dated on the altar on the left "JOANNES/BELLINVS/MDX"
Acquired: 1806

This painting was purchased from the Ospedale Maggiore in Milan. Executed when the artist was about eighty years old, it demonstrates both that his mastery was not in any way diminished by his age and that he had a remarkable capacity for renovating his style. If it is compared with the two works described below, it is evident that the painting is wholly constructed with colour, without any assistance from drawing, obtaining an extremely natural effect, so that, despite the cloth separating the holy group from the background, they are in harmony with the atmosphere enveloping the landscape. As in other works by Bellini, the simplicity of the picture conceals complex meanings: the monkey, perching on the marble altar bearing the artist's signature and the date, represents the painter himself, a natural "monkey" offering his art to God; while the tree on the right, with its twigs smeared with birdlime and a bird tied to it as a decoy, might symbolize the Passion of Christ.

Andrea Mantegna
(Isola di Carturo, Padua c. 1430-Mantua 1506)

12 *St Luke Polyptych*
Tempera on panel
177 x 230 cm overall
Signed on the marble column bearing St Luke's lectern
Acquired: 1811

This polyptych, which Mantegna completed in 1455, adorned the chapel of San Luca in the church of Santa Giustina in Padua, and was surrounded by a gilded and painted frame, with a projecting canopy above the central figure. Within this very traditional structure, the artist has conceived a harmonious, deep space: the dais on which the saints stand is notably foreshortened at the ends, and it is likely – on the model of Donatello's altar for the basilica of Sant'Antonio in Padua – that the original frame contributed to the overall illusionism, giving the impression of a loggia from which the figures looked out with a marked *sotto in su* effect.

This early work attests to the artist's great interest in the mimetic reproduction of materials (note, for example, the marble column bearing St Luke's lectern, among the veins of which the artist's signature has been deciphered) and his now well-established predilection for sharp clarity of drawing, forming austere, vigorous figures having sculptural force.

Giovanni Bellini
(Venice c. 1430-1516)

13 *Pietà*
Tempera on panel
86 x 107 cm
Acquired: 1811

This painting, a gift from Eugène de Beauharnais, may be dated between 1465 and 1470, when the artist progressively distanced himself from the style of Andrea Mantegna. The outlines and details are meticulously drawn (note the hands of the Mother and her dead Son, and St John the Evangelist's hair), as they were in Mantegna's works, but the contours enclose large surfaces of colour. Also typical of Bellini is the emphasis given to the human element – the grief of the protagonists on a tragic occasion – and this is echoed on a vast scale by the dull tones of the landscape. The painter's proud, humanistic faith in the capacity of his art is proclaimed by the inscription from an elegy by the Roman poet Propertius: "If these tearful eyes almost make you weep, it is the work of Giovanni Bellini that weeps".

Andrea Mantegna
(Isola di Carturo, Padua c. 1430-Mantua 1506)

14 *Virgin and Child with a Choir of Cherubim*
Oil tempera on panel
88 x 70 cm
Acquired: 1808

Although this painting came to the Brera from the church of Santa Maria Maggiore in Venice, it is probably the work Mantegna gave to the abbot Matteo Bosso, who was a friend of his. The unusually vivid colours and the festive yet solemn composition testify to the influence exerted on the artist by Giovanni Bellini, to whom, for a long time, this picture was attributed.

Andrea Mantegna
(Isola di Carturo, Padua c. 1430-Mantua 1506)

15 *Dead Christ*
Tempera on canvas
68 x 81 cm
Acquired: 1824

This painting was purchased from the heirs of Giuseppe Bossi, a painter who was the secretary of the Brera Academy during its early years and who had himself bought it in Rome in 1806. The earlier history of the painting is, however, uncertain because various versions of the "foreshortened Christ" are documented that went their different ways. With an unusually close view that inevitably rivets the viewer's attention, the canvas depicts the moment preceding the entombment, when Christ, laid out on a marble slab, is mourned by the Virgin, a pious woman and St John. Their sorrowful faces are, however, audaciously relegated to a corner of the composition, which is dominated by the foreshortened figure of Christ, stiffened by death, with his wounds displayed in the foreground. These realistic, poignant details are counterbalanced by the severe and composed tone that is one of Mantegna's characteristic features and, in this case, is accentuated by the colours lacking brightness due to the technique – unvarnished tempera – used by the artist.

Giovanni Bellini
(Venice c. 1430-1516)

16 *Virgin and Child*
Tempera on panel
84 x 62 cm
Acquired: 1808

Known as the "Madonna Greca" because of the monograms in Greek letters at the sides, this painting, before coming to the Brera, hung in the office of the Regulators of the Accounts in the Doge's Palace, Venice.
Due to the greater simplicity of both the composition, reduced to its essential elements, and the style, with its emphasis on simple planes of colour, it is likely that Giovanni Bellini – noted for his long and prolific career – executed this work shortly after the *Pietà* (no. 13).

Room VII
Venetian portraits of the 16th century

Room VII

Cariani (Giovanni Busi)
1

Moro (Francesco Torbido)
2

Titian (Tiziano Vecellio)
3

Lorenzo Lotto
4 5 6 8

Paris Bordone
7

Giovan Battista Moroni
9 10

**Palma Giovane
(Jacopo Negretti)**
11 13

Tintoretto (Jacopo Robusti)
12

The theme of a comparison between Leonardo da Vinci and Giovanni Bellini as early as 1498 (by Isabella d'Este, the marquise of Mantua), the art of painting portraits constituted – at least, from the time of Antonello da Messina onwards – a means of enhancing the reputations of the Italian painters. The latter, influenced by the output of the Flemish artists, transformed the court portrait, in which the sitter is seen in profile, into a more naturalistic vision, at times enriched with symbolic meanings. In this room there are some outstanding examples of portraits painted in the area under Venetian domination during the 16th century; the parallel output of the Lombard artists may be seen in room XIX. In the 16th century, thanks to the conjunction of a favourable political situation and a period of prosperity, portraiture developed notably in both Venice and its mainland territories, including Bergamo. Although there are no portraits here by Giovanni Bellini and Giorgione, an effect of the latter's contribution to portraiture may be seen in the *Portrait of a Man* (no. 2) by Francesco Torbido (called Il Moro). Due to its synthesis of the style of Giorgione and the chiaroscuro of Leonardo da Vinci, this remarkable work appears to illustrate Vasari's opinion that, with its strong chiaroscuro, Giorgione's style was copied from that of Leonardo. The *Portrait of a Man* (no. 1) by Cariani, on the other hand, is closer to the modes of Titian (to whom it has recently been attributed) than to those of Giorgione, although the composition and the sitter's pose are derived from the latter artist. Paris Bordone's *Two Lovers* (otherwise known as *The Promise of Marriage*, no. 7) could also be considered to echo Giorgionesque compositions or groups, but the result appears to be crystallized and less atmospheric here, although the colour and the physical substance of the paint, evoking precious brocades and other fabrics, appear – as always in the case of Venetian painting – sumptuous and palpable. The splendid portrait by Titian (no. 3), with its fluent handling and immediacy, is modelled on his more official portraits. And Lorenzo Lotto, another artist of Venetian origin, seems to have been inspired by Titian in his *Portrait of an Elderly Gentleman with Gloves* (no. 5), one of the masterpieces of the artist, who also painted the portraits of Laura da Paola (no. 6) and Febo da Brescia (no. 8). These are the only known example of a pair of portraits by this artist; in them, the enamel-like surface of the paint allows the creation of remarkable mimetic effects with great realism and fluency. Giovan Battista Moroni, in his turn, turned the portrait into a means of social advancement for the Bergamasque middle class and profoundly renewed its iconography. (P.C.M.)

Cariani (Giovanni Busi) (attributed)
(Venice c. 1485-c. 1550)

1 *Portrait of a Man*
Oil on canvas
71 x 57 cm
Dated on the parapet "MDX(V?)"
Acquired: 1929

This painting comes from the Sottocasa Collection in Bergamo; the decipherment of the date indicates that the work was executed between 1515 and 1520. Formerly attributed to Gerolamo Savoldo and Titian, this portrait, with its Giogionesque modes, reveals that the artist was influenced by the models in vogue among the Venetian aristocracy. X-ray analysis has detected the presence of an underlying portrait depicting a man and a woman in attitudes similar to those in Cariani's *Seduction* (Hermitage, St Petersburg); curiously enough, the same X-ray analysis has led some art historians to ascribe the painting once again to Titian, although the majority of scholars do not agree with this hypothesis.

Moro (Francesco Torbido)
(Venice 1480-Verona c. 1561)

2 *Portrait of a Man*
Oil on canvas
72 x 56 cm
Signed on the left "FRS./TVRBIDVS.V./FACIEBAT"
Acquired: 1888

Executed during the artist's mature period, around 1520, this painting is one of the few works known to be autograph by Torbido, who was, as Vasari reports, a pupil of Giorgione. Here the echoes of Venetian painting, with its strong chiaroscuro, combine with the palpable Leonardesque sfumato to create one of the most powerful portraits of the Renaissance, which testifies to Leonardo's influence on Venetian artists including, according to Vasari, Giorgione.

Titian (Tiziano Vecellio)
(Pieve di Cadore, Belluno 1488/1490-Venice 1576)

3 Portrait of Count Antonio Porcia
Oil on canvas
115 x 93 cm
Signed on the right,
on the window-sill "TITIANVS"
Acquired: 1891

On the basis of its composition, this portrait, donated to the gallery by Eugenia Litta Visconti Arese, can be ascribed to the years between 1535 and 1540. It shows the refined, analytical style of Titian, who attenuates the solemnity of the sitter by depicting a landscape in the right background that expands the pictorial space. The canvas is interrupted on the right as is shown by the sitter's left hand, the whole of which was painted on the vertical strip on the right of the canvas; it has now been partially hidden by the frame. The vaster setting that resulted from this gave the sitter a more stately air and, by emphasizing his importance, made this work an official portrait.

Lorenzo Lotto
(Venice c. 1480-Loreto, Ancona 1556)

4 Portrait of a Man
Oil on canvas
115 x 98 cm
Acquired: 1855

This work, which came to the Brera with the Pietro Oggioni bequest, was executed in the period 1543 to 1545, or in 1551, in which case it is probably the portrait of Giovanni Taurini da Montepulciano, the vicegerent of Ancona. With its restrained style, this portrait reflects the subtly introspective nature of Lotto's painting; although the influence of Giorgione and Titian is also evident here, the artist's representation of the sitter seems to convey a greater sense of familiarity.

Lorenzo Lotto
(Venice c. 1480-Loreto, Ancona 1556)

5 Portrait of an Elderly Gentleman with Gloves (Liberale da Pinedel)
Oil on canvas
90 x 75 cm
Signed upper left "L. Loto"
Acquired: 1859

Purchased by the painter Francesco Hayez on behalf of the Brera Academy, this work was painted in 1543 or 1544. One of Lotto's most intense portraits, it is rightly considered to be a masterpiece of Renaissance art. The sitter, a man of high social status – probably Liberale da Pinedel – is portrayed, with vibrant handling of the paint and careful attention being paid to the anatomical detail, as a somewhat melancholy figure.

Lorenzo Lotto
(Venice c. 1480-Loreto, Ancona 1556)

6 Portrait of Laura da Pola
Oil on canvas
90 x 75 cm
Signed lower right "Laurent. Loto. p."
Acquired: 1859

This painting was also purchased by Francesco Hayez for the Brera Academy, together with the portrait of Febo da Brescia, Laura's husband, hanging here on the same wall. The cost of the two paintings – the only example of a pair of portraits painted by Lotto – was reimbursed by the king of Italy, Vittorio Emanuele II, in 1860. One of Lotto's most magnificent portraits, it is based on the colour contrast between the sumptuous fabrics and the smooth surfaces of the woman's skin. Although the sitter is shown as a flawless wife of high social status, Lotto has portrayed her in an informal, natural pose. The two paintings, recorded in his *Libro delle spese diverse* (the artist's account book), were completed in 1544.

Paris Bordone
(Treviso c. 1500-Venice 1571)

7 *Two Lovers*
(or *The Promise of Marriage*)
Oil on canvas
80.5 x 86 cm
Acquired: 1890

Although this work, which may be dated around 1525, combines one of Titian's subjects (compare his *Love Scene*, in the Casa Buonarroti, Florence) and Giorgione's modes, it bears the imprint of Bordone's own personal style. The sensual rendering of the two figures in the foreground, augmented by the typically Venetian use of colour, is attenuated here by the somewhat unexpected presence in the upper left corner of a man who is, perhaps, the witness of the promise of marriage. The composition may have been inspired by the portraits of married couples sculpted in marble by Antonio and Tullio Lombardo.

Lorenzo Lotto
(Venice c. 1480-Loreto, Ancona 1556)

8 *Portrait of Febo da Brescia*
Oil on canvas
82 x 78 cm
Signed on the parapet lower left
"Laurent. Loto. p."
Acquired: 1859

Dated 1543 or 1544, this is the pendant to the *Portrait of Laura da Pola*, wife of the sitter, Febo (or Deifobo) da Brescia, a nobleman living in Treviso. The painting gives the artist an opportunity to treat pictorially the characteristics of an entire social class, of which he creates a penetrating, meticulous representation. Note, for example, the enormous care with which, emulating Titian's technique, the artist has depicted the fur lining of the sitter's cloak.

Giovan Battista Moroni
(Albino, Bergamo
c. 1520/24-1578)

9 *Portrait of Antonio Navagero*
Oil on canvas
115 x 90 cm
Dated "M.D.LXV" lower right
on the base
Acquired: 1813

Executed in a period during which the artist completely detached himself from the influence of Mannerism, becoming even more original and innovatory, this portrait is a masterly fusion of an official representation and an intimate psychological study, exalted by the choice of vivid colours. The mode of the full-length portrait seems inspired by Titian, who adopted it in his official portraits.

Giovan Battista Moroni
(Albino, Bergamo
c. 1520/24-1578)

10 *Portrait of a Young Man*
Oil on canvas
56 x 49 cm
Acquired: 1862

Dating from around 1560, this work was produced in Moroni's mature period. Surrounded by an oval painted frame that distances the sitter from the observer and accentuates his detachment, this portrait has been executed in an extremely refined manner thanks to the delicate colour variations and the carefully modulated light.

Palma Giovane
(Jacopo Negretti)
(Venice 1544-1628)

11 *Head of an Old Man* (recto);
Head of a Child (verso)
Oil on cardboard
38 x 28 cm
Acquired: 1811

Originally in the collection of the Cardinal Cesare Monti, which was bequeathed to the Milan Archbishopric in 1650, this work may be dated around 1590. On the recto, formerly attributed to Titian, the paint is handled fluently, with a sparing use of colour but numerous skilfully executed passages. The verso, discovered when the cardboard was detached from its canvas support, bears a face (perhaps one of the artist's daughters) rapidly sketched out with a technique that could almost be described as "pre-impressionist".

Tintoretto
(Jacopo Robusti)
(Venice 1519-1594)

12 *Portrait of a Young Man*
Oil on canvas
115 x 85 cm
Acquired: 1857

The attribution of this portrait, which may be dated around 1560-65, was formerly disputed. It is a typical example of a Mannerist portrait in which the artist becomes an acute observer of the aristocratic class, paying particular attention to the sitter's elegant clothes, haughty expression and rather affected pose; however, thanks to the painter's cursive and fluent technique, these features are made less evident.

**Palma Giovane
(Jacopo Negretti)**
(Venice 1544-1628)

13 *Self-Portrait*
Oil on canvas
126 x 96 cm
Acquired: 1811

This work can be dated around 1580: by that year the artist had long settled in Venice after his stay in Rome (1567-70); in this painting he turns towards the observer with a self-assured expression and, almost as if he wished to stress the importance of his profession, he portrays himself busy painting a picture with a religious theme. We witness the compenetration of volumes and false planes, so that the risen Christ is forcefully projected into the foreground, following a Tintorettesque schema. Tintoretto was indeed Palma's main source of inspiration, together with Titian, whose *Pietà* (now in the Gallerie dell'Accademia in Venice) he completed.

Room VIII
Venetian paintings of the 15th century

Room VIII

Michele da Verona
1

Alvise Vivarini
2 7

**Cima da Conegliano
(Giovanni Battista Cima)**
3 5

Gentile and Giovanni Bellini
4

Giovanni Mansueti
6

Marcello Fogolino
8

Francesco Bonsignori
9

**Palma Vecchio
(Jacopo Negretti)**
10

Bartolomeo Montagna
11 12

Andrea Mantegna
13

Francesco Morone
14

The specific environmental conditions of Venice, which made the preservation of wall-paintings difficult, not only affected the type of pictorial decoration of the *scuole* (nos. 4 and 6), but also that of the religious buildings, which consisted of altarpieces rather then fresco cycles. Often huge – as in the case of a number of the canvases displayed here – they were surrounded by elaborate frames, frequently made of stone, which harmonized with the painted space and linked this to the real space of the church, creating subtle illusionistic effects.

In accordance with this spatial unification, the figures of saints that formerly flanked the Virgin or the principal saint, isolated in the individual panels of the polyptych, were assembled in a single picture, absorbed in prayer or meditation, thus creating the *Sacra Conversazione* (holy conversation). The polyptych did not, however, disappear, because it was still popular with the more conservative clients, as the works by Alvise Vivarini and Palma Vecchio (nos. 7 and 10) demonstrate, although Palma's painting was, in fact, executed for a peripheral area of the Venetian territories, the mountains near Bergamo.

Beginning with the first examples by Giovanni Bellini and Antonello da Messina, the settings for these *Sacre Conversazioni* – with a markedly vertical format and no predella – were depicted as being inside the apse of a church, although the growing attention to the rendering of the naturalistic elements and, in particular, the representation of the landscape, often led to the closed space being replaced by an open structure that permitted the holy groups to be bathed in the ever-varying natural light (nos. 3, 5, 11, 12).

Although credit for the invention of this type of painting should go to Giovanni Bellini, from the 1490s onwards he was joined – with excellent results – by provincial artists who had trained in Venice, such as Bartolomeo Montagna or Cima da Conegliano, and worked both in the city and in its mainland territories. (E.D.)

Michele da Verona
(Verona c.1470-1536/44)

1 *Crucifixion*
Oil on canvas
335 x 720 cm
Signed and dated on the pedestals of two columns: on the left "MCCCCC/.I./DIE.II/ IVNII"; ; on the right "PER ME MICHAELEM VERONENSEM"
Acquired: 1811

This crucifixion was painted by Michele da Verona for the refectory of the monastery of San Giorgio in Braida, Verona, but, judging by the coat of arms that appears upper right, it was commissioned by Niccolò Orsini, the count of Pitigliano, a condottiere and, from 1495 onwards, captain-general of the Venetian army. The scene takes place on a sort of stage flanked by columns beyond which a vast landscape extends. Many episodes are narrated: the quarrel over Christ's clothes, the centurion's conversion, the Virgin swooning; with its geometrical forms, this very detailed painting reveals that the artist was influenced by Antonello da Messina.

Alvise Vivarini
(Venice c. 1450-1505)

2 *Christ Blessing*
Oil on panel
52 x 37 cm
Signed and dated lower left "ALVISVS VIVARINVS DE MVRIANO PIN. MCCCCLXXXXVIII"
Acquired: 1824

Probably executed for a private client, with its soft, rounded volumes this is one of the artist's last paintings. From an iconographical point of view it is an unusual work because the figure giving a blessing, who is, however, carrying a small cross, seems to be a fusion of the types of the *Salvator Mundi* (Christ blessing, in three-quarter view or, more frequently, frontally) and Christ carrying the cross.

**Cima da Conegliano
(Giovanni Battista Cima)**
(Conegliano, Treviso
1459/60-1517/18)

3 *St Peter Martyr with
St Nicholas of Bari and
St Benedict*
Oil on panel
330 x 216 cm
Acquired: 1811

This work was commissioned by a spice merchant, Benedetto Carlone, as an altarpiece dedicated to St Peter Martyr in the church of Corpus Domini in Venice, where he intended to be buried. This explains the choice of two of the saints depicted: St Peter because the altar was dedicated to him; St Benedict because he was Carlone's patron saint. The painting, which may be dated 1505 or 1506, is one of the artist's most outstanding works thanks to the well-balanced composition the main focus of which is the solemn and very human figure of St Peter Martyr standing out against the sky, but surrounded by classically austere architecture. The smooth layers of paint demonstrate that Cima carefully observed the contemporary works of Giovanni Bellini, who had always had an important influence on him, and also Giorgione's more advanced modes – in particular, the landscape, bathed in a calm light and animated by everyday episodes, is no longer a rigid series of backcloths, but rather fades into the distance in a natural manner.

Gentile Bellini
(Venice 1429-1507)

Giovanni Bellini
(Venice c. 1430-1516)

4 *St Mark Preaching in Alexandria*
Oil on canvas
347 x 770
Acquired: 1809

Together with other paintings narrating the main events in the saint's life, this immense canvas adorned the Scuola Grande di San Marco in Venice. Begun by Gentile Bellini in 1504, it was left unfinished three years later, when the painter died and was subsequently completed by his brother.

The scene, as it was conceived and partially executed by Gentile, takes place in a fabulous Oriental square that combines elements of Venetian architecture with views of Constantinople, where the artist worked at the court of Mahomet II, having been sent there by the Venetian government in 1497. The composition, with throngs of onlookers among whom the members of the *scuola* are portrayed, is typical of other vast canvases executed by Gentile, but Giovanni probably did not merely limit himself to finishing off his brother's work. In fact, his hand may be identified in numerous portraits, in which the softer colouring and less rigid poses are evident not only in the group on the left but also in the figures on the right; it has also been suggested that he painted the imposing architecture at the far end of the square.

Cima da Conegliano
(Giovanni Battista Cima)
(Conegliano, Treviso
1459/60-1517/18)

5 *Virgin and Child Enthroned
with St Sebastian, St John
the Baptist, St Mary Magdalene,
St Roch and Donors*
Tempera on panel
transferred to canvas
301 x 211 cm
Acquired: 1811

The painting was executed around 1487-89 for the altar of San Giovanni Battista in the cathedral at Oderzo, near Treviso; this was linked to a confraternity, the members of which, depicted on a smaller scale according to a hierarchical perspective of medieval origin, surround the holy group. This work is evidently less mature than the altarpiece dedicated to St Peter Martyr described above: the holy figures, wrapped in thick draperies with harsh folds, have clearly drawn facial features and are placed in a slender, less substantial chapel opening onto the sky, while the depth of the composition is less convincing.

Giovanni Mansueti
(Venice 1465/70-1526/27)

6 *St Mark Baptizing Anianus*
Oil on canvas
335 x 135 cm
Acquired: 1808

Giovanni Mansueti was probably a pupil of Gentile Bellini, thanks to whom he cultivated his narrative vein, which remained unaltered throughout his career. This is demonstrated by this canvas, formerly in the Scuola Grande di San Marco, which, although executed in the period 1516-18, still contains 15th-century features: the colours are surrounded by sharp outlines; with the exception of what are probably portraits of the members of the *scuola* in the foreground, the figures are generic; the whole painting is dominated by the complex perspective structure of the incredible setting, which has been made more magnificent by the brilliant colours and the lavish use of gold to give emphasis to the architecture.

Alvise Vivarini
(Venice c. 1450-1505)

7 *Assumption of the Virgin*
Oil tempera on panel
225 x 114 cm
Acquired: 1811

Alvise Vivarini was one of the first painters to apply the innovations regarding perspective that Antonello da Messina had introduced to Venice, using them in numerous works – executed both for the mainland territories and the towns on the Adriatic coast traditionally linked to Venice – in which he remained faithful to the conventional form of the polyptych with a number of panels. This painting, for example, almost certainly commissioned by the famous condottiere Bartolomeo Colleoni, was formerly in the church of Santa Maria dell'Incoronata at Martinengo, near Bergamo, where it was surmounted by a lunette depicting the Pietà, now in the Museo Diocesano in Bergamo, and flanked by two side panels, now lost. This work dating from the 1480s contains elongated figures, surrounded by clear outlines but having solid volumes modelled by the light, with refined effects of iridescence.

Marcello Fogolino
(Vicenza c. 1475-
Trento? after 1548)

8 *Virgin and Child with St Job and St Gothard*
Oil on panel
203 x 160 cm
Acquired: 1812

This painting, one of Fogolino's earliest works (c. 1508), comes from the chapel of Santa Barbara in the church of Santa Croce in Vicenza. The simple, restrained composition, the perfect form of the Virgin's face and the geometry of the throne bear witness to the fact that the painter was a fervent exponent of the style, with its particular emphasis on perspective, that was spread in the Veneto by Antonello da Messina, Bartolomeo Montagna and Cima da Conegliano.

Francesco Bonsignori
(Verona c. 1460-
Caldiero, Verona 1519)

9 *St Louis and St Francis Holding the Monogram of Christ*
Oil on canvas
110 x 170 cm
Acquired: 1811

A pupil of Andrea Mantegna, Bonsignori executed this painting, which was modelled on a work by his master, for the church of San Francesco in Mantua. Here it hung above the pulpit, which explains both the foreshortening of the figures – because it was intended to be seen from below – and the quotation from St Paul running round the edge of the tondo the two saints are holding. Particularly notable in this simple yet monumental painting is St Francis's face, depicted with the refinement of a portrait, a genre in which Bonsignori excelled.

Palma Vecchio
(Jacopo Negretti)
(Serina, Bergamo
c. 1480-Venice 1528)

10 *St Helen and Constantine with St Roch and St Sebastian*
Oil on panel
Central panel 163 x 84 cm
Side panels 143 x 61 cm
Acquired: 1813

Although Palma Vecchio worked mainly in Venice, he maintained his contacts with the area where he was born, the mountains north of Bergamo: the three panels in this room formed the lower tier of a polyptych painted around 1520 for the high altar of the church of Santa Croce at Gerosa, near Bergamo. The church was rebuilt in the 18th century and its furnishings, including the polyptych, were purchased by private citizens; the panels were donated to the Brera by the politician and collector Count Francesco Melzi d'Eril. The provenance of the work, a church dedicated to the Holy Cross, explains its subject, because, according to a legend, it was St Helen, the mother of Constantine the Great, who discovered the True Cross.

Bartolomeo Montagna
(Vicenza 1449-1523)

11 *Virgin and Child Enthroned with St Francis and St Bernardine of Siena*
Tempera on panel
215 x 166 cm
Acquired: 1812

Originally in the church of San Biagio in Vicenza, this work may be dated from the last decade of the 15th century, a period in which the artist was experimenting with perspective, as is evident in the construction of the throne, in the disposition of the saints at the sides – forming "wings" that give depth to the scene – and even in the Virgin's foot, which protrudes as if to measure the space in front of it. Little is known about the painter's training, but it is certain that as a young man he worked in Venice, where he immediately displayed his gift for intelligent assimilation. In this case, he shows himself to be familiar with the architectural vocabulary that Bramante had introduced to Lombardy, as the shell inserted to decorate the entablature testifies.

Bartolomeo Montagna
(Vicenza 1449-1523)

12 *Virgin and Child Enthroned with St Andrew, St Monica, St Ursula and St Sigismund*
Oil on canvas
410 x 260 cm
Signed and dated on the lowest step of the throne "OPVS/BARTHOLOMEI/MONTA/GNA/MCCCCLXXXXVIIII"
Acquired: 1811

This huge painting was on the altar belonging to the Squarzi family, which was dedicated to St Monica, in the church of San Michele in Vicenza. If this work is compared with the panel painting described above, it is possible to note the maturation of the artist, with the growing monumentality of the figures and, above all, the perfect rendering of the complex architectural background and the intricate light effects creating a flickering network of reflections of various degrees of intensity. This progress was evidently the result of Montagna's visit to Lombardy, where he discovered both Bramante's architectural works and – as may be seen in some of the sharp profiles – the style of the sculptors working on the Certosa di Pavia. The refined colour accords are innovatory – for example, the Virgin is dressed in orange brocade over which a light blue-purple scarf is wrapped.

Andrea Mantegna
(Isola di Carturo, Padua c. 1430- Mantua 1506)

13 *St Bernardine of Siena and Angels*
Tempera on canvas
385 x 220 cm
Acquired: 1811

Originally in the chapel of San Bernardino in the church of San Francesco in Mantua, this painting – which was probably commissioned at the end of the 1460s by the marquis Ludovico Gonzaga, who wanted to be buried in this chapel – was the result of the collaboration between Mantegna, who designed the canvas and painted the central part, and an assistant, who probably executed the upper parts, the quality of which is poorer. Despite this lack of homogeneity, the innovatory nature of the painting should be stressed because it is the first unified altarpiece painted by Mantegna and it is framed by an illusionistic architectural setting that may have been an extension of the real frame, now lost.

Francesco Morone
(Verona c. 1471-1529)

14 *Virgin and Child Enthroned with St Zeno and St Nicholas*
Tempera on canvas
192 x 125 cm
Acquired: 1811

This altarpiece was formerly in the church of San Giacomo alla Pigna in Verona, on the side altar dedicated to St Zeno. Francesco Morone, who followed in the footsteps of his father, a painter in the manner of Mantegna, soon developed his own style (this work may be dated 1502-03), with geometrical simplification of the forms, the volumes of which are emphasized by planes of light – this is particularly noticeable in the figures of saints wrapped in cloaks.

Room IX
Venetian paintings of the 16th century

Room IX

Lorenzo Lotto
1
Titian (Tiziano Vecellio)
2
Veronese (Paolo Caliari)
3 4 10 11 12
Padovanino (Alessandro Varotari)
5
Tintoretto (Jacopo Robusti)
6 7 8 9
Jacopo Bassano (Jacopo da Ponte)
13

This room is devoted to the greatest splendour of 16th century Venetian painting; in addition to works by Titian, Lorenzo Lotto and Jacopo Bassano, there are paintings by Veronese and Tintoretto. These are all outstanding artists, committed – over and above the differences in their personalities – to a style of painting in which colour takes pride of place.

According to Pietro Aretino, a friend of Titian's and a brilliant writer on art and the theatre who was famous for his licentious texts and his letters, Venice was different from the rest of Italy, and its patronage was worthy of attention for three main reasons: the city's stability and security; the absence of a court and, as a result, the lack of a dominant taste imposed by a ruling family; and the enormous wealth of the State, the doges, the Church and the *scuole*. While Rome was experiencing a period of temporary decline after the terrible sack of 1527, Venice – "the only free place in Italy", a state of land and sea, earned immense prestige until it became a myth, causing a French ambassador to exclaim: "It is the most triumphant city I have ever seen... governed with great wisdom... here God is served with great solemnity".

The leading protagonist of the remarkable evolution of Venetian painting in the 16th century was Titian, the arbiter of taste and cultural torch-bearer for over half a century; already internationally renowned in his day, he was the favourite artist of his great contemporaries. A pupil of Titian, according to tradition, was Tintoretto, who was, in reality, from the beginning of his career, influenced by Bonifacio Veronese (Bonifazio de' Pitati), Michelangelo and the Mannerism imported into Venice by artists who had been trained or had worked in Rome, Tuscany and Emilia, such as Jacopo Sansovino, Francesco Salviati, Giovanni da Udine, Pordenone and Giorgio Vasari.

The Mannerist style, as it was elegantly expressed by Parmigianino – and also by Giulio Romano in Mantua – was the driving force behind Veronese, who, although he was born and trained outside Venice, was the serene and nonconformist interpreter of the taste and spirit of the city, and Jacopo Bassano, another outstanding artist born on the margin of the Venetian cultural area who was particularly interested in realism and genre painting.

Quite distinct from these artists was the individualistic and restless Lorenzo Lotto, who, in opposition to the predominant influence of Giorgione and Titian, took a totally anti-classicistic stance that aroused no interest in Venice, and worked, above all, on the mainland in Treviso and Bergamo, and in the peripheral area of the Marches. (L.A.)

Lorenzo Lotto
(Venice 1480-Loreto, Ancona 1556)

1 *Pietà*
Oil on canvas
185 x 150 cm
Signed lower right "Laurentio Lotto"
Acquired: 1811

Commissioned by the mother superior of the Dominican convent of San Paolo in Treviso and intended for the altar of the Pietà in the convent church, which was opposite the one where (1555-60) the altarpiece by Paris Bordone, *The Virgin Presenting St Dominic to Christ* (room XIV, no. 18), was subsequently placed, this is one of Lotto's best documented works. In 1545 the artist, in fact, mentions it on three occasions in the *Libro delle spese diverse* in which, from 1538 onwards, he began to record his commissions and payments, providing valuable information about his work and his moral and religious problems.

The northern iconography of the painting is unusual in the Veneto, although it has precedents in works by Robert Campin and Rogier van der Weyden and, in Italy, Sandro Botticelli. A work that is both tragic and agitated and unusually sombre – which is why it was not appreciated in the late 18th and early 19th centuries – it may be associated with the meditation on death that obsessed the painter in his last years.

Titian (Tiziano Vecellio)
(Pieve di Cadore, Belluno 1488/90-Venice 1576)

2 *St Jerome in Penitence*
Oil on panel
235 x 125 cm
Signed bottom centre "Ticianus F."
Acquired: 1808

The upper part of this painting, which was executed around 1555 for an altar in the church of Santa Maria Nuova in Venice, was modified (the arched panel at the top was added) during the 18th century; it was originally rectangular, like other versions of the same subject – with, however, different dates – in the Nuevos Museos, El Escorial (Spain), and the Thyssen-Bornemisza Collection, formerly in Lugano, now in Madrid. Executed with thin layers of colour, which allow the ground to show through and exalt the dull, monotonous range of colours, this highly dramatic painting is notable for its perfect combination of a vibrant vision of the landscape and the Michelangelesque gigantism of the figure of the saint synthesized with a cursive, summary line.

Veronese (Paolo Caliari)
(Verona 1528-Venice 1588)

3 *Last Supper*
Oil on canvas
220 x 523 cm
Acquired: 1811

Commissioned by the Scuola del Santissimo Sacramento in Venice for the church of Santa Sofia, where all the Venetian sources state that it was located, this painting was executed after 1581, if the description of the building in Francesco Sansovino's guide to Venice (*Venetia città nobilissima et singolare*), published in that year, is to be believed, because there is no mention of the canvas. One of Veronese's last works, only in the 1930s it was recognized as being autograph. There are, in fact, a number of features that make this an unusual work for this artist: the colours are dull, with few iridescent effects; the setting is very simple; and the composition is notably asymmetrical: the space is divided unequally by the off-centre column; the table is at an oblique angle to the picture-plane; and Christ is positioned on the edge of the scene. These Tintorettesque traits associated with a profound religious belief – strongly influenced by the Counter-Reformation – make it one of the most outstanding works produced by Veronese towards the end of his career.

Veronese (Paolo Caliari)
(Verona 1528-Venice 1588)

4 *Baptism and Temptation of Christ*
Oil on canvas
248 x 450 cm
Acquired: 1809

This painting, which combines the baptism and temptation of Christ in a singular composition, is perhaps the finest work in the large cycle painted by Veronese and his assistants for the small church of San Nicoletto della Lattuga (or dei Frari), demolished in the 19th century, which was adjacent to the monumental church of Santa Maria Gloriosa dei Frari in Venice.
The execution of the cycle, which was not mentioned by Sansovino's guide to Venice published in 1581, may be dated to 1582 or shortly afterwards, and marks a spectacular revival of the decorative style of Veronese, who in this period was busy decorating the Sala del Maggior Consiglio in the Doge's Palace, which was being restored after the fire of 1577. This canvas resembles the *Last Supper* in the asymmetrical composition and the oblique perspective, but differs from it as regards its splendid landscape setting – with trees and meadows fading into the distant view of Jerusalem – and the range of bright colours.

Padovanino
(Alessandro Varotari)
(Padua 1588-Venice 1649)

5 *The Victory of the Inhabitants of Chartres over the Normans*
Oil on canvas
510 x 587 cm
Signed and dated lower right
"A<small>LEX</small>.^{RI}/V<small>AROTA</small>/<small>RII</small>/P<small>ATAVINI</small>/O<small>PVS</small>/1618"
Acquired: 1809

This painting comes from the church, now demolished, of Santa Maria Maggiore in Venice. In 1827 it was transferred from the Brera to the church of San Simpliciano in Milan, from where it was returned to the gallery in 1979. Monumental in its conception and format, the canvas has been hung in this room, despite the fact that it dates from the 17th century, because in it the influences of Titian, Palma Giovane, Tintoretto and 16th-century Roman art are all apparent.

The subject of this painting is very unusual: in fact, it portrays a little-known episode in the history of Christianity, the miraculous victory of the inhabitants of Chartres over the Normans, who were defeated by displaying the Virgin's veil (transformed by Padovanino into a roseate robe), a precious relic left by Charlemagne to his son Charles the Bald, who donated it to Chartres cathedral. Much praised by 17th- and 18th-century sources, this painting was long considered to be the artist's most outstanding work.

Tintoretto (Jacopo Robusti)
(Venice 1519-1594)

6 *The Finding of the Body of St Mark*
Oil on canvas
396 x 400 cm
Acquired: 1811

Commissioned by Tommaso Rangone, a physician and scholar of renown who originally came from Ravenna and was the guardian of the Scuola di San Marco in Venice, this painting was executed between 1562 and 1566. Together with the *Abduction of the Body of St Mark*, *St Mark Saving a Saracen* and the *Miracle of the Slave* – the latter was painted fourteen years previously – it was part of a cycle with scenes from the life of the saint adorning this Venetian *scuola*. Coming to the Brera after the Scuola had been suppressed, for forty years (1847-86) it hung in the church of San Marco in Milan; since it was returned to the Brera it has become one of the most famous pictures in the gallery.

The subject of this painting – which is not immediately obvious – is excellently described by the painter and art historian Carlo Ridolfi, who, in his *Meraviglie dell'arte* (1648), explains that "one sees the way in which the body of St Mark in Alexandria was taken by the Venetian merchants Buono da Malamocco and Rustico da Torcello from the Greek priests. In a long arcade, there are tombs attached to the walls, drawn perfectly in perspective, from which many bodies are being removed; on the floor is that of St Mark lying in such a position that it follows the eye wherever one stands. Moreover, in this scene the artist ingeniously depicts a demoniac deliberately brought here – as is customary in exhumations of holy bodies – in whom the agitation the devil causes in human bodies is clearly visible."

This painting sums up the basic elements of Tintoretto's painting: a gift for narrative; a remarkable feeling for the dynamic and spatial factors; great skill in the use of colour, light and three-dimensionality; and, in the artist's maturity, the theatricality of the settings, the vertiginous perspective and the deliberately scenographic effect of the lighting and the violent, peremptory gestures of the figures.

Tintoretto (Jacopo Robusti)
(Venice 1519-1594)

7 *St Helen, St Barbara, St Andrew, St Macarius, Another Saint and a Donor Adoring the Cross*
Oil on canvas
275 x 165 cm
Acquired: 1805

One of the first Venetian works to reach the Brera, this painting came to the gallery from the church of Santa Croce in Milan and, until fifteen years ago, it was identified with a canvas depicting St Helen commissioned in 1584 by the Scuola dei Tessitori della Tela (Confraternity of the Weavers of Cloth) for the chapel dedicated to the saint in the church of San Marcuola in Venice, which was believed to have been sold and taken to Milan before 1674, when it was documented in the Milanese church. Now that this hypothesis has been rejected – and with it, the attribution to the last part of the artist's career – a date around 1560 has been proposed because of the echoes of Veronese's style, but the question of whether a Milanese patron existed has yet to be resolved: there is no trace, in fact, of any links between Tintoretto and Milan.
An extremely conventional work, with the saints duly represented with their attributes (a cross for St Helen, a tower for St Barbara, a double cross for St Macarius), the only features of interest are the portraits of the devout donor and his patron saint.

Tintoretto (Jacopo Robusti)
(Venice 1519-1594)

8 *Allegory of Fortune*
Oil on canvas
105 x 144 cm
Acquired: before 1812

This painting, the attribution of which was formerly in dispute, has been variously ascribed to Andrea Schiavone and Tintoretto, to whom it has been assigned by the most recent studies, according to which it is an early work, datable to 1544-45. Nonetheless, its provenance remains uncertain: it was certainly in the Brera before 1812, when, together with other paintings, it was given to the Milan Archbishopric in exchange for works in the collection of Cardinal Cesare Monti, and only returned to the gallery in 1906. Equally problematic is the subject, which has, however, been interpreted as an allegory of Fortune triumphing over Avarice, which is in the guise of a Harpy.

Tintoretto (Jacopo Robusti)
(Venice 1519-1594)

9 *Pietà*
Oil on canvas
108 x 170 cm
Acquired: 1808

The piety typical of the Counter-Reformation inspires the restrained dramatic quality of this Pietà, which is noteworthy for its balanced composition and the skilful modelling of the figures. Intended for a lunette in the courtyard of the Procuratie di San Marco, it was executed – according to the documents recording payment for the work – between 1563 and 1571.

Veronese (Paolo Caliari)
(Verona 1528-Venice 1588)

10 *St Anthony Abbot with St Cornelius and St Cyprian*
Oil on canvas
270 x 180 cm
Acquired: 1808

This painting was executed for the high altar of the church of Sant'Antonio Abate, now demolished, on the island of Torcello in the Lagoon of Venice. Much admired by the art historians of the past and ignored in more recent times, this work has now come back into favour thanks, above all, to its restoration, which has allowed the splendid colours – yellows, reds and bright pinks – to emerge once again; together with the realistic motif of the kneeling page, they confirm that it is autograph. In the past, the date of this painting has given rise to various hypotheses, but it must have been executed in the period of the artist's career beginning with the *Family of Darius before Alexander* of 1565 (National Gallery, London) and concluding with the series with the Cuccina family of 1571 (Gemäldegalerie, Dresden), works in which some of the motifs in the Brera picture – such as the column and the page – appear.

10

11

Veronese (Paolo Caliari)
(Verona 1528-Venice 1588)

11 *Feast in the House of Simon*
Oil on canvas
275 x 710 cm
Acquired: 1817

Executed about 1570 for the refectory of the monastery of San Sebastiano in Venice, where the artist painted his first important cycle of frescoes with a religious theme, this huge canvas was sent to Paris in 1797 together with another seventeen paintings and two sculptures as Napoleon's spoils of war. After 1815 it was returned to Venice and later sent to Milan to replace the *Feast of Pope Gregory*, which had been given back to the sanctuary of Monte Berico in Vicenza. With architecture in Palladian style providing the same wide stage-set as in the other banquets, the *Feast in the House of Simon* is the simplest and most serene of the sumptuous profane feasts that led to Veronese being censured for heresy by the Inquisition.

Room IX

Veronese (Paolo Caliari)
(Verona 1528-Venice 1588)

12 *Agony in the Garden*
Oil on canvas
108 x 180 cm
Acquired: 1808

This painting comes from the church of Santa Maria Maggiore in Venice, also the provenance of Mantegna's *Virgin and Child with a Choir of Cherubim* (room VI, no. 14). The first reference to the work is found in the will, dated January 1584, of Simone Lando, "the Doge's secretary", who donated all his sacred pictures, including Veronese's *Agony in the Garden*, to the convent of the Franciscan nuns of Santa Maria Maggiore "to adorn the large chapel". A very late work, datable to 1582-83, this painting marks a meditative and emotional turning-point in the artist's religious thought, leading him to invent the scene of Christ fainting when the Passion is announced. The dramatic significance of this in human terms is stressed by the dark, smoky colours mixed with the pinks and light blues of the figures of Christ and the angel.

Jacopo Bassano
(Jacopo da Ponte)
(Bassano, Vicenza c. 1510-1592)

13 *St Roch and the Plague Victims*
Oil on canvas
350 x 210 cm
Signed and dated lower right
"Jacs A POTE/BASSIS/PINGEBAT"
Acquired: 1811

This painting, executed for the high altar of the church of San Rocco in Vicenza, probably as an *ex-voto* after the plague of 1575, was first mentioned as being in that church by the Florentine writer Raffaello Borghini in *Il Riposo* (1584). It is one of the most outstanding late works by the artist, who in 1581 reduced his activity and was increasingly assisted by his sons Gerolamo and Francesco. The very conventional composition, with the Virgin above and the saint and the sick below seen against a generic monumental background, is redeemed by the stark realism of the figures in the foreground.

Room XIV
Venetian paintings of the 16th century

Room XIV

Pordenone
(Giovan Antonio de' Sacchis)
1

Romanino
(Gerolamo de' Romani)
2 8 10

Lorenzo Lotto
3

Moretto da Brescia
(Alessandro Bonvicino)
4 5 6

Giovan Battista Moroni
7 11

Gian Gerolamo Savoldo
9

Cariani (Giovanni Busi)
12 13

Bonifacio Veronese
(Bonifazio de' Pitati)
14 15

Lambert Sustris
16

Paris Bordone
17 18 19 20

Palma Vecchio
(Jacopo Negretti)
21

The Venetian painting of the 16th century involved all the Venetian mainland territories, arriving, with Bergamo and Brescia, as far as the area that, both politically and artistically, had hitherto gravitated towards Milan. This border area produced artists who were able to combine the Lombard style, of which Vincenzo Foppa was the leading exponent, with the skilled use of colour and the sumptuous modes that were typical of Venetian painting in the tradition of Giorgione and Titian.

In this room, the works of a decidedly Venetian character, inspired by both Giorgione and Titian, such as those of Cariani, from Bergamo, Paris Bordone, from Treviso, and Bonifazio de' Pitati (Bonifacio Veronese), from Verona, may be contrasted with those of the Brescians Romanino, Moretto and Gian Gerolamo Savoldo, and the Bergamasque Giovan Battista Moroni, in which the artistic language and colour of Venice acquire a wide variety of cadences and inflections. In the first group, especially the two works by Bonifacio Veronese, *Christ and the Woman Taken in Adultery* (no. 14) and the *Finding of Moses* (no. 15), and the huge altarpiece by Cariani depicting the *Virgin and Child Enthroned with Angels and Saints* (no. 12), the colour is splendid and the atmosphere thoroughly Venetian. Cariani's altarpiece directly emulates Giorgione's use of colour and his compositions, although it is more crowded with figures – it may be compared with Giorgione's *Castelfranco Madonna*, which, albeit more austere, is the model for this painting – while, in the works by Paris Bordone, the influence of Titian is easily perceptible.

However, in the large *Virgin and Child in Glory with Angels and Saints* (no. 9) by Savoldo, executed for the church of San Domenico in Pesaro around 1524-25, a sudden change in scale and style is noticeable; in this work, besides the influence of Titian, there are echoes of Lombard naturalism and new, vivid light effects. And it was from these artists – Savoldo, Moretto and Moroni – and their different way of interpreting light and natural phenomena that Michelangelo Merisi da Caravaggio (a town not far from Bergamo) drew inspiration for his style with its focus on the naturalistic element. (P.C.M)

Pordenone
(Giovan Antonio de' Sacchis)
(Pordenone c. 1483/84-
Ferrara 1539)

1 *Transfiguration*
Tempera on panel
93 x 64 cm
Acquired: 1925/26

Coming from the church of San Salvatore at Collalto, near Treviso, and datable to 1515 or 1516, this painting is the central panel of a triptych, one wing of which depicted St Peter and St Prosdocimus (now in the North Carolina Museum, Raleigh), the other St John the Baptist and St Jerome (lost). It was produced in the artist's mature period, when his handling of the paint was more delicate and fluent, with numerous Giorgionesque echoes. The solid composition, more evident in the upper register, becomes dynamic in the foreshortened figures seen below, depicted in dramatic poses.

Romanino
(Gerolamo de' Romani)
(Brescia c. 1484/87-1560)

2 *Virgin and Child*
Oil on panel
83 x 62 cm
Acquired: 1895

This painting, which may be dated around 1516 or 1517, was part of the collection of Cardinal Cesare Monti that was bequeathed to the Milan Archbishopric in 1650. Executed in a period in which the artist distanced himself from the modes of Palma Vecchio, this work displays the temporary influence of Titian, whose works Romanino had been able to see when working in Padua. The handling of the paint reveals a refined linearity, which is evident in the drapery, together with the use of warm colours. There is a copy of this painting in a private collection in Brescia.

Lorenzo Lotto
(Venice 1480-Loreto, Ancona 1556)

3 *Assumption of the Virgin*
Oil on panel
27 x 56 cm
Acquired: 1855

Part of the Oggioni bequest, this painting, which may be dated around 1512 and was formerly attributed to Raphael and then to Fra Bartolomeo, is now believed to be the central panel of the predella under the *Pietà* in the Museo Civico, Jesi. This hypothesis is supported by the composition: the Apostles are depicted in a sequence of agitated and astonished poses as, in a wide and all-encompassing space, they gaze up at the centrally positioned Virgin in the heavens.

Moretto da Brescia
(Alessandro Bonvicino)
(Brescia c. 1497/98-1552)

5 *The Assumption of the Virgin with St Jerome, St Mark (?), St Catherine of Alexandria and St Clare; St Francis of Assisi*
Oil on panel
Central panel 148 x 60 cm
Side panels 114 x 60 cm
St Francis 114 x 60 cm
Acquired: 1808

These four panels, datable to around 1530, are part of a polyptych with six panels from the church of Santa Maria degli Angeli in Gardone Val Trompia, near Brescia, which came to the Brera in one piece, but was soon dismembered. The two panels flanking St Francis in the lower tier were sent to the Louvre, while the elaborate frame is still in its original location. The polyptych represents a moment of felicitous spirituality; this is evoked through the solid construction of the figures, which, isolated in separate spaces, appear to be imbued with humble devotion that is evident in the calm, rarefied attitudes of the saints and their faces, whether they be ascetic or more commonplace.

Room XIV

Moretto da Brescia
(Alessandro Bonvicino)
(Brescia c. 1497/98-1552)

4 *Virgin and Child*
Oil on canvas
49 x 57 cm
Acquired: 1911

Formerly in the Gustavo Frizzoni Collection, this work may be ascribed to the years around 1540. The refined handling of the paint has produced delicate and vibrant forms, enhanced by iridescent colour variations. There are numerous copies and variants of this painting, one of which may be autograph, bearing witness to the fact that Moretto's contemporaries held this work in high regard.

Moretto da Brescia (Alessandro Bonvicino)
(Brescia c. 1497/98-1552)

6 *Virgin and Child in Glory with St Jerome, St Francis and St Anthony Abbot*
Oil on canvas
225 x 185 cm
Acquired: 1808

Like the previous work, this altarpiece also comes from the church of Santa Maria degli Angeli in Gardone Val Trompia, near Brescia, and is datable to 1543. The composition is formed by a series of planes and is distinguished by formal severity that stresses the ascetic and penitent nature of the saints portrayed. The artist is more self-indulgent and descriptive in his depiction of the Virgin and Child, which has evident devotional connotations. The splendid silvery, translucent tones are typical of Moretto's painting.

Giovan Battista Moroni
(Albino, Bergamo c. 1520/24-Bergamo 1578)

7 *Virgin and Child with St Catherine, St Francis and Donor*
Oil on canvas
102 x 110 cm
Acquired: 1818

This work, executed around 1550, clearly shows the influence of Lotto and Moretto, and testifies to Moroni's gradual abandonment of academic modes, visible in the sharp outlines of certain figures, for a more intimate style, as may be seen in the figure of the donor, which foreshadows the artist's subsequent devotional output. Thanks to a difference in scale, the relationship with the sacred scene is even more evident here, as if this were materializing before the donor in accordance with the tenets of St Ignatius of Loyola's *Spiritual Exercizes* (1548).

**Romanino
(Gerolamo de' Romani)**
(Brescia c. 1484/87-1560)

*8 Christ Carrying the Cross
Dragged by an Executioner*
Oil on canvas
81 x 72 cm
Acquired: 1998

Formerly in the Averoldi Collection, Brescia, in the 19th century it was acquired by the Benigno Crespi Collection in Milan. Sold during the auction of the Crespi Collection in Paris in 1914, it then formed part of the Gentili di Giuseppe Collection in that city, from which it went to the Milanese owners who sold it to the Brera Gallery in 1998. A masterpiece of the painter's mature period, this work, which has recently been assigned to the early 1540s, contains echoes of what the art historian M.I. Ferrari described as the "spirit of Pordenonesque origin" combined with the evident influence of Savoldo's painting. The theme of "Christ carrying the cross" is of German origin (Martin Schongauer, for example), but was revived in Lombardy at the end of the 15th century by Bergognone and Leonardo da Vinci. Here the inclusion of the figure of a moustached executioner with a feathered hat seems also to indicate the influence of Flemish painting. The religious subject offers an opportunity for an exercise in pure painting: the sleeve in yellow-pink satin is the true protagonist, its highlights allowing the image to vibrate, lending a realistic effect typical of Lombard to the painting.

Gian Gerolamo Savoldo
(Brescia? c. 1480-
Venice? after 1548)

9 *Virgin and Child in Glory with Angels and St Peter, St Dominic, St Paul and St Jerome*
Oil on panel
475 x 307 cm
Signed lower right "Opera da Jonone Jeronimo de Brisia di Savoldj"
Acquired: 1811

Datable to between 1524 and 1526, this altarpiece was commissioned in 1524 by the Dominican monks in Pesaro. Although it clearly shows the influence of Lotto and Titian and has a bold spatial conception, the most outstanding feature of this picture is the light, which bathes and exalts the two groups of figures – the heavenly and the worldly ones – in contrasting ways. This is the most important public commission obtained by Savoldo, who has skilfully divided up the imposing space in an extremely simple manner, adopting a low viewpoint centring on the vista of the Fondamenta in Venice.

Romanino
(Gerolamo de' Romani)
(Brescia c. 1484/87-1560)

10 *Presentation of Jesus in the Temple*
Oil on panel
188 x 140 cm
Signed and dated on the cartouche
"HIERONIMI ROM/ANI BRIXIANI/OPVS/ 1529"
Acquired: 1923

Coming from the Brunelli Collection in Brescia, this painting clearly shows the influence of Moretto, who was a pupil of Romanino, especially in the severe compositional scheme and the solid architectural setting in which the devout, absorbed figures are depicted. Particularly noteworthy are the heads of some of the figures in the background, which, with their Titianesque overtones, appear almost to be portraits.

Giovan Battista Moroni
(Albino, Bergamo c. 1520/24- Bergamo 1578)

11 *Assumption of the Virgin*
Oil on canvas
360 x 225 cm
Acquired: 1811

Originally in the church of the convent of San Benedetto in Bergamo and datable to 1570, this complex work appears to combine the academic influence of Moretto, with whom Moroni trained, and the more animated and antithetical modes adopted by the artist in his religious painting. Permeated with luminescent iridescence stressed by chiaroscuro effects, the figures stand out against the monochrome background in which a spectral landscape appears to float.

Cariani (Giovanni Busi)
(Venice c. 1485-c. 1550)

12 *Virgin and Child Enthroned and Angels with St Apollonia, St Augustine, St Catherine, St Joseph, St Grata, St Philip Benizi and St Barbara*
Oil on canvas
270 x 211 cm
Acquired: 1805

Originally in the church of San Giovanni in Bergamo, this altarpiece was executed in 1517 or 1518. At the foot of the painting there was a small *Pietà*, now in a private collection. The compositional scheme in which the figures are placed on successive planes is very complex, while the Giorgionesque landscape in the background also plays an important role in the splendid symphony of forms and colours. Although the influences of Titian, Palma Vecchio and Lotto are evident, Cariani must be given credit for his strongly innovatory spirit in the Bergamasque artistic milieu of his day.

Cariani (Giovanni Busi)
(Venice c. 1485-c. 1550)

13 *Resurrection of Christ with St Jerome, St John the Baptist and the Donors Ottaviano and Domitilla Vimercati*
Oil on canvas
208 x 170 cm
Signed lower left
"JOANES/CAR/IAN/VS/P." and dated at the bottom next to the name of the donor "OCTAVIANVS VIC.S EQVES. MDXX"
Acquired: 1957

Donated to the Brera by Count Paolo Gerli, this painting was commissioned by a nobleman of Crema, who, together with his wife, appears here as the donor. In this composition, in which the artist combines elements of the Venetian tradition and those of the area around Cremona, a brilliant light flashes sharply over the whole scene, which is dominated by the triumphant figure of Christ.

**Bonifacio Veronese
(Bonifazio de' Pitati)**
(Verona c. 1487-Venice 1553)

14 *Christ and the Woman Taken in Adultery*
Oil on canvas
175 x 340 cm
Acquired: 1811

Part of the bequest of Cardinal Cesare Monti and datable around 1550, this work, which was certainly conceived by the now elderly artist, was probably concluded by assistants (for instance, Antonio Palma). In the extremely varied types of figure, both echoes of the Venetian style and the influence of Mannerism are discernible. In the background, beyond the setting of classical architecture, there is an imaginary view of Jerusalem.

14

15

**Bonifacio Veronese
(Bonifazio de' Pitati)**
(Verona c. 1487-Venice 1553)

15 *Finding of Moses*
Oil on canvas
175 x 345 cm
Acquired: 1811

Also part of the bequest of Cardinal Cesare Monti and datable between 1540 and 1545, this painting represents the finding of the infant Moses, who is being shown to the pharaoh's daughter. Conceived as a *fête champêtre*, the scene seems to be the celebration of life at court. Inspired by the modes of Venetian painting, the artist shows he is not immune from the influence of Mannerism. In this work, which may not be wholly autograph, it is possible that the artist was assisted by Domenico Biondo.

Lambert Sustris
(Amsterdam c. 1515/20-
Venice c. 1584)

16 *Way to Calvary*
Oil on canvas
106 x 131 cm
Acquired: 1855

Part of the Oggioni bequest, this work may be dated around 1540-42. An excellent example of the cultured, intellectual painting of Lambert Sustris, a Dutch artist who emigrated to Venice, this work shows not only the influence of the German masters but also that of Mannerism, as may be seen in the accentuated diagonal movement of the composition and the fluent, refined handling of the paint.

Paris Bordone
(Treviso c. 1500-Venice 1571)

17 *Baptism of Christ*
Oil on canvas
175 x 202 cm
Acquired: 1811

Formerly in the collection of Cardinal Cesare Monti, this outstanding work, which was executed around 1550 while the artist was working in Milan, combines echoes of refined classicism with a more advanced artistic language. The controlled dynamic of the poses freezes the scene in a twilight vision expressing great spiritual tension. A number of autograph replicas of the same subject exist.

Paris Bordone
(Treviso c. 1500-Venice 1571)

18 *The Virgin Presenting St Dominic to Christ*
Oil on panel
148 x 106 cm
Signed on the cartouche "O. PARIDIS BORDONO"
Acquired: 1811

Originally in the Dominican convent of San Paolo in Treviso, this painting may be dated between 1555 and 1560 and testifies to the fact that the artist had accepted the severe style required by the Tridentine decrees. In the original yet simple compositional scheme an alternation of diagonal lines animates the scene, which is dominated by the figure of Christ with its shadowy, powerful beauty.

Paris Bordone
(Treviso c. 1500-Venice 1571)

19 *Holy Family with St Ambrose and a Donor*
Oil on panel
93 x 130 cm
Acquired: 1896

Formerly in the collection of Cardinal Cesare Monti, this work may be dated around 1526. With an intimate narrative structure, the artist arranges the figures in an all-encompassing space, a fusion of nature and architecture, making use of contrasting tones, especially complementary colours. While the influence of Giorgione and Titian is evident, Bordone reworks it in his own way, heralding later Mannerist modes. The remarkable portrait of the donor is comparable to the best of Titian's works.

Paris Bordone
(Treviso c. 1500-Venice 1571)

20 *Pentecost*
Oil on canvas
305 x 220 cm
Acquired: 1808

This painting, datable to around 1526 or 1527, came to the Brera after the suppression of the church of the Santo Spirito in Crema. In this work, which has a very evident compositional scheme, the figures are placed in an imposing classical setting where they are given prominence not only through their poses, but also by the use of brilliant colours. This work reveals that, at an early stage in his career, the artist was fully prepared to adopt conventional compositions with Roman echoes.

Palma Vecchio (Jacopo Negretti)
(Serina, Bergamo 1480-Venice 1528)

21 *Adoration of the Magi with St Helen*
Oil on canvas
470 x 260 cm
Acquired: 1811

Commissioned in 1525 for the church of Sant'Elena in Isola, Venice, this work was executed about 1525 or 1526. The compositional scheme of this imposing altarpiece is both complex and fragmentary, although it contains passages of a very high quality, such as the figure of St Helen and the landscape forming the background, where sheep graze and a train of horses and camels makes its way through a rocky defile.

Room XV

Gaudenzio Ferrari
1 2 **3** 16

**Bramantino
(Bartolomeo Suardi)**
4 5 **6**

Vincenzo Foppa
7 8 **9**

Master of the Pala Sforzesca
10

**Giovanni Bernardino Scotti
and Giovan Stefano Scotti**
11

**Bergognone
(Ambrogio da Fossano)**
12

Bernardino Luini
13

Marco d'Oggiono
14 **15**

The last of the four Napoleonic rooms houses an important collection of polyptychs, altarpieces and detached frescoes that offer the visitor an overview of Milanese and Lombard painting in the late 15th century and the first half of the following century. This period coincides with the rule of the Sforza, especially that of Ludovico il Moro, who fell from power in 1499, then with the French domination and the restoration of the Sforza under the Spanish protectorate. These works document the monumental mode of Lombard art after the arrival of Bramante. This is demonstrated by the works of Vincenzo Foppa (nos. 9, 7, 8) and Bramantino (nos. 4, 5, 6). The Brera owns an important cycle of detached frescoes by Bramante – *Men-at-Arms*, from the Casa Visconti, later Panigarola (one of which is temporarily visible from room XV while awaiting permanent display) – that had a strongly innovatory role in Lombard art during the Sforza period. By contrast, the *Pala Sforzesca* (no. 10), hanging next to these masterpieces by Foppa and Bramante, bears witness to the difficulty of a court artist around 1494, when he had to measure himself against the Bramantesque and Leonardesque innovations. On the other hand, nearly the whole of the output of Bergognone – whose altarpiece (no. 12) from the monastery of Nerviano, dating from the end of his career (1522), is displayed here – belongs to a more profound and wholly Lombard tradition. However, Bramantino was the first artist who, in the Sforza period, sought to incorporate different elements into his artistic language that were neither Leonardesque nor Lombard, managing to develop his own style, especially by combining the influence of Bernardino Butinone and the Ferrarese school with the impulse to seek a classicistic, monumental vision that came from his master, Bramante. His *Crucifixion* (no. 6) must certainly have constituted an outstanding model for the artists who were able to study it in the early 16th century. One of these was Gaudenzio Ferrari, whose fresco cycle (nos. 1 and 16) has been reassembled in this room; this was painted for a chapel in the church of Santa Maria della Pace in Milan, on the altar of which was the *Birth of the Virgin*, also by Gaudenzio, now in the Contini Bonacossi Collection, Milan. The frescoes by Bernardino Luini (no. 13), now displayed in a small room adjacent to room XV, come from the chapel of San Giuseppe in the same church. Together with the altarpieces by Luini (no. 13) and Marco d'Oggiono (no. 15), also in room XV, they illustrate the tendencies in Milanese painting in the second and third decades of the 16th century, a period already marked by the presence of the French rulers. (P.C.M.)

Gaudenzio Ferrari
(Valduggia, Vercelli c. 1480- Milan 1546)

1 and 16 *Scenes from the Lives of Joachim and Anne*
Detached frescoes

1
Lower tier:
Presentation at the Temple
Left side panel 186 x 65 cm
Adoration of the Magi
Central panel 190 x 136 cm
King Balthazar and *Procession of the Magi*
Side panels 190 x 65 cm
Upper tier:
Assumption of the Virgin
Tondo 115 cm
Angels Playing Musical Instruments
Curved side panels 105 x 105 cm

16
Lower tier
Annunciation of the Birth of Mary
Central panel 190 x 135 cm
Lamentation of Anne and *Expulsion of Joachim from the Temple*
Side panels 190 x 65 cm
Upper tier
Consecration of Mary
Tondo 115 cm
Annunciatory Angel and Virgin Annunciate
Curved side panels 105 x 105 cm
Acquired: 1808

These frescoes decorated the third chapel on the right (the chapel of the Natività della Vergine) in the church of Santa Maria della Pace in Milan, belonging to the Franciscans who adhered to the doctrine of Blessed Amedeus Mendez da Silva. Coming to the Brera after the suppression of the monastery adjacent to the church, they were transferred to a wooden support by Giuseppe Steffanoni in 1900-01. The artist had the task of illustrating the childhood of Mary in accordance with the tenets of the religious group whose aim was a return to the faith of the early days of Christianity. It is a very late work by the Piedmontese painter, datable to 1541-43 (as recent studies by R. Sacchi have indicated), at the end of his sojourn in Milan. Although there are evident traces of Gaudenzio's assistants (it has been suggested that number of scenes, such as the tondos and the curved panels at their sides, were painted by Giovan Battista Della Cerva), the cycle contains scenes of great freshness and vitality, and very spectacular compositions, many of which are presented diagonally, in order to expand the depth and, possibly, the width of the space in the narrow chapel. A number of the panels demonstrate that Gaudenzio had seen the work of such Milanese artists as Bramantino (from whom he seems to have derived the view of the towered city in the *Annunciation of the Birth of Mary*), devising compositional schemes that influenced such Milanese late-Mannerist artists as Cerano, Daniele Crespi and Tanzio da Varallo.

Gaudenzio Ferrari
(Valduggia, Vercelli c. 1480-Milan 1546)

2 Martyrdom of St Catherine of Alexandria
Oil on panel
334 x 210 cm
Acquired: 1829

Coming from the church of Sant'Angelo in Milan, this work, datable around 1541-43, has unjustly been considered excessively complex by art historians. This huge panel painting represents the moment when the miracle was about to happen (the spiked wheels to which the saint was bound broke and she was saved), with the suspense of the instant before the miraculous forces were unleashed. This theatrical scene takes place on two planes, with skilfully executed passages displaying splendid pictorial effects that were carefully observed by the 17th-century Mannerists: Tanzio da Varallo, for instance, borrowed the swooping angel for his *Sennacherib and the Angel* (San Gaudenzio, Novara).

Gaudenzio Ferrari
(Valduggia, Vercelli c. 1480-Milan 1546)

3 Virgin and Child
Oil on panel
100 x 75 cm
Acquired: 1890

This is part of a larger painting in which the bird that the Child was attempting to grasp was also visible (as may be seen in an old copy of the painting now in the Museum der Bildenden Künste, Leipzig); it constituted the central panel of a triptych that was perhaps intended for a church in Vercelli. The painting may be dated around 1514-16, as was recognized some time ago by the art historian Anna Maria Brizio, and as has recently been confirmed by a stylistic analysis of the wings (*St Peter with a Donor* and *St John the Baptist*, both now in the Galleria Sabauda, Turin). This was a phase when the influence of Leonardo was very evident (note the use of chiaroscuro and the idealized grace of the Virgin's face), and Gaudenzio creates a classical structure based on the figures in Leonardo's *Last Supper*.

**Bramantino
(Bartolomeo Suardi)**
(Milan c. 1465-1530)

4 *Virgin and Child
and a Male Figure*
Oil on panel
61 x 47 cm
Acquired: 1896

Formerly part of the collection of Cardinal Cesare Monti in Milan that was bequeathed to the Archbishopric in 1650, this painting, which was executed in the second decade of the 16th century, was intended for private devotion and may have been commissioned by Marshal Gian Giacomo Trivulzio, who died in 1518. Despite the Child's gesture, this image is far from being naturalistic, and its remoteness is suggested not only by the classicizing setting but also by the Virgin's timeless attire. It is indeed a superb example of the formal abstraction attained by Bramantino in his mature works.

**Bramantino
(Bartolomeo Suardi)**
(Milan c. 1465-1530)

5 *Virgin and Child with Angels*
Detached fresco
240 x 135 cm
Acquired: 1808

This fresco formerly decorated the façade of the Palazzo della Ragione in Piazza dei Mercanti, Milan, where the painter and writer on art theory Giovan Paolo Lomazzo (1538-1600) had seen frescoes by Bramante, the supposed master of Bramantino. Intended to be seen from below (the viewpoint is at the level of the dais on which the Virgin is seated) – although the figures, which are not foreshortened, are seen frontally – this work bears witness to the artist's experimentation with light and perspective in the first decade of the 16th century. This is particularly evident in the play of light and the reddish reflections on the faces of the angels in the background. The softness of these flesh colours and the ideal beauty of the faces seem to foreshadow the style of Gaudenzio Ferrari.

Bramantino
(Bartolomeo Suardi)
(Milan c. 1465-1530)

6 *Crucifixion*
Oil on canvas
372 x 270 cm
Acquired: before 1806

This large canvas, the provenance of which is unknown, was already in the Brera in 1806, when it was attributed to Bramante. It has been suggested that it was originally in the church of Santa Maria di Brera, or that it came from Milan cathedral, although there is no mention of it being there in any of the old guidebooks. Another possibility was that it was executed for a private client, perhaps Bramantino's patron Gian Giacomo Trivulzio, who may have intended to hang it in the Palazzo Trivulzio in Via Rugabella, Milan, where the king of France, Francis I, was a guest in 1521. The painting seems to have been executed by the artist following one or more visits to Rome, with possible pentimenti and modifications made during the first decade of the 16th century (analyses carried out in the gallery using infrared reflectography and X-rays have shown that the background was repainted at least twice). This is an imposing and tragic representation, with symbolic meanings (the passing of time, before the revelation of Christ and after his sacrifice, indicated by the sun and the moon), in which references to antiquity seem to reflect the artist's capacity to evoke a distant world lost in the mists of time. The painting is notable for the unusual size of the figures and the way the planes are composed, with an imaginary vista of Jerusalem in the background, based on a view of Rome and its ancient monuments.

Vincenzo Foppa
(Brescia c. 1472-c. 1515)

8 *Virgin and Child with St John the Baptist and St John the Evangelist*
Fresco transferred to canvas
192 x 173 cm
Dated at the bottom
"MCCCCLXXXV DIE X OCTVBR"
Acquired: before 1884

This fresco comes from the church of Santa Maria di Brera, which was incorporated into the Napoleonic rooms of the gallery at the beginning of the 19th century. In one of the rooms below, now part of the Brera Academy, it is still possible to see the sinopia of the fresco, which was detached not long before 1884 from above the door of what was formerly the sacristy of the church. The remarkable illusionistic effect used by the painter, with the simulation of a space open to the sky beyond a coffered arch in a classicizing style with antique medallions, in front of which stands the Virgin flanked by saints, could have been derived from Bramantesque models, and perhaps the arch on the façade of the

Vincenzo Foppa
(Brescia c. 1472-c. 1515)

7 St Sebastian
Fresco transferred
to canvas
265 x 170 cm
Acquired: 1808

Executed for a chapel of the church of Santa Maria di Brera, this fresco, datable around 1485, is considered by art historians to be a splendid exercise in perspective, although here its use appears to be very free, almost arbitrary (the artist does not make the lines converge on a single vanishing point) and scenographic. The artist's recourse to an antiquarian repertoire is evident (once again there is a triumphal arch with elaborate medallions and capitals), while the figure of St Sebastian resembles a classical sculpture. Foppa's taste for naturalistic detail is also noticeable; thus in the heads of the soldiers he offers a small sample of portraits in a very realistic style, clearly showing the influence of Bramante. Together with the use of light and shade and reflections, these elements make this fresco a very typical example of Foppa's output.

church of Sant'Andrea in Mantua, which was designed by Leon Battista Alberti. The projecting cornice, the *trompe-l'oeil* of the carpet and the fact that the whole scene is viewed from below create a strongly three-dimensional effect that was very influential in Lombardy (it also inspired Bergognone in a fresco in the Certosa di Pavia). Finally, it should be noted how the painter has managed to obtain remarkably delicate flesh tones and brilliant colour effects with the fresco technique.

Vincenzo Foppa
(Brescia c. 1472-c. 1515)

9 Santa Maria delle Grazie Polyptych
Tempera and oil on panel

Lower tier:
Virgin and Child with Angels
Central panel 185.5 x 98.5 cm
St Jerome and St Alexander
Left panel 150.5 x 96 cm
St Vincent and St Anthony
Right panel 151 x 96 cm

Upper tier:
Stigmatization of St Francis
Central panel 144 x 96.5
St Clare and St Bonaventure
Left panel 140 x 98.2 cm
St Louis of Toulouse and St Bernardine of Siena
Right panel 139 x 98 cm
Christ Blessing
Pinnacle panel 42 x 41 cm
Predella:
Annunciation; Visitation; Two Angels; Nativity; Flight into Egypt
Each panel 42 x 97 cm
Acquired: 1811, 1901 and 1912

This splendid polyptych was formerly in the church of Santa Maria delle Grazie in Bergamo. Its original arrangement is uncertain, but some panels are still missing and the present-day recomposition is almost certainly arbitrary. The panel with the Virgin might have projected from the rest of the polyptych because of the foreshortening of the dais on which the throne stands. This polyptych, datable to the 1590s, contains strong traces of the Paduan and Ferrarese modes and echoes of Butinone, but with the influence of Bramante and possibly also Leonardo (the position of the Child's body derives from Leonardo's studies for his *Madonna with the Cat*). Nonetheless, this is an extremely personal work, with a taste, tone and light that are wholly Lombard and archaizing: rather than being unified, the space is split up into the individual panels, in contrast with the canons of perspective. The figures have a gravity that is tempered by their everyday appearance that is typical of Foppa's personages, despite the preciosity of the gold, the marble and the clothes, derived from the painting in the Flemish manner, such as that of Donato de' Bardi, studied by Foppa in Liguria.

Master of the Pala Sforzesca
(active in Lombardy 1490-1520)

10 *Pala Sforzesca (Virgin and Child, the Doctors of the Church and the Family of Ludovico il Moro)*
Tempera and oil on panel
230 x 165 cm
Acquired: before 1808

Commissioned by Ludovico il Moro in 1494 for the church of Sant'Ambrogio ad Nemus in Milan, this altarpiece – formerly believed to have been at least partially executed by Leonardo da Vinci – is by a Lombard artist who had perhaps trained in the circle of Ambrogio de' Predis and was then influenced by Leonardo. The painter, linked to the court, was obliged to adhere to a hierarchical compositional scheme, emphasizing the most decorative aspects of life there (the clothes and jewellery) and only partly succeeding in adapting his style to the more up-to-date modes of Bramante and Leonardo. Thus the artist misinterprets Leonardo's *sfumato*, while Bramante's concept of space is reduced to a perspective cube. Details in the painting which merit attention include the refined technique used in the rendition of the blue brocade of Ludovico's doublet and the goldsmith's precision in the forms of the faces, where chiaroscuro creates quasi-sculptural effects.

Giovanni Bernardino Scotti and Giovan Stefano Scotti
(active in Lombardy 1485-1520)

11 *Crucifix with St Catherine, St Francis, St Bonaventure (?) and St Peter (?)*
Oil on panel
243 x 143 cm
Acquired: 1905

Originally in the church of Sant'Angelo in Milan, this painting, datable to a period before 1495, has been attributed to the two brothers on a stylistic basis. It is of particular interest because Giovan Stefano Scotti was described by the writer Giovan Paolo Lomazzo as the teacher of Gaudenzio Ferrari and Bernardino Luini. Although it is impossible to verify this statement, this work may be regarded as an attempt to combine elements deriving from Mantegna and Bernardino Butinone with the innovations of Bergognone and Zenale. Indeed, despite its harshness and inconsistency, this cultural climate may have had some influence on the formation of Bramantino.

Bergognone
(Ambrogio da Fossano)
(Milan? c. 1453-Milan 1523)

12 *Coronation of the Virgin*
Oil on panel
Lunette 125 x 245 cm
Assumption of the Virgin
Oil on panel
271 x 245 cm
Signed and dated bottom centre
"Ambrosij. bergognoni. 1522"
Acquired: 1809

In these two paintings, which come from the Olivetan monastery at Nerviano, near Milan, Bergognone appears to somewhat wearily continue his repertoire of faces and models in a late Quattrocento style. The composition (in particular, the *Coronation of the Virgin* in the lunette above) is also reminiscent of previous works by the same artist, notably the fresco in the apse of San Simpliciano in Milan, executed in 1507-08, although there are echoes of the artist's earlier frescoes in the Certosa di Pavia. Nevertheless, the painting of the faces is of a high quality, as is that of the splendid landscape, animated by the simple everyday life of the Lombards, surrounding a lake.

Bernardino Luini (attributed)
(Dumenza, near Luino,
Varese c. 1480-Milan 1532)

13 *Annunciation*
Oil on panel
265 x 165 cm
Acquired: 1805

Since this work came to the Brera, probably from the church of Santa Marta in Milan, the attribution has alternated between Luini and the circle of Bernardo Zenale, from whom both the mode and the types are derived. In fact, around 1512-15, Luini and Zenale shared a very similar style: both seemed to be affected by the first symptoms of a Mannerist evolution that manifests itself here in a complex composition including two monochromes deriving from Dürer's *Small Passion* of 1510 in the background. The painting, which seems to reflect heterodox theories (note the thirteen angels in flight rather than a single annunciatory one), may be dated around 1515-17.

Marco d'Oggiono and a follower
(Oggiono, Lecco 1475-Milan 1524)

14 *Assumption of the Magdalen*
Oil on panel
146 x 103 cm
Acquired: 1989

This painting came to the Brera after it had been retrieved from Germany in the postwar period. Formerly in the collection of Amedeo dal Pozzo, it was subsequently mentioned as being in private collections in Britain and Milan before being purchased by Goering for Hitler's museum. The painting is also described in the inventory, dated 1529, of property inherited by Marco d'Oggiono's widow as being unfinished and lacking the landscape. Thus Marco was responsible for the upper part of the work, with its vaguely Raphaelesque mode, while the lower part seems to have been completed at a later date, perhaps by a Flemish painter.

Marco d'Oggiono
(Oggiono, Lecco 1475-Milan 1524)

15 *Three Archangels*
Oil on panel
255 x 190 cm
Acquired: 1806

This work also comes from the church of Santa Marta in Milan, which, at the beginning of the 16th century, was the meeting-place for monks calling for a return of the Church to poverty and the spirit of its origins. They were inspired by the *Apocalypsis Nova* of Blessed Amedeus Mendez da Silva in which the cult of the angels played a central role.
Marco d'Oggiono's altarpiece must have been completed by 1516, the year when the altar for which it was executed was consecrated. Although, in this work, Marco reinterprets the types and the grace of Leonardo's paintings, the faces and the bluish landscape compare favourably with those of his great master.

Room XVIII

Sofonisba Anguissola
1 17

Altobello Melone
2 22

Simone Peterzano
3

Antonio Campi
4 18

Giovan Paolo Lomazzo
5 14

Martino Piazza
6

Callisto Piazza
7 21

Giovanni Agostino da Lodi
8

Vincenzo Campi
9 10 11 12

Giovanni Ambrogio Figino
13 15

Bernardino Campi
16

Camillo Boccaccino
19

Giulio Campi
20 24

Boccaccio Boccaccino
23

In addition to the Leonardesque style that was dominant in Milan in the first three decades of the 16th century – sometimes combined with Raphaelesque elements, as in the *Madonna of the Apple* (room XIX, no. 8) by Giampietrino – in the other Lombard centres different artistic currents manifested themselves. Although originating partly from Leonardo's example, some of these lay the foundations, on the one hand, for a Mannerist style influenced by the great Emilian, Venetian and Roman masters, and, on the other, for the birth of a new, more realistic mode that provided the basis of Caravaggio's revolution.

In his *Baptism of Christ* (no. 7), Callisto Piazza from Lodi was evidently hovering between Leonardism, the influence of Gaudenzio Ferrari in his types and Venetian painting. By contrast, Altobello Melone's *Lamentation* (no. 22) is dramatic and severe; in this work elements of Brescian art and the harsher modes of Romanino's painting seem to merge. Cremona is represented by an important altarpiece by Giulio Campi (no. 20), dated 1530, and another by Camillo Boccaccino (no. 19), dated 1532, in which the impact of Raphaelesque and Leonardesque models is evident, and by a later *Lamentation* (no. 16) by Bernardino Campi (1574), which highlights the degree to which the city was exposed to Correggesque and Emilian influences.

But, in this important Lombard city, taste soon evolved towards a predilection for more intense realism, thanks also to the knowledge of texts and the presence of foreign artists: the four genre scenes by Vincenzo Campi (nos. 9, 10, 11 and 12) presage the paths that the young Caravaggio would later tread. The latter's master, Simone Peterzano, painted the outstanding *Venus and Cupid with Two Satyrs in a Landscape* (no. 3), which was recently added to the Brera's collections. A rare profane work by this artist, it incorporates a still life in the foreground that certainly constitutes the model for Caravaggio's *Basket of Fruit* in the Pinacoteca Ambrosiana, Milan. The secular aspects of North Italian Mannerism are represented by a series of portraits by artists from Cremona (Antonio Campi, Sofonisba Anguissola, Altobello Melone) and Milan (Giovanni Ambrogio Figino and Giovan Paolo Lomazzo) that reflect – also in the sitters' dress – the passage from the second Sforza period to the Spanish occupation. The paintings in this room conclude with two notable altarpieces by Figino and Lomazzo, thus linking the Milanese late Mannerists with the Venetian and Roman currents of the great Italian painting of the High Renaissance and such outstanding artists as Michelangelo and Tintoretto. (P.C.M.)

Sofonisba Anguissola
(Cremona 1532/33-
Palermo 1625)

1 *Self-Portrait* (?)
Oil on canvas
36 x 29 cm
Signed lower left
"(...)ophonisba (...)issola (...)ilcaris filia
(...)in(...)sis (...)" and dated 1561 (?)
Acquired: 1911

This work must have been executed when the painter was at the court of Madrid, where she arrived in 1559. It is unlikely that, as has been suggested, the sitter is in reality her sister Minerva, because the latter had remained in Italy. The artist may have portrayed herself with idealized features here, although the picture could easily be that of a woman aged about thirty. In any case, the portrait, which is meticulously executed with a miniaturist's skill, is that of a mature, intelligent person with a lively character.

Altobello Melone
(Cremona c. 1485-before 1543)

2 *Portrait of Alda Gambara* (?)
Oil on panel
60 x 50 cm
Acquired: 1989

Originally in the Trivulzio Collection in Milan, this painting, which changed hands a number of times and was sent to Germany to form part of the "Hitler group", came to the Brera when it was retrieved after the Second World War. Before being recognized as an autograph work by Altobello Melone (datable around 1515-16), it was variously ascribed to Boltraffio and Bartolomeo Veneto. These attributions, in fact, indicate the range of the influences on the painter at this time, including not only the Lombard Leonardesque artists but also the modes of contemporary Venetian and Brescian painting. It has been suggested that, rather than the poetess Alda Gambara, the woman portrayed may be a member of the Avogadro family. The fact that, in addition to a pendant, there are also a number of copies of this portrait is a sign of the sitter's popularity. The fortress of Brescia is depicted in the background.

Simone Peterzano
(Bergamo c. 1540-
Milan after 1596)

3 Venus and Cupid with Two Satyrs in a Landscape
Oil on canvas
135.2 x 206.9 cm
Acquired: 1998

Purchased on the New York art market, this painting was formerly in a French collection. A very rare profane work by Caravaggio's master, it is, therefore, of particular importance because it illustrates the stylistic influences that his pupil may have assimilated during his artistic training in Lombardy. The still life in the foreground is a clear sign of how Peterzano was able to transmit an interest in the naturalistic representation of objects to Caravaggio. But this is, in any case, an outstanding work in which the influence of Venetian painting on Peterzano's art is evident: the artist was clearly inspired by Titian's *Pardo Venus* (Louvre, Paris) and absorbed, possibly in Venice, elements of antiquarianism (the Venus seems to be modelled on the copy of the Hellenistic *Sleeping Ariadne* in the Vatican Museums). With its magnificent colours – the pinks and blues of the drapery, the blue and gold landscape in the background, the delicate variations in the flesh-colours – the painting may be dated around 1570, when the artist was still particularly fascinated by Venetian painting.

Antonio Campi
(Cremona 1523-1587)

4 Portrait of Bartolomeo Arese
Oil on panel
56 x 49 cm
Acquired: 1962

An old slip of paper glued to the back of the painting identifies the sitter as Bartolomeo Arese, the ducal treasurer in Milan in the period 1520-23. Formerly attributed to Giulio Campi, the work was ascribed to Antonio due to the emphatically anatomical treatment of the face and its intense, almost fierce expressiveness. It is likely that this portrait was executed in the 1560s when the sitter was about sixty years old; in this period, in fact, Bartolomeo Arese was the patron of various works of art and fresco cycles in Milan.

Giovan Paolo Lomazzo
(Milan 1538-1592)

5 *Self-Portrait as the Abbot of the Academy of the Vall de Bregn*
Oil on canvas
56 x 44 cm
Acquired: 1821

In this irreverent and grotesque painting, the artist is arrayed as the academic and abbot of the Academy of the Vall de Bregn (the vernacular form of Valle di Blenio, north of Bellinzona), where dialect was spoken and the serious religious painting of the day was challenged. In this work, Lomazzo seems to have combined Leonardesque physiognomy and chiaroscuro (including echoes of Leonardo's *St John the Baptist* in the Louvre) with the colouristic mode that he assimilated from the followers of Giorgione and Titian, and the result is somewhat ambiguous. The painting may be dated around 1560 (certainly before 1572, the year in which the artist went blind).

Martino Piazza
(Lodi active until 1527)

6 *St John the Baptist*
Oil on panel
183 x 57 cm
Acquired: 1805

Variously ascribed in the past to Boltraffio, Bramantino and Alberto Piazza, this work has now been definitely attributed to Martino Piazza. In the delicate landscape, the gradation of the colours and the atmospheric rendering of the subject, the artist from Lodi shows the influence of the Milanese Leonardesque painters, echoing, in particular, the style of Giampietrino and Marco d'Oggiono. It is likely that Martino's son Callisto was trained in his workshop; for example, in his *Baptism of Christ*, displayed next to this work, Callisto seems to have derived his almost exaggerated depiction of anatomy from his father.

Callisto Piazza
(Lodi c. 1500-Milan 1562)

7 *Baptism of Christ*
Oil on canvas
295 x 255 cm
Acquired: 1811

When this work, which was originally in the church of Santa Caterina in Crema, came to the Brera it was attributed to Carlo Urbino. It is clearly inspired by the famous *Baptism of Christ* by Cesare da Sesto (formerly in the Milan Mint, now in the Gallarati-Scotti Collection, Milan), although the artist is evidently also familiar with the *Baptism of Christ* by Gaudenzio Ferrari executed about 1540-42 for the church of Santa Maria presso San Celso in Milan, the compositional scheme of which he repeats precisely. The huge canvas, which must have been painted shortly after Gaudenzio's work, comprises a number of elements of Lombard Leonardism (the landscape and the soft gradation of the flesh-colours), but, in addition, Callisto Piazza pays greater attention to realistic detail, tempered with colouring deriving from Venetian painting.

Giovanni Agostino da Lodi
(Lodi active c. 1490-1520)

8 *Virgin and Child with an Angel*
Oil on panel
75 x 67 cm
Acquired: 1912

Although, when it was acquired by the Brera, this work was believed to be by Bramantino, it has now been universally attributed to Giovanni Agostino da Lodi. Behind the Virgin and Child, to whom an angel is offering an orange, is a red cloth hanging from a branch of an orange tree, while to the left a mountainous landscape is visible, in accordance with a typically Venetian – and Giorgionesque – compositional scheme. The skilful modelling of the faces and the refined colours of the landscape, with echoes of Bernardo Zenale, suggest, however, that this painting was executed in Lombardy, after the artist's return from the Veneto, around 1515-20. It is, in fact, very similar to Giovanni Agostino's altarpiece in the parish church at Gerenzano (near Saronno, north of Milan).

Room XVIII

Vincenzo Campi
(Cremona 1536-1591)

9 *Fruit Seller*
Oil on canvas
143 x 213 cm

10 *Fishmonger*
Oil on canvas
144.5 x 217 cm

11 *Poulterer*
Oil on canvas
147 x 215 cm

12 *Kitchen*
Oil on canvas
145 x 220 cm
Acquired: 1809

Coming from the monastery of the Gerolomiti di San Sigismondo in Cremona, these paintings, which have been dated around 1590, are considered to be the forerunners of the still life in Italy and show the influence of Flemish painting, especially that of Pieter Aertsen and Joachim Beuckelaer. Immediately popular both in Cremona and the rest of Italy, these works were repeated on a number of occasions by Vincenzo Campi. They are particularly notable for the attention paid to the details — some of them amusing — of everyday life, with the almost caricatural treatment of a number of the faces. A similar series (consisting of five works), painted at an earlier date, are in the Fugger castle at Kirchheim am Mindel, near Augsburg, in Germany.

Giovanni Ambrogio Figino
(Milan 1551/54-1608)

13 *Portrait of Lucio Foppa*
Oil on panel
196 x 99 cm
Signed lower right
"JO. AMBROSIVS FIGINVS P."
Acquired: 1809

This work was part of the Sannazzari Collection donated to the Ospedale Maggiore in Milan in 1802. A masterpiece of Figino's portraiture, it is datable to the 1590s. The sitter is portrayed in an elaborate suit of armour, in accordance with the Spanish style in vogue in Milan between 1570 and 1600. Alternating passages worthy of a miniaturist with strong contrasts of light and shade, this painting is full length, as was customary for official portraits of the 16th century.

Giovan Paolo Lomazzo
(Milan 1538-1592)

14 *Crucifixion with the Virgin, St John the Evangelist and St Mary Magdalene*
Oil on panel
250 x 148 cm
Acquired: 1809

The work is mentioned by the artist himself in his *Rime* (1587) as having been executed for the church of San Giovanni in Conca, Milan, before he went blind in 1572. It is an important example of the output of Lomazzo's mature period, when he sought to combine Titian's late style with his northern European vision. But, even more than Michelangelo and Pellegrino Tibaldi, the artist seems to have a capacity for handling paint freely, with iridescent effects that were rarely seen in Milan at that time.

Bernardino Campi
(Cremona 1519-
Reggio Emilia 1591)

16 *Lamentation over the Dead Christ with St Catherine of Alexandria, the Prophets Elijah and Elisha and Gabriele Quintiniano*
Oil on canvas
235 x 160 cm
Signed and dated at the bottom
"R.DVS P. HONORIS GABRIEL DE PIZZA MILIIS DE QVINTIANO. FILIVS. ET PR. CONVENTVS CREMAE DE OBSS.^A· FECIT FIERI ANNO AETATIS SVAE. LXVIIII. PICTORE D. BERNARDINO DE CAMPO CREMONENSE./M.D.LXXIIII"
Acquired: 1811

Intended for the church of the Carmelitani in Crema, this work seems to reveal the artist's familiarity with Michelangelo's *Pietà* in the Vatican, although the execution displays the mark of Parmigianino's modes and the influence of Emilian painting more generally. Effects of fastidious refinement and Mannerism freeze the sense of tragedy that, nonetheless, emanates from the group of the Virgin and Christ, and the latter's lifeless body, especially his head, rendered with the skilful use of chiaroscuro, is one of the most outstanding parts of the painting. Numerous copies of this work exist.

16

Giovanni Ambrogio Figino
(Milan 1551/54-1608)

15 *Virgin and Child with St John the Evangelist and St Michael*
Oil on canvas
314 x 175 cm
Acquired: 1809

This was the altarpiece in the chapel of San Giovanni Evangelista in the Collegio dei Nobili Dottori in Milan (now Palazzo dei Giuresconsulti). Painted shortly before 1590, it is a powerfully composed work revealing the classicistic influences on the artist: the archangel Michael derives from Raphael, while St John clearly echoes the figures by Michelangelo in the Sistine Chapel that he had seen in Rome, and, with the rotary motion of their bodies, they contrast with the static group of the Virgin and Child. The figure of the devil seen from behind is also notable; this was a motif that was very popular in the Lombard painting of the 17th century.

Sofonisba Anguissola
(Cremona 1532/33-
Palermo 1625)

17 *Pietà*
Oil on canvas
44 x 27 cm
Acquired: 1909

Formerly attributed to Bernardino Campi, this work is, in fact, a copy on a smaller scale of part of the Campi's *Lamentation* (no. 16) by his pupil Sofonisba Anguissola. It is probable, however, that when Anguissola executed this work she based it on a copy or engraving sent to her by Campi because his painting was dated 1574 and she had been in Spain since 1559. Her version, which is more intimist and less dramatic, isolates the central group, thus obtaining an effect of greater concentration in accordance with the dictates of the Counter-Reformation.

Antonio Campi
(Cremona 1523-1587)

18 *Virgin and Child with St Joseph, St Catherine and St Agnes*
Oil on canvas
230 x 143 cm
Signed lower left
"ANTONIVS CAMP(V)S"
Acquired: 1810

Originally in the church of San Barnaba in Milan, this work, datable to around 1570, is executed in an elegant and refined Parmigianinesque manner, with the masterly disposition of the figures in space (there are similarities with Veronese's compositional schemes) and a profusion of decorative details in the draperies, especially in St Agnes's clothes. Nonetheless, compared to Parmigianino's style, the handling of the paint is harsher, while the use of light is typically Lombard.

Camillo Boccaccino
(Cremona c. 1505-1546)

19 *Virgin and Child with Saints*
Oil on canvas
296 x 165 cm
Signed and dated on the cartouche
"Camilli Boccaccinj/op.S· M.D.XXXII"
Acquired: 1809

This work was executed for the Carmelite friars of the church of San Bartolomeo in Cremona, on the altar of which it was formerly situated. For this splendid painting, divided into two levels, the artist drew inspiration from illustrious classicist examples: for the Virgin in the clouds, Camillo Boccaccino has used Raphael's *Madonna of Foligno* as a model, but there are also reminiscences of Correggio and Pordenone and, in the landscape, Titian. The recent restoration (1997) has revealed passages of vegetation in the foreground and very refined details (such as St Jerome's head), indicating the close attention the artist paid to the works painted by Cesare da Sesto in Milan.

Giulio Campi
(Cremona c. 1508-1573)

20 *Virgin and Child with St Catherine of Alexandria, St Francis and a Donor, Stampa Soncino*
Oil on panel
266 x 167 cm
Signed lower left "Julius Campus cremonensis facie/bat" and dated 1530
Acquired: 1883

Although this work was originally in the church of Santa Maria delle Grazie in Soncino (a small town between Milan and Brescia), after the suppression of the Carmelite monastery it was acquired by the Castelbarco Visconti family in Milan, from whom it was purchased for the Brera.

It was part of an extensive decorative scheme, consisting mainly of frescoes, in which the artist demonstrated that he had assimilated the Raphaelesque style. Here the model seems to be the *Sistine Madonna* combined with that of the *Madonna of Foligno*. The portrait of the donor is more in the manner of Romanino, and echoes of Holbein have also been noted. The remarkable landscape opening up at the bottom of the painting, with its light blue, pink and yellow tones, appears to have been an example for many of the landscapes in the Cremonese paintings – and those from other parts of Lombardy as well – displayed in this room.

20

Callisto Piazza
(Lodi c. 1500-Milan 1562)

21 *Virgin and Child with St John the Baptist and St Jerome*
Oil on panel
215 x 188 cm
Signed lower left
"CALIXTVS LAVDENSIS"
Acquired: 1829

Originally on the altar of San Gerolamo in the church of San Francesco in Brescia, this work was executed during the period when Venetian painting had its greatest influence on the artist, who, towards 1529, was at the end of his sojourn in Brescia. Thus there are clear Giorgionesque overtones as reinterpreted by the Brescians Romanino and Moretto, while a strongly incisive, calligraphic style is noticeable, especially in the monumental structure of the figures, which may reflect affinities with northern European art or that of Ferrara. The figures of the two saints are remarkable: in St Jerome it is even possible to perceive echoes of Dürer's stay in Venice.

Altobello Melone
(Cremona c. 1485-before 1543)

22 *Lamentation over the Dead Christ*
Oil on panel
160 x 175 cm
Acquired: 1916

The provenance of this painting, which was purchased by the Pio Ricovero Maternità in Milan, is unknown. The model for the composition seems to be Venetian, but the dry style shows the influence of Romanino, who came into contact with the artist in 1517 in Cremona. The work could, however, have been executed before this and reveals an early visit by Melone to Venice; in this case, it would be dated around 1511. But the work also displays a knowledge of the Lombard, Cremonese and Bramantesque modes and also of Bramantino, who, in the same period, produced paintings very similar to this one, with rigid and dramatic geometric volumes.

Boccaccio Boccaccino
(Cremona c. 1465-1524/25)

23 *Virgin and Child with a Bird*
Oil on panel
49 x 40 cm
Acquired: 1925

Art historians have stressed the strong Venetian influence in this painting, with the modes of Giovanni Bellini and Giorgione seen in the light of a Po Valley – especially Ferrarese – interpretation of the theme. Principally because of its marked chiaroscuro, this picture seems to be related to the group of the Virgin and Child in the San Giuliano altarpiece in Venice that Boccaccino executed around 1509. Thus a date around 1510, shortly after the painter arrived in Venice, seems to be the most appropriate for this work.

Giulio Campi
(Cremona c. 1508-1573)

24 *Virgin and Child with St Matthias, St Anthony of Padua, Blessed Alberto di Villa d'Ogna and a Donor*
Oil on panel
250 x 148 cm
Acquired: 1811

This painting, assigned to Altobello Melone by the old sources and later attributed to Romanino, comes from the church of San Mattia in Cremona. In fact, it is from these artists that Giulio Campi seems to have derived some of the features of this work, which is very well structured. Also evident are echoes of Dosso Dossi's and Correggio's styles, as are the natural airiness of the landscape and the artist's skill as a portraitist, demonstrated by the donor's head on the left. The date, towards 1530, is close to that of the Soncino altarpiece (no. 20).

Room XIX
Lombard religious paintings and portraits of the 15th and 16th centuries

Room XIX

**Bergognone
(Ambrogio da Fossano)**
1 2

Andrea Solario
3 12

Bernardino Luini
4 **5**

Cesare da Sesto
6

Follower of Leonardo da Vinci
7

**Giampietrino
(Giovan Pietro Rizzoli)**
8

Bartolomeo Veneto
9

Giovan Antonio Boltraffio
10

Lombard painter
11

Giovanni Ambrogio de' Predis
13

Giovanni Agostino da Lodi
14

Donato de' Bardi
15

In the second half of the 15th century Lombard painting, developed from what was still essentially a Late-Gothic mode into a wholly Renaissance style. This transformation, which coincided with the replacement of the Visconti by the Sforza as the rulers of Milan, was not only due to the achievements of the more outstanding local artists, such as Vincenzo Foppa, but also to the assimilation of trends and styles from beyond the Alps, especially those of Flanders and Provence, which reached Lombardy through Liguria and also as a result of trade relations. Works by Flemish artists were, in fact, to be found in Liguria and Ferrara, which had political links with Milan, while Savoyard and Provençal artists worked in Piedmont and Milan. One of the leading exponents of a synthesis between the Late-Gothic artistic language of northern Italy, with its Venetian inflection, and the art of northern Europe was the Pavian Donato de' Bardi, who worked in Liguria. In this room there is an important fragment of a panel from his polyptych depicting *St John the Baptist* (no. 15). The Flemish style absorbed by Donato de' Bardi was transmitted to Foppa and Bergognone, and two Madonnas by the latter (nos. 1 and 2) hang in this room. The first of these reveals the artist's assimilation of the Franco-Provençal handling of colour, while, in the second, the further evolution of his style is evident, with the absorption of Leonardesque elements. It is, in fact, with the arrival of Bramante and Leonardo da Vinci in Lombardy that the local school of painting made rapid progress towards forms of monumentalism and greater psychological penetration. On the right-hand side of the room hang paintings that are mainly secular in character: apart from a work by Giovanni Agostino da Lodi (no. 14) that was influenced by both Bramante and Leonardo, they are portraits (nos. 10-13) that have adapted Leonardesque forms, with works by Ambrogio de' Predis, Solario, Boltraffio, Bartolomeo Veneto and an as yet anonymous Lombard painter (no. 11). On the opposite wall, by contrast, beginning with the two Madonnas by Bergognone and a notable painting by Solario (no. 3) executed in Venice, the theme is the evolution of the Virgin and Child (nos. 4, 5, 6), including works by Bernardino Luini and Cesare da Sesto in which Leonardo's aesthetic is accepted in its entirety. The culmination of this development is the *Virgin and Child and the Lamb* (no. 7) by an anonymous follower of Leonardo, which is directly modelled on Leonardo's drawings for the lost *Madonna with the Cat*. The series concludes with the *Madonna with the Apple* (no. 8) by Giampietrino, which is based on a Leonardesque compositional scheme, although Raphaelesque elements are also evident. (P.C.M.)

Bergognone
(Ambrogio da Fossano)
(Milan? c. 1453-Milan 1523)

1 *Virgin and Child, St Catherine of Siena and a Carthusian Monk*
Tempera on panel
46 x 40.5 cm
Acquired: 1891

This painting, which may have come from the Certosa di Pavia, was executed in either the 1470s or 1480s and belongs to Bergognone's first phase, when echoes of Flemish and Provençal art were noticeable in his work. The light colours, the clarity of the forms and the rendering of the landscape in the background make this a masterpiece of the artist's early period, during which he developed his own style by combining the transalpine modes with those deriving from Mantegna and Foppa.

Bergognone
(Ambrogio da Fossano)
(Milan? c. 1453-Milan 1523)

2 *Virgin and Sleeping Child* (*Madonna of the Veil*)
Tempera and oil on panel
60 x 40 cm
Acquired: 1911

This painting represents a later stage in the artist's development, probably in the late 1490s, as seems to be indicated by the more delicate handling of the paint and the emphatic chiaroscuro resulting from the influence of the Leonardesque style, which the artist probably assimilated in Milan after 1494. The subject of this painting – the Virgin raising a veil from the body of the sleeping Child – which was later used by Raphael, alludes to the Passion and death of Christ (the veil symbolizes the shroud in which his body was wrapped). Characteristically, in the landscape seen through the window on the right the artist focuses his attention on the everyday aspects of life, such as men at work and monks praying. There is a replica of this painting in a private collection in Milan.

Andrea Solario
(Milan c. 1468/70-1524)

3 *Virgin and Child with
St Joseph and St Simeon*
Tempera and oil on panel
transferred to canvas
102 x 87 cm
Signed lower left on the parapet
"ANDREAS MEDIOLANENSIS"
and dated 1495
Acquired: 1811

This work comes from the church of San Pietro Martire on the island of Murano, in the Lagoon of Venice, where, in his *Meraviglie dell'arte* (1648), the painter and writer Carlo Ridolfi mentioned having seen it. Donated to the Brera by viceroy Prince Eugène de Beauharnais, it is one of the most important works in Solario's oeuvre because it reveals that, at an early stage in his career, he had assimilated Leonardo's psychological introspection and the gentleness of Boltraffio's faces, combining these with Venetian colour and Dürer's meticulous technique, which is particularly noticeable in the rendering of the faces and beards of the two saints. The signature of the artist, who described himself as "Mediolanensis" (from Milan), indicates that at that time (1495) he was in Venice and that elements of Leonard's style had already spread to the city.

Bernardino Luini (attributed)
(Dumenza, near Luino,
Varese c. 1480-Milan 1532)

4 Pala Busti: Virgin and Child with Saints and Donors
Tempera and oil on panel
195 x 145 cm
Bears the inscription below
"ANTONIVS BVSTIVS DIVIS/IACOBO ET PHILIPPO/SACRAVIT ANNO MDXV" and the initials "AB" in the tondos in the dais
Acquired: 1809

The attribution of this painting, which comes from the church of Santa Maria di Brera, has been much disputed: it was originally ascribed to Ambrogio Bevilacqua, then to Bernardino Luini and, more recently, to the circle of Bernardo Zenale. It is related in various ways to the output of the two latter artists – the portraits resemble those of Luini, but the architecture and the type of the enthroned Virgin are reminiscent of works by Zenale, such as the altarpiece now in the Art Museum in Denver. Despite the archaism of the profile portraits, in this masterly work there are the first signs of the Mannerism that began to appear in Milanese painting around 1515.

Bernardino Luini
(Dumenza, near Luino,
Varese c. 1480-Milan 1532)

5 *Virgin and Child
(Madonna of the Rose Garden)*
Oil on panel
70 x 63 cm
Acquired: 1826

Traditionally believed to be from the Certosa di Pavia, this work is the most outstanding work of Luini's early period. Some hesitancy in the composition – despite its reflection of Leonardesque modes, which emerges in the pose of the Child reaching out to grasp the columbine (a symbol of the Holy Ghost), thus prefiguring the Passion – and elements drawn from the Lombard tradition, such as the light effects and the setting, seem to confirm the early date for the work (around 1508-10). This painting is notable for the refined and precise handling of the paint and for its naturalistic vision, despite the limited pictorial space, which is practically a *hortus conclusus* in the medieval or Gothic and chivalric traditions, updated with elements from Bergognone, Zenale and, above all, Leonardo.

Cesare da Sesto
(Sesto Calende? 1477-Milan 1523)

6 *Virgin and Child
(Madonna of the Tree)*
Tempera and oil on panel
46 x 36 cm
Acquired: 1824

In this painting, one of Cesare da Sesto's most outstanding works, the artist has, in fact, combined the models and the refined use of glazing of Leonardesque origin with the elegance of a composition by Raphael and the Venetian mode of colouring that he may have derived from Solario. Because of all these various influences, this painting cannot be dated before about 1515, when the artist returned to Lombardy after a journey to central Italy during which he came into contact with the painting of Raphael and Roman classicism. A number of replicas and copies of the work exist, as do the preparatory drawings now in Windsor, Turin, Venice and New York.

Follower of Leonardo da Vinci
(active in Central Italy at the beginning of the 16th century)

7 Virgin and Child and the Lamb
Tempera and oil on panel
60 x 52 cm
Acquired: 1891

The painting was purchased as a work by Sodoma (Giovanni Antonio Bazzi), after a previous attribution to Leonardo. The composition is, in fact, based on the drawings by Leonardo for the *Madonna with the Cat* (British Museum, London, and Uffizi, Florence), which are characterized by notable dynamism. The cat struggling to free itself in Leonardo's drawings is replaced here by the lamb, the symbol of Christ's sacrifice. Nevertheless, recent X-ray analyses have demonstrated the existence, under the layer of paint, of a previous version of the picture, in which the form of a cat is visible. Thus the artist who painted this picture, which is remarkable for the gentleness and grace of the Virgin and the enamel-like surface of the paint, had evidently seen Leonardo's paintings. This may have occurred in Florence, towards 1505, when we know that a certain "Ferrando spagnolo" – Fernando de Llanos, or perhaps Fernando Yanez de la Almedina, who was responsible for a similar painting now in the National Gallery in Washington – was one of the assistants working with Leonardo on the *Battle of Anghiari*.

Giampietrino (Giovan Pietro Rizzoli)
(active in Milan c. 1495-1549)

8 Virgin and Child (Madonna of the Apple)
Oil on panel
49 x 38 cm
Acquired: 1995

In this late work by Giampietrino, datable to the 1520s, in which the artist attempts to combine the Leonardesque and Raphaelesque styles, the view of the Virgin almost from behind and the gesture of the Child seem to have been derived directly from drawings by Leonardo. This painting was immediately very popular and there are numerous autograph replicas (there is one in the picture gallery in the Castello Sforzesco, Milan). However, the one in the Brera seems not only to be the prototype, but also the finest version.

Bartolomeo Veneto
(active in Veneto and Lombardy c. 1502-1530)

9 *The Lute Player*
Oil on panel
65 x 50 cm
Dated 1520 on scroll,
left of centre at bottom
Acquired: 1931

Traditionally believed to represent Cecilia Gallerani, but in fact a genre picture, not a portrait, this painting was very popular in Lombardy in the first half of the 16th century. There are at least ten replicas, both autograph and by Bartolomeo's workshop, which sometimes transform the secular subject into a sacred one, that of St Catherine of Alexandria, adding a halo and the spiked wheel on which she was to be martyred, and removing the lute from the composition. The subject may have originated from Venice, where, since Giorgione's day, compositions of this type with a few musicians had been in vogue. Thus, stylistically speaking, this work could be seen as a compromise between the Leonardesque and the Giorgionesque modes.

Giovan Antonio Boltraffio
(Milan 1467-1516)

10 *Portrait of the Poet Girolamo Casio*
Oil on panel
52 x 43 cm
Acquired: 1902

This painting, which is worn, especially in the face (where the paint has formed small lumps), has been attributed to Francesco Francia, but today it is thought to have been executed by Boltraffio around 1500, in the same period as the *Pala Casio* (Louvre, Paris). The painting appears to be modelled on Leonardo's *Portrait of a Musician* (Pinacoteca Ambrosiana, Milan), but here the artist seems to be more interested in combining the Lombard realist tradition with Leonardesque idealization than passively adhering to the prototype. The very bright colours, furthermore, link the portrait to the Bolognese school rather than the Milanese portraiture of the day. There are numerous other portraits of the sitter painted by Boltraffio (Moscow, San Diego, Devonshire Collection, Chatsworth).

Lombard painter
(active in the second decade of the 16th century)

11 *Two Genuflecting Donors*
Oil on panel
140 x 120 cm
Acquired: 1897

This painting has been variously attributed to Giovan Battista Moroni, Giovan Francesco Bembo and Giovan Antonio Boltraffio, although the most recent hypothesis ascribes it to the Pavian Bernardino Ferrari. It is certainly a fragment of a larger altarpiece in the upper part of which the Virgin was depicted. From the point of view of its composition, it resembles Boltraffio's *Pala Casio*, in the Louvre, and, more closely, an altarpiece by Garofalo now in the Pinacoteca, Ferrara (*Pala Suxena* or *Madonna of the Clouds*). While echoes of the Leonardesque tradition are evident in the landscape, the portraits of the donors recall not only Boltraffio's portraits, but, because of their sharp focus, also those of Holbein. The artist, who is certainly a Lombard, may have come into contact with the art of northern Europe through Giovanni Agostino da Lodi or Andrea Solario.

Andrea Solario
(Milan c. 1468/70-1524)

12 *Portrait of a Young Man*
Tempera and oil on panel
42 x 32 cm
Acquired: 1811

This portrait comes from Cardinal Cesare Monti Collection in Milan. Although the inventory made at the time listed it as being by Cesare da Sesto, it is, in fact, an outstanding work by Andrea Solario, who combined the psychological introspection of Leonardo's portraits with a style in which there are echoes of Venetian painting (Alvise Vivarini and Antonello da Messina). Thus, Leonardo's prototype, the *Portrait of a Musician* (Pinacoteca Ambrosiana, Milan), is reinterpreted in a North European style, producing an image that is remarkable for its immediacy and vividness, and, at the same time, renewing Venetian portraiture in the Bellinesque tradition, so that a date shortly after 1500 seems to be the most probable.

Giovanni Ambrogio de' Predis
(Milan c. 1455-after 1508)

13 *Portrait of a Young Man*
Oil on panel
49 x 39 cm
Acquired: 1914

Bearing Seneca's motto "Vita si scias uti longa est" (If you make good use of it, life is long), which may have been copied from Leonardo's *Codex Trivulzi* (c. 1490), this work is traditionally attributed to de' Predis, the official portraitist of the Sforza, and this seems to be confirmed by the rigidity in the handling of the paint and the fixity of the sitter's gaze, features that are typical of other autograph portraits by the artist. He does not, in fact, fully comprehend the refined psychological introspection of Leonardo's portraits, but there is no doubt that he was inspired by the *Portrait of a Musician* in the Pinacoteca Ambrosiana, which means that this painting may be dated around 1490.

Giovanni Agostino da Lodi
(active in Lombardy and Veneto end of 15th century-c. 1520)

14 *St Peter and St John the Evangelist*
Oil and tempera on panel
25.5 x 34.5 cm
Signed left centre
"JOH.ES AVGVSTINVS LAVDE.SIS P."
Acquired: 1913

This is one of the earliest known works by this painter, and, in particular, the one that allowed a name to be given to "Pseudo-Boccaccino", who had already been partially identified by scholars at the end of the 19th century, since this is the only signed work by this artist known to exist. In this painting, which was probably executed in Venice in the mid-1490s, Giovanni merges echoes of the groups of busts and figures in Leonardo's *Last Supper* with Bramante's strongly sculptural style. There is a copy in the Alte Pinakothek, Munich.

Donato de' Bardi
(Pavia active in Liguria and Lombardy 1426-1451)

15 *St John the Baptist*
Tempera on panel with gold ground
39.4 x 32 cm
Acquired: 1997

This painting has been identified by the art historian Federico Zeri as being part of a polyptych executed by Donato de' Bardi between 1445 and 1451. Another two panels of the same polyptych are in a private collection in Milan, while a third one is in the Brooklyn Art Museum in New York. Produced in the painter's mature period, this work clearly demonstrates the way in which he has combined the influence of Franco-Flemish art with elements from Venetian and Paduan painting. This synthesis, which gave rise to a refined and rigorous style, with particular emphasis on the formal aspects of painting, was transmitted to the Lombards Foppa and Bergognone. In the second half of the Quattrocento it gave birth to one of the most stimulating currents in North Italian painting, which became an alternative to the Leonardesque and Bramantesque styles.

IA II III IV V
I
VI VII VIII
IX
XIV
XIX
XV
XVIII
XX
XXI
XXII
XXIII
XXIV
XXVII
XXVIII
XXIX
XXX
XXXI
XXXII
XXXIII
XXXIV
XXXV XXXVI
XXXVII
XXXVIII

Room XX

Master of the Gesuati
1 2

Francesco del Cossa
3 5

Cosmè Tura
4

Lorenzo Costa
6

Master of Violantria (Amico Aspertini?)
7

Giovan Francesco Maineri
8

Marco Palmezzano
9

Francesco Zaganelli
10

Bernardino Zaganelli
11

Mantuan painter
12

Venetian painter
13 14

Lorenzo Leonbruno
15

Filippo Mazzola
16

This room houses paintings that, apart from the origin of the artists – nearly all linked to the courts in the Po valley – have in common their small size and the attention that has evidently been paid to the art of northern Europe, whether this be German or Flemish (rooms XXXII and XXXIII). Of these works, pride of place must certainly go to those from Ferrara, because in the 15th century the very original art of this city, ruled by the Este dynasty, reached full maturity and had a long-lasting influence on the neighbouring areas.

The driving force behind this development was the very lively court where, under Leonello d'Este and then under his successors Borso and Ercole I, humanist studies, the rediscovery of literature and the Roman civilization were mixed with the medieval chivalrous romances and the cult of science and astrology, thus giving birth to a very refined culture. Moreover, the rulers maintained close dynastic, commercial and cultural relations with Milan, Mantua and Padua, welcoming the innovations coming from those cities. This development also had an impact on the figurative arts: although it continued to appreciate the magnificence and meticulousness of International Gothic (nos. 1 and 2), the court availed itself of the services of Leon Battista Alberti (a writer of treatises, architect, sculptor and man-of-letters, and one of the figures whose role was fundamental for the diffusion of the renewal of the arts in the Renaissance) and Piero della Francesca; it sought out Flemish artists and their works; and it favoured the so-called minor arts (manuscript illumination, medals, textiles and jewellery).

In this stimulating climate, under the rule of Borso, the Ferrarese school began to evolve thanks to three artists, Cosmè (or Cosimo) Tura, Francesco del Cossa and Ercole de' Roberti, all represented, albeit with works of varying quality, in the Brera (nos. 3, 4 and 5 here and no. 10 in room XXII). They developed a distinctive style having common features in which different elements were combined to create images that were almost excessively refined and dreamlike, and rendered with very detailed realism.

The continuous contacts between the various centres and Cossa's departure from Ferrara for Bologna, followed soon after by that of Ercole de' Roberti, favoured the diffusion of this style, which was, however, immediately toned down and deprived of its most idiosyncratic features, and also brought up to date (nos. 6 and 8). In Romagna, where the cultural independence of the various centres, even very small ones, was very deep-rooted, the convergence of the different artistic currents produced a wide variety of results (nos. 9, 10, 11). (E.D.)

Master of the Gesuati
(active in Ferrara around 1450)

1 and 2 *Scenes from the Life of St. Jerome*
Tempera on panel
Each panel 41 x 30 cm
Acquired: 1820

These two small panels, together with another three of similar size also illustrating the life of St Jerome and now in public and private collections, must have formed part of a portable altarpiece. Because of the presence in them of friars belonging to the order of the Gesuati, it has been suggested that they belonged to the oratory of San Girolamo in Ferrara, founded by this order. A mid-15th-century Ferrarese origin is also indicated by the style of the anonymous artist, who combines, perspicaciously, but without overindulging in elegance, a capacity to depict the smallest details – typical of Flemish and German painting – with Late-Gothic elements.

Francesco del Cossa
(Ferrara c. 1436-Bologna 1478)

3 *St John the Baptist*

5 *St Peter*
Tempera on panel
112 x 55 cm each
Acquired: 1893

These two paintings are side panels from the huge polyptych dedicated to St Vincent Ferrer commissioned by Floriano Griffoni, a rich merchant from Bologna, for his family chapel in the basilica of San Petronio in that city. When executing this splendid work, Francesco del Cossa was assisted by the young Ercole de' Roberti; probably completed by 1473, it was dismembered between 1725 and 1730 when the chapel was rebuilt. After going to various collections in Bologna and Ferrara, its component parts were dispersed to different museums.

Only a little younger than Cosmè Tura, del Cossa probably had a similar training, but, rather than by the expressionistic style typical of the other painter, he was influenced by the rigorous perspective of Piero della Francesca. In these works, executed after the artist had moved from Ferrara to Bologna, where he remained for the rest of his life, the monumental figures stand out against landscapes that must have given the polyptych a sense of unity, while the jagged rocks on which they pose and the pillars behind them allow the space to be precisely defined. The whole scene is dominated by the crystalline light lending clarity and verisimilitude to every detail, even the most unlikely ones, so that St Peter's baldness, the improbable crosier, with a lifelike miniature lamb, held by St John and the elevated castle behind him are all very convincing.

Cosmè Tura
(Ferrara c. 1430-1496)

4 Crucifixion
Tempera on panel
22 x 17 cm
Acquired: 1903

This painting is a fragment of the panel representing *St Jerome* in the National Gallery, London, which is probably a small altarpiece executed during the 1470s for a church in Ferrara. Cosmè Tura, who trained in Padua, where he was able to see Donatello's sculptures and reliefs, was an outstanding figure in the Este court, for which he not only executed individual paintings and polyptychs, but also produced designs for tapestries and furnishings.

Although this small work, datable to the artist's mature period, only provides a limited sample of his very distinctive art, which comprised rarefied and dramatic works, it does permit us to appreciate some of its constituent elements, such as the sensitive vivacity of the line, here perceptible especially in the thin luminous outlines delimiting and modelling the figure, or the uneasy expressive tension.

Lorenzo Costa
(Ferrara c. 1460-Mantua 1535)

6 Adoration of the Magi
Tempera on panel
75 x 181 cm
Signed and dated on the Virgin's dais "LAVRENTIVS COSTA F. 1499"
Acquired: 1809

This painting was originally the predella of the altarpiece by Francesco Francia depicting the *Nativity with Saints*, formerly in the church of Santa Maria della Misericordia in Bologna. Lorenzo Costa, who was trained in Ferrara in the manner of Cosmè Tura and Ercole de' Roberti, worked mainly in Bologna, but spent the last part of his career in Mantua. In Bologna he met Francia and was influenced by his balanced, delicate paintings (room XXIII, no. 4), but his encounter with the Florentine painting of the age of Savonarola, mirror of the moral and religious unease of the times, marked a turning-point to which this picture clearly bears witness. An example of continuous representation, with different episodes of the narrative shown side by side so that the main subject is almost obscured, it is peopled by slender figures wrapped in mantles with capricious folds and standing in mannered poses against a fantastic landscape rich in details and incidents.

Master of Violantria
(Amico Aspertini?)
(active in Bologna c. 1500-1520)

7 *A Teacher at his Desk with his Pupils*
Oil tempera on panel
34 x 38 cm
Acquired: 1930

The artist responsible for this picture is certainly the one who painted a fragment of a cassone in which a female figure appears bearing the name Violantria; he has been identified as the Bolognese Amico Aspertini, who, however, in his autograph works at the beginning of the 16th century – when this painting was probably executed – displayed a different style. In fact, the handling of the paint on the panel is cursive and summary, the spatial structure is ungrammatical and the figures out of proportion to each other, although this reflects the bizarre tone of the composition. There is also some doubt as to the function of this panel, which was certainly not intended to be an isolated painting.

Giovan Francesco Maineri
(Parma active 1489-1506)

8 *Severed Head of St John the Baptist*
Oil on panel transferred to canvas
44 x 30 cm
Acquired: 1921

This small painting is probably the one with the same subject that was commissioned in 1502 by Ercole I d'Este for Sister Lucia da Narni, and perhaps then acquired by the Canonici Collection, although its later history is unknown – in fact, it came to the Brera from the church of Casatenovo, between Milan and Lecco, to which it had been donated by a private citizen. The artist, born in Parma, but evidently very much influenced by Ercole de' Roberti, spent most of his career in Ferrara, with a few brief periods at the court of Mantua. The saint's delicate head, seen in profile, is outlined with finesse and displays lustre and precision that is Flemish in taste, while the macabre depiction of the severed neck suggests that the artist was familiar with Leonardo's anatomical studies.

Marco Palmezzano
(Forlì 1459/63-1539)

9 *Severed Head of St John the Baptist*
Oil on panel
29 x 36 cm
Acquired: 1811

This painting was formerly in the church of the Minori Osservanti at Cotignola, in Romagna. It is not known whether it was intended to be an independent work or – as is more likely – it was the central panel of a predella. It may be dated to the 1490s, the period when the painter was most strongly influenced by Venetian painting.

9

Francesco Zaganelli
(Cotignola, Ravenna 1460/70-1532)

10 *Christ Carrying the Cross*
Oil on panel
95 x 55 cm
On loan from the Litta Modignani family since 1940

Francesco Zaganelli worked all over Romagna, often together with his brother Bernardino, until 1510, when he finally settled, alone, in Ravenna. Although he was trained in the Ferrarese and Romagnol traditions, he was open to other influences. This painting, datable to the second decade of the 16th century, manifests the artist's interest in German painting, especially that of Dürer, who visited Italy twice and may have left one of his works in Cotignola. In this work, the painting of northern Europe is reflected not only in such features as the type of landscape and the ample, sharp folds, but also in the intensely pathetic tone, obtained by using deep, contrasting colours with delicate handling of the paint and a glossy surface.

10

Bernardino Zaganelli
(Cotignola, Ravenna 1460/70-1509?)

11 *Christ Carrying the Cross*
Oil on panel
37 x 31 cm
Acquired: 1811

Considering its subject and small size, this work, which was formerly in the church of Corpus Domini in Forlì, may have been intended for private devotion. Its restrained and melancholy expressiveness is heightened by smooth modelling, delicate passages of chiaroscuro and subdued colours.

Mantuan painter
(active in the 1530s)

12 *Flagellation*
Tempera on canvas
66 x 50 cm
Acquired: 1962

Nothing is known about the history of this small canvas before it was purchased for the Brera. After being ascribed to an Emilian painter in the circle of Giovan Francesco Maineri, it has recently been associated with the complex painting of the Mantuan court after the death of Lorenzo Leonbruno (no. 15). This attribution is supported by the bizarre perspective, the complicated architecture evoking wholly fantastic antiquity and the vigorous bodies of the torturers.

Venetian painter
(active c. 1480)

13 *Portrait of a Man*

14 *Portrait of a Woman*
Tempera on panel
25 x 18 cm each
Acquired: 1894

These portraits were the recto and verso of the same panel, which had been cut down the middle before it reached the Brera. Both the technique, with great attention being paid to detail, and the style of the clothes suggest an anonymous Venetian artist active in the late 15th century who was also familiar with Flemish painting, as is demonstrated by the format of the portraits.

Lorenzo Leonbruno
(Mantua c. 1477-
Mantua? 1537)

15 *Allegory of Fortune*
Oil on panel
76 x 100 cm
Signed at the bottom
"HEC SI IN ADVERSA QUID IN PROSPERA
LIONBRVNVS PINXISET FORTVNA"
Acquired: 1914

The provenance of this work, which came to the Brera from the Benigno Crespi Collection, is unknown. Executed by Leonbruno around 1523, when he was still court painter in Mantua and was evidently influenced by Mantegna's style, the painting is inspired by Lucian's famous description of the picture of Calumny by the Greek painter Apelles (4th century B.C.). Leonbruno enriches the complex allegory with pessimistic meanings, introducing at top centre the figure of Fortune bestowing money, sceptres and crowns – symbols of worldly success and power – on the negative personifications, while she hurls instruments of torture and imprisonment at the positive allegories. The work has also been interpreted in connection with the fact that the artist was out of favour with the Gonzaga after the arrival in Mantua in 1524 of Giulio Romano, who introduced a much more modern style of painting that reflected the innovations elaborated in Rome in the circle of Raphael. From this point of view, it is significant that Leonbruno's mode was a quasi-archaizing one and, in his choice of monochrome, echoes models by Mantegna.

15

Filippo Mazzola
(Parma c. 1460-1505)

16 *Portrait of a Man*
Oil on panel
44 x 28 cm
Acquired: 1811

Originally in the collection of the Cardinal Cesare Monti, which was bequeathed to the Milan Archbishopric in 1650, this is perhaps one of the finest portraits executed by Filippo Mazzola, born in Parma but strongly influenced by Venetian painting. Particularly noticeable is the sensitive assimilation of the style of Antonello da Messina and the Flemish painters, the influence of the latter being especially evident in the smooth, meticulous reproduction of the details (the sitter's beard, the wart on his nose, the thin strip of fur on his collar), only explicable in terms of a sojourn in Venice during the 1480s.

16

■ Room XXI
15th-century polyptychs from the Marches

Room XXI

Fra Carnevale
1
Girolamo di Giovanni
2
Bartolomeo di Tommaso
3
Alunno (Niccolò di Liberatore)
4
Pietro Alamanno
5
Carlo Crivelli
6 **7** **8** **9** **10**
Vittore Crivelli
11 12 13

The region of the Marches, in Central Italy on the Adriatic Sea, is an excellent example of how the artistic innovations produced in the leading centres – which in the Quattrocento were above all Florence, Padua and Venice – could be transformed by the combination of various influences, by the resistance of a public and patrons who were culturally less up to date and the persistence of local traditions. It is significant that, for the whole of the 15th century, in the Marches there was a prevalence of the altarpiece with a number of panels (the polyptych), often with a gold ground, surrounded by very elaborate frames that, unfortunately, have nearly always been destroyed. In contrast, by the middle of the century, the unified altarpiece – in which the figures of the holy personages stood out in a coherent perspective space delimited by elements of architecture or landscape – had already begun to spread in the other areas.

The works hanging in this room efficaciously illustrate a number of the variants in the painting of the Marches in the second half of the Quattrocento, which in turn is a reflection of the variegated cultural traditions of the region. For a long period, the numerous small states into which the region was divided fostered International Gothic, and only slowly accepted the innovations of the Renaissance. These included the revival of interest in the art of antiquity; geometrical coherence in the representation of space; and the realistic depiction of the facial features and expressions of the personages. In this respect, the places where these new developments were first accepted were Camerino (nos. 1 and 2) and Urbino (room XXIV), where dynasties imbued with humanistic culture ruled, but they did not have an immediate widespread following. By contrast, Carlo Crivelli met with enormous success: a Venetian painter who had trained in Padua, from 1468 onwards he lived and worked in the Marches, painting many masterpieces and, with his distinctive style, influencing numerous less important artists (no. 5), especially his brother Vittore. (E.D.)

Room XXI

Fra Carnevale
(active in Urbino 1445-1484)

1 *St Peter*
Tempera on panel
140 x 48 cm
Acquired: 1903

This painting came to the Brera in the bequest of the collector Casimiro Sipriot. Its original provenance is unknown, although it was certainly part of a polyptych, now dismembered, of which other panels have been identified, such as the one depicting St Francis of Assisi in the Pinacoteca Ambrosiana, Milan. The solid figure confidently occupying the shallow depth of the painting, the firm outlines of the clothes and the realistic details, such as the wrinkles on the face and the gnarled hands are typical features of this artist who trained in Florence, but was later active mainly in his native city, Urbino, where he came into contact with other artists who had been summoned to work at the court, especially Piero della Francesca.

Girolamo di Giovanni
(active in Camerino 1449-1474)

2 Gualdo Tadino Polyptych
Tempera on panel
Lower tier:
Central panel 132 x 60 cm
Side panels 118 x 42 cm

Upper tier:
Central panel 190 x 60 cm
Side panels 154 x 42 cm
On loan from Museo Poldi Pezzoli, Milan, since 1922

It was the Museo Poldi Pezzoli, Milan, that purchased and reassembled the panels which had been scattered as a result of suppressions and sales. The upper tier, which has kept the original frame, was still in the sacristy of the cathedral at Gualdo Tadino, in Umbria, in the early 20th century, while the other panels had already been sold on the antique market in the 19th century. Recently, in view of the contrasting histories of the panels and, above all, because the direction of the light is different in the two tiers, it has been conjectured that this polyptych is, in fact, an assemblage of two separate works that were, however, executed in the same period. Be that as it may, this is one of the most outstanding works by Girolamo di Giovanni; born in Camerino, he was one of the first painters in the Marches to take an interest in the innovations of the Renaissance and, in fact, in 1450 he was documented as being in Padua, then a leading centre of the arts. At the same time, however, he came into contact with the painting of Piero della Francesca, from whom he derived individual motifs and, above all, as this work, datable to before 1462, attests, the simplification of the figures and the shadowless light determining perfect volumes and exalting the abstract colours he had learnt to use in Padua.

Bartolomeo di Tommaso
(Foligno, Perugia 1406/1411-
Roma before 1454)

3 *Virgin of the Sun*
Tempera on panel
121 x 42 cm
Acquired: 1811

In the early years of his career, Bartolomeo di Tommaso often worked in the Marches, the provenance of this work, which was formerly in the church of San Giacomo in Pergola. The subject of the painting, the "Virgin of the Sun", which is typical of the region, alludes to the Immaculate Conception. The ample, soft folds enlivened by the capricious gold border, the mellow colours and the delicate facial features reveal the influence of Late-Gothic Venetian painting, combined with attempts, especially evident in the Child, to render the solidity of the volumes in a convincing manner.

Alunno
(Niccolò di Liberatore)
(Foligno, Perugia c. 1430-1502)

4 *Cagli Polyptych*
Tempera on panel
317 x 274 cm overall
Signed and dated
on the base of the throne
"NICOLAVS FVLGINAS MCCCCLXV"
Acquired: 1811

This polyptych comes from the monastery of San Francesco at Cagli, in the Marches, and is the result of the collaboration between Alunno and his father-in-law, who may have been responsible for some parts of the upper tier. The artist, who was particularly active in Umbria, also executed various works for patrons in the Marches and, in the later part of his career, was influenced by Carlo Crivelli. This work, however, was produced in his early maturity: the solid, simplified figures, which are a reworking of the local Trecento tradition based on the examples of Beato Angelico, coexist with the meticulous representation of the details – such as the flowery meadow on which the saints are standing and St. Louis's velvet cowl – and the pronounced characterization of the faces, with the absorbed, intense expressions typical of this artist.

Pietro Alamanno
(active 1475-1497)

5 *Monterubbiano Polyptych*
Tempera on panel
Central panel (lower tier) 108 x 51.5 cm
Central panel (upper tier) 62.4 x 49.5 cm
Side panels 146.5 x 33 cm
Acquired: 1811

Pietro Alamanno (of Austrian origin) probably visited Padua and Venice, where he would have met Carlo Crivelli and it was perhaps the latter's example that encouraged him to go to the Marches, which he inundated with polyptychs inspired by Crivelli's works. This polyptych comes from Monterubbiano and is the result of the reassembly in the Brera of panels that probably belonged to two different works. The central part, in fact, with the Virgin enthroned and the Resurrection, has features such as the smooth gold ground, that do not correspond with the other panels. The work is, nonetheless, a significant example of Alamanno's painting, which interprets the Crivellesque models by simplifying them, covering them with delicate colours and giving little plastic emphasis to the figures and scant expressiveness to the faces.

Carlo Crivelli
(Venice c. 1430-the Marches 1494/95)

6 *Crucifixion*
Oil on panel
218 x 75 cm
Acquired: 1811

It has been supposed that this panel was the upper pinnacle of a polyptych in the cathedral in Camerino and that it was placed over the *Madonna della Candeletta* (no. 7). This hypothesis is plausible in a number of respects – the perspective and lighting common to both panels, the identical dimensions – but it remains a conjecture. And, in fact, doubt has been cast on it by the fact that when the panel with the Madonna came to the Brera, according to the measurements contained in the *Inventario Napoleonico* (this is the register in which the information regarding the paintings was recorded when they came to the Brera, and is usually reliable), it was twenty centimetres wider. Moreover, the gloomy, stiff figures in the *Crucifixion* stand out against a very detailed landscape instead of a gold ground, as in the other panel. It is, however, interesting to note that the gold in the upper part of the *Crucifixion* is the result of an old restoration and, so far, it has not been possible to ascertain what the original gilding was like.

Carlo Crivelli
(Venice c. 1430-
the Marches 1494/95)

7 Madonna della Candeletta
Oil on panel
218 x 75 cm
Signed under the throne
"KAROLVS CRIVELLVS VENETVS
EQVES LAVREATVS PINXIT"
Acquired: 1811

This painting is the central panel of the huge, very complex polyptych commissioned in 1488 and completed after 1490 (it has been hypothesized that the upper part consisted of the *Crucifixion*, no. 6) that formerly adorned the high altar of Camerino cathedral. Although the stylistic features typical of the artist are still present, the more naturalistic elements of the earlier *Camerino Triptych* (no. 10) have been omitted: the image, perfectly frontal and immobile, is seen from above, accentuating its verticality, and is framed by an improbable bower that exalts the distance and fixity. And this all contributes to the mysterious fascination of this painting, which has always been one of the most popular in the Brera.

Carlo Crivelli
(Venezia c. 1430-
the Marches 1494/95)

8 *Pietà*
Oil on panel
128 x 225 cm

9 *Coronation of the Virgin*
Oil on panel
225 x 225 cm
Signed and dated on a scroll under the throne "CAROLVS CRIVELLVS VENETVS MILES PINXIT MCCCCLXXXIII"
Acquired: 1855

Coming to the Brera as part of the Pietro Oggioni bequest and painted for the church of San Francesco in Fabriano, these panels are the last known works by Crivelli. They bear witness to his artistic coherence because, once again, he juxtaposes passages containing marked naturalistic illusionism – such as the objects placed on the parapet of the tomb in the *Pietà* or the rendering of the drapery – with a spatial structure that cannot be measured because it is without distinctive features and is crammed with figures and decoration. The complex decoration, exaggerated gestures (the intertwining hands of Mary Magdalene and Christ) and unnatural colour have the same aim of heightened, non-naturalistic expressiveness – the sky, for instance, is a solid slab veined with golden clouds.

Carlo Crivelli
(Venice c. 1430-the Marches 1494/95)

10 *Camerino Triptych*
Tempera (?) on panel

Virgin and Child
Central panel 190 x 78 cm

St Peter and St Dominic; St Peter Martyr and St Venantius
Side panels 170 x 60 cm

St Anthony Abbot, St Jerome and St Andrew; St James, St Bernardine of Siena and St Nicodemus
Predella 26 x 62 cm each
Signed and dated under
the Virgin's throne
"OPVS CAROLI CRIVELLI VENETI/ M48II"
Acquired: 1811

This work came to the Brera from the church of San Domenico in Camerino. It was probably at that time that the original frame was lost; this contained other panels in addition to the ones displayed here, and although two of these, depicting the Annunciatory Angel and the Virgin Annunciate, did in fact come to the Brera, they were exchanged for other works and are now in museums abroad. The figures, clearly identified by details and attributes in relief (St Peter's keys, the Virgin's jewels, the blades and hilts of the knives that killed St Peter Martyr), are contoured with sinuous but incisive lines, to which is added the artist's remarkable skill in reproducing materials – for example, the surcoat of voile worn by St Peter – and the predilection, which was certainly shared by the patrons, for glittering decoration. Furthermore, the throne and the dais on which the saints stand are adorned with classicizing motifs and fruit and flowers alluding to the Passion and death of Christ. Although these stylistic features are typical of the artist, it should not be forgotten that this work comes from Camerino, where Crivelli lived for some time. The more up-to-date culture of the court circles and the influence of such painters as Girolamo di Giovanni probably induced him to give a more natural appearance to the work: despite the abstract gold ground, he has conceived a space unified by the marble steps where the personages are portrayed with variety and psychological finesse.

Vittore Crivelli
(Venice 1440?-Fermo,
Ascoli Piceno 1501)

11 *St John the Evangelist*
Tempera on panel
132 x 50 cm
Acquired: 1811

This painting is a panel from a dismembered triptych that may be dated towards the end of the artist's career. In this panel, however, the more nervous and incisive draughtsmanship of some parts – the hands, for example – demonstrates that Vittore had followed the example of his more talented brother, perhaps using his drawings, although, in his works, Carlo's sharper, more dramatic models are transformed into mildly pathetic figures.

Vittore Crivelli
(Venice 1440?-Fermo,
Ascoli Piceno 1501)

12 *St Genesius and St Joachim*
Tempera on panel
134 x 60 cm

13 *St Francis and St Anne*
Tempera on panel
134 x 65 cm
Acquired: 1811

These two panels were certainly the wings of a triptych, the central part of which must have depicted, as was customary, the Virgin and Child. The pale, springlike colours and the simplified folds of the garments worn by the gaunt figures indicate that it is a late work (c. 1497) and thus probably from the Marches, the region where Vittore worked from 1481 to his death.

Room XXII

15th- and 16th-century paintings from Ferrara and Emilia-Romagna

Room XXII

Francesco and Bernardino Zaganelli
1

Niccolò Rondinelli
2 6

Marco Palmezzano
3 4

Francesco Zaganelli
5

Nicolò Pisano
(Niccolò di Bartolomeo dell'Abrugia)
7 8

Geminiano Benzoni
9

Ercole de' Roberti
10

Ludovico Mazzolino
11

Dosso Dossi
(Giovanni di Niccolò Luteri)
12 15

Garofalo (Benvenuto Tisi)
13

Ortolano
(Giovanni Battista Benvenuti)
14

In this room, where there is a masterpiece by Ercole de' Roberti (no. 10), there are further examples of the painting of Ferrara and Romagna. At the end of the 15th century all the most significant artistic output in Ferrara was linked to the court, but, after Ercole de' Roberti left, the local painters (no. 9) limited themselves to dull, uninspired variations on a limited number of themes. It was only at the beginning of the next century – thanks also to the influence of artists from outside the area, such as Boccaccio Boccaccino and Nicolò Pisano (no. 7 and 8) – that a new generation of painters appeared that was capable of producing works of a high standard. Although they did not abandon the Quattrocento tradition of their native city, Ludovico Mazzolino, Ortolano, Garofalo and Dosso Dossi looked elsewhere for inspiration. Favoured in this quest by Alfonso I d'Este's predilection for Venetian painting, they aligned themselves with the tendency, clearly perceptible in the rest of Italy, to recognize Venice and Rome as the centres where the most important innovations were taking place. For all these painters, in fact, the fundamental influence of their early period was, first of all, the painting of Giorgione, then that of Titian, based on colour and atmospheric effect. Each of them was then able to amalgamate this in an original way with Raphael's classicism, which consisted of solid draughtsmanship, constructive symmetry reflecting an ideal of harmony between men and objects, and an intense but composed expressiveness. However, this did not lead to the same achievements. The differences become evident when comparing the works displayed in this room: note, for instance, Dosso Dossi's use of fantastic light effects (no. 12) and the natural tones used by Garofalo (no. 13); or the lively expressiveness of Mazzolino's figures contrasting with the intense composure of Ortolano's ones (no. 14). A somewhat different case was Romagna, an area that, even more than most other regions of Italy, was divided up into small independent states, none of which had a dominant role, either politically or culturally. In this area, the political centre of gravity implied a specific artistic orientation: thus Ravenna, like almost all the cities on the Adriatic coast, was inevitably drawn into the orbit of Venice (nos. 2, 6); Faenza was heavily influenced by Florence; while Forlì, notably during the rule of Girolamo Riario, the nephew of Pope Sixtus IV, was under the sway of Rome (no. 3). Nonetheless, particularly towards the end of the Quattrocento, these tendencies permitted lively and incessant artistic experimentation, which was especially evident in the work of the most outstanding painters (nos. 1, 3, 4). (E.D.)

Francesco Zaganelli
(Cotignola, Ravenna 1460/70-Ravenna 1532)

Bernardino Zaganelli
(Cotignola, Ravenna 1460/70-1509)

1 Virgin and Child Enthroned with St Florian and St John the Baptist
Oil on panel
197 x 160 cm
Signed and dated on the scroll on the base of the throne "YHS Franciscus et Bernardinus fratres cotignolani de Zaga/nelis/faciebant 1499"
Acquired: 1811

This painting was formerly in the church of the Osservanti, dedicated to St Francis, at Cotignola, near Ravenna, where the lunette depicting the *Pietà* that surmounted it is still *in situ*. The first known work by the two artist brothers – who often worked together on the same painting – it attests to their training in the Ferrarese tradition, although this is modified here by the studied symmetry of the composition and mellowed by the softer handling of the colours. The precision of the landscape and a number of sharply outlined draperies, displaying North European influence, indicate that the work was painted exclusively by Francesco – who was later influenced by these models – probably using his brother's drawing.

Niccolò Rondinelli
(active 1495-1502)

2 Virgin and Child Enthroned with St Nicholas of Bari, St Peter, St Bartholomew and St Augustine
Oil on panel
269 x 220 cm
Acquired: 1811

Together with its predella, now scattered among various collections, this painting was formerly in the church of San Domenico in Ravenna. It is a late work by Niccolò Rondinelli, whose training was influenced by the output of Marco Palmezzano, as is demonstrated here by the architecture and grotesque decoration. He also paid particular attention to the work of the Venetian Giovanni Bellini, from whom he derived the overall composition, with the Virgin seated on a high throne, the angels playing musical instruments at her feet and the types of the faces. The hallmarks of his style are the stylized, flattened folds in the drapery, the brilliant colours and the solidity of the volumes.

Marco Palmezzano
(Forlì 1459/63-1539)

3 *Virgin and Child with Saints*
Oil on panel
170 x 158 cm
Signed and dated along the lower edge
"MARCHVS PALMIZANVS FOROLIVIENSE FECERVNT/MCCCCLXXXIII"
Acquired: 1809

Although it is known that this painting was sent to the Brera from Forlì, its exact location in that city is uncertain, since the traditional link with the Confraternita dei Bianchi di Valverde has been refuted. The quality of the execution and the proud signature in letters modelled on Roman inscriptions seem to suggest a fairly prestigious patron, for whom Marco Palmezzano created a majestic and refined painting, its limpid colours applied with dense brushwork using transparent paints. Deriving from the large altarpieces painted for churches in Pesaro by Giovanni Bellini and Marco Zoppa, the clear disposition of the saints around the Virgin makes this one of the most outstanding works by the artist.

Marco Palmezzano
(Forlì 1459/63-1539)

4 *Coronation of the Virgin with St Francis of Assisi and St Benedict*
Oil on panel
160 x 125 cm
Signed on the scroll at the bottom
"... Palmezano/da Forlì..."
Acquired: 1811

Formerly in the church of the Osservanti at Cotignola, near Ravenna, this painting is one of the most outstanding works of the artist's early maturity. The orderly composition with its almost obstinate use of perspective, the clearly modelled figures and objects spread on different planes are derived from Melozzo da Forlì, a painter with whom Palmezzano probably collaborated in Rome. The brilliant enamel-like colours, applied in clear-cut, compact surfaces, which are so different from the vibrant ones seen in the altarpiece of 1493 (no. 3), bear witness to the artist's assimilation – also from a technical point of view – of Venetian painting.

Francesco Zaganelli
(Cotignola, Ravenna 1460/70-Ravenna 1532)

5 *Dead Christ with Two Angels*
Oil on panel
162 x 105 cm
Acquired: 1811

One of Zaganelli's most intense and poignant works, this painting comes from the church of San Domenico at Lugo, near Ravenna, and may be dated around 1515. Because this work is intended to be viewed from below, it has been conjectured that it is the pinnacle panel of a huge polyptych, but it is more likely that, from the outset, it was conceived as an independent altarpiece. The simple composition, with its unadorned, metaphysical space, is exalted by the refinement of the colours, with audacious contrasts of cold tones, violet-greys, warm reds and iridescent oranges, as in the angel on the left.

Niccolò Rondinelli
(active 1495-1502)

6 *St John the Baptist Appearing to Galla Placidia*
Oil on panel
175 x 175 cm
Acquired: 1809

The event portrayed in this painting, which was formerly in the church of San Giovanni Evangelista in Ravenna, is closely related to the history of this building, constructed in the 5th century A.D. by the empress Galla Placidia as an *ex-voto* after she had survived a shipwreck. The empress also wanted to provide the new church with a relic of the saint, who granted her request by appearing to her while she was praying and leaving his right slipper. Executed prior to the altarpiece described above (no. 2), it shows the influence of Venetian painting, especially that of Giovanni Bellini, in whose workshop the painter may have trained, and Vittore Carpaccio.

Nicolò Pisano (Niccolò di Bartolomeo dell'Abrugia)
(Pisa 1470-1538)

7 Virgin and Child with St James of Galice and St Helen
Oil on panel transferred to canvas
225 x 173 cm
Acquired: 1811

This painting was commissioned between 1512 and 1514 by the confraternity of the Battuti Neri for the high altar of the oratory of Santa Maria Annunziata in Ferrara, where a relic of the True Cross was kept, which explains the presence of St Helen.
By the beginning of the 16th century the simple, symmetrical compositional scheme of this picture must have appeared somewhat dated, but it harmonizes perfectly with the intense, albeit composed, expressiveness of the figures, one of the typical features of this painter's output.

Nicolò Pisano (Niccolò di Bartolomeo dell'Abrugia)
(Pisa 1470-1538)

8 *Virgin and Child*
Oil on panel
40 x 33.8 cm
Acquired: 1904

It is only recently that this small panel painting, datable to around 1510, has been attributed to Nicolò Pisano, who was active in Ferrara at the end of the 15th century and a protagonist of the renewal of the city's artistic output under the twofold influence of the new Venetian painting and that of Raphael. The former mode is evident in the landscape, constructed with warm colours imbued with light, while the solid, yet very gentle, figure of the Virgin is derived from Raphael's Florentine Madonnas.

Geminiano Benzoni
(active in Ferrara 1489-1513)

9 *St Paul*
Oil on panel
52 x 37 cm
Acquired: 1932

A member of a family of craftsmen and painters, this artist – by whom there are only very few known works – is documented as working in Ferrara in the late 15th and early 16th centuries. This painting of St Paul, with its sumptuous, deep enamel-like colours and its refined details, is an excellent example of the style that was in vogue in the city in this period. The artist has inherited the tradition of the three leading Ferrarese artists of the Quattrocento – Cosmè Tura, Francesco del Cossa and Ercole de' Roberti (especially the latter) – but his is a toned-down legacy, deprived of its expressionistic features and updated with the meticulous treatment of the landscape, reminiscent of Flemish painting, and the classicizing composure of the saint.

Ercole de' Roberti
(Ferrara c. 1450-1496)

10 *Virgin and Child with St Elizabeth, St Anne, St Augustine and the Blessed Pietro degli Onesti*
Oil on canvas
323 x 240 cm
Acquired: 1811

This painting, formerly in the church of San Francesco in Ravenna, was executed between 1479 and 1481 for the high altar of the church of Santa Maria in Porto Fuori in the same city, where the Canonici Lateranensi officiated, and it is to them that the two saints at the sides of the throne refer. St Augustine was, in fact, the patron of the Canonici, while Pietro degli Onesti was their founder. According to legend, it was the Blessed Pietro who built the church of Santa Maria in Porto Fuori as an *ex-voto* for having survived a storm while he was sailing on a ship off the coast near Ravenna. Thus the sparkling seascape, against which the columns supporting the throne stand out, probably refers to this episode. In this work, which is important not only for its excellent quality but also because it is the only properly documented work by Ercole de' Roberti, the painter achieves a remarkably balanced result. This is stressed by the symmetrical composition, where a number of features are typical of both de' Roberti's output and Ferrarese painting in general: the expressionistic tension, which is present here above all in the visionary figures peopling the bas-reliefs adorning the architecture, or the masterly way in which the artist accurately renders the materials and the highlights on such fantastic objects as the marble columns supporting the dais on which the throne stands, allowing us to see the landscape in the distance.

Room XXII 207

Ludovico Mazzolino
(Ferrara c. 1480-c. 1528)

11 *Raising of Lazarus*
Oil on panel
38.5 x 50.5 cm
Dated bottom right 1527
Acquired: 1914

Although this work had belonged to various private collections before it was purchased by the Brera on the occasion of the sale of the Crespi Collection, its original provenance is unknown. The date indicates that it is one of the last works by Mazzolino, who executed a number of panel paintings of this size during the final phase of his career. In all these pictures the artist combined a soft, yet intense, palette with an illuminator's attention to detail and a capacity to invent unconventional images. In this case, unusually, Lazarus is being removed from a cistern rather than the traditional cave, while the gravity of the gestures of the Apostles contrasts with the exaggerated poses of the group on the left.

**Dosso Dossi
(Giovanni di Niccolò Luteri)**
(Modena 1473/74-Ferrara 1542)

12 *St Sebastian*
Oil on panel
182 x 95 cm
Acquired: 1808

This painting, formerly in the church of the Santissima Annunziata in Cremona, may be dated around 1526. Not only was Dosso Dossi one of the most outstanding painters at the Ferrarese court but he also played a leading role in North Italian art, paying close attention to its most significant developments and interpreting them in his own original style. In this case, there are evident echoes of Raphael's refined and imposing late manner as it had been diffused by his pupils, especially Giulio Romano, (who since 1524 had been working in Mantua), and this harmonizes with a style that is closely linked to Venetian painting. These elements are recognizable in the Brera picture: evoking glowing light and softness, the paint lends remarkable naturalness to such passages as the tree to which the saint is bound and the still life constituted by the arms at his feet, or else it gives the appearance of living flesh to the saint's splendid naked body, which is, however, enclosed by very elegant contours and stands in a contrived pose, the artificiality of which is heightened by the capricious fluttering of the mantle.

Garofalo (Benvenuto Tisi)
(Ferrara c. 1476-Ferrara 1559)

13 *Lamentation over the Dead Christ*
Oil on panel
300 x 166 cm
Signed and dated on the stone under St John's feet "MDXXVII AG. BENVENVTO GAROFOLO"
Acquired: 1811

This painting, formerly located on the high altar of the church of Sant'Antonio in Polesine in Ferrara, constitutes one of the greatest achievements of this artist, considered to be the "Ferrarese Raphael" by the local art historians because, after his youthful enthusiasm for the painting of Giorgione, in common with the other painters of his generation, a journey to Rome around 1513 brought him under the influence of Raphael's style.

In this painting the composed rhythms and the monumental forms are derived from the study of Raphael's works. These are, however, interpreted superficially and rendered in a somewhat mechanical manner: the figures are all crowded into the foreground and symmetrically flank the central group constituted by Christ and the Virgin, but this awkward disposition is redeemed by the remarkable way colour is used, with refined contrasts and subtle variations: note the accords of yellow and blue in the figure on the extreme left, Mary Magdalene's robe in the centre, brightened by an orange scarf, and the different tones of white in the Virgin's hairstyle.

Ortolano
(Giovanni Battista Benvenuti)
(Ferrara c.1487-after 1527)

14 *Crucifixion with the Virgin and St John the Baptist, St John the Evangelist, St Mary Magdalene and St Augustine*
Oil on panel
258 x 176 cm
Acquired: 1905

This painting, executed for the church of the monastery of Sant'Agostino in Ferrara, belonged to various private collections before it came onto the art market, where it was purchased by the State for the Brera Gallery. The intense colours, clearly separated by the light and shade, project the figures depicted with only a few simple planes against the luminous sky, and they are accompanied by eloquent but immobilized gestures, thus lending an unmistakable tone to a composition that, like all those datable to the early 1520s, is deeply influenced by Raphael's work. However, Ortolano interprets this as a model of an inner restraint and simplicity, and in a less exterior manner than his contemporary, Garofalo.

Dosso Dossi
(Giovanni di Niccolò Luteri)
(Modena 1473/74-Ferrara 1542)

15 *St John the Baptist; St George*
Oil on panel
163 x 48 cm each
Acquired: 1904

These two panels were the wings of a triptych in the oratory of the Sacramento at Massa Lombarda, near Ravenna. However, since the features of Francesco d'Este, signore of the small town from 1535 onwards and munificent patron of the church of San Paolo, have been recognized in St George's face, it is possible that the painting by Dossi – then the most celebrated painter in the Ferarra area – was originally intended for this building. These late works, characterized by sculptural forms stressed by strong chiaroscuro and artificial positions, bear witness to the fact that the artist was aware of developments in Roman painting thanks to pupils and followers of Raphael (room XXVII).

Room XXIII
16th-century paintings from Emilia-Romagna

Room XXIII

Correggio (Antonio Allegri)
1 **3**

Michelangelo Anselmi
2

**Francesco Francia
(Francesco Raibolini)**
4

This room is almost entirely occupied by one of the two storerooms in the museum viewable from the exterior. In these, from 1982 onwards, paintings and frescoes that cannot be displayed due to lack of space or the need for restoration, or while rebuilding work is underway, have been placed on sliding frames. At present 640 works are stored in these rooms; about a quarter of these – including the frescoes by Bergognone, Luini and Bramante, and the Lombard and Piedmontese paintings of the 15th and 16th centuries – will be displayed in the rooms adjacent to the Napoleonic rooms that are due to reopen in the next few years.

In the limited space remaining, which is little more than a corridor – although it has kept the old room number – several Emilian paintings of the early Cinquecento are exhibited. These include a late work by Francesco Francia (no. 4) testifying to the influence of the religious sentimentalism and composed modes of Pietro Perugino in Emilia; two rare examples of Correggio's early output (nos. 1 and 3), painted a few years before he decorated the Camera di San Paolo in Parma, the artist's first major commission, from which his fame as the innovator of Italian painting in the early Cinquecento derived; and a work by Michelangelo Anselmi (no. 2), based on the *maniera moderna*, in which there are echoes of the elegance of Correggio and Parmigianino. (L.A.)

Correggio (Antonio Allegri)
(Correggio, Reggio Emilia 1489-1534)

1 *Nativity with St Elizabeth and the Infant St John the Baptist*
Oil on panel
79 x 100 cm
Acquired: 1913

Purchased in Paris at the auction of the Benigno Crespi Collection, this painting belonged to the famous Ludovisi Collection in Rome in the 17th century. Datable to 1512-13, when the artist was in Mantua, it is one of the most interesting works of his early period, showing the influence of Mantegna, his favourite artist at that time, from whom he borrowed the figures of St Elizabeth and St Joseph; Dosso Dossi and Giorgione, who inspired the view of the landscape; Leonardo, who gave him the idea of immersing the figures in a "soft and profound" chiaroscuro, as the critic Roberto Longhi described it; and also his fellow-countrymen Lorenzo Costa and Garofalo, from whom he derived the tender, sentimental Virgin and the compositional scheme.

Michelangelo Anselmi
(Lucca or Siena 1491/92-
Parma 1554/56)

2 *St Jerome and St Catherine of Alexandria*
Oil on canvas
155 x 110 cm
Acquired: 1901

This painting was probably commissioned by a private citizen for the chapel of the Concezione in the church of San Francesco del Prato in Parma, where, in 1532-35, Anselmi had painted an important fresco cycle. This work is a perfect synthesis of the two major components in the artist's painting: his training in Siena with Sodoma, which is apparent in the choice of warm, vibrant colours and his taste for movement; and the influence of the leading local painters, Correggio and Parmigianino, from whom he derived the landscape, the foreshortened figure of the saint and the diagonal, unbalanced composition.

Correggio (Antonio Allegri)
(Correggio, Reggio Emilia 1489-1534)

3 *Adoration of the Magi*
Oil on canvas
84 x 108 cm
Acquired: 1895

This painting was formerly in the collection of the Cardinal Cesare Monti that was bequeathed to the Milan Archbishopric, where it was ascribed to Scarsellino. It was the art historian Bernard Berenson who, when the work came to the Brera, first attributed it to Correggio. It is an early work, dated, with some uncertainty, 1515-18, and reflects the artist's interest in the Emilian "Proto-Mannerists" – Dosso Dossi, Amico Aspertini, Leonbruno, Ludovico Mazzolino and Garofalo – from whom were derived the rotary, tortuous movements of the figures (the Magi, first and foremost), the soft and misty, vaguely Leonardesque, landscape and the oblique, asymmetrical composition.

Francesco Francia (Francesco Raibolini)
(Bologna c. 1450-1517)

4 *Annunciation*
Tempera and oil on panel
transferred to canvas
237 x 227 cm
Acquired: 1811

As is stated in his will made in 1505, the physician Antonio de Grado commissioned this painting for the chapel of the Santa Annunciata in the church of San Francesco in Mantua, and, because of his standing, the artist chosen for the task was Francesco Francia, who had been invited to work at the court of the Gonzaga by the marquise Isabella. Balanced and solemn, yet simple, this large painting pays homage not only to Perugino and his fervent, albeit deferential, piety, but also to the Central Italian classicism of the early Cinquecento.

Room XXIV

Piero della Francesca
1

Luca Signorelli
2 3

**Donato Bramante
(Donato di Pascuccio d'Antonio)**
4

Raphael (Raffaello Sanzio)
5

The artists who painted the works displayed in this room are all, in one way or another, linked to Urbino, the city in the Marches where one of the most original variants of the Renaissance developed. Piero della Francesca's *Brera Altarpiece* (no. 1) was painted for Urbino; Bramante and Raphael (nos. 4 and 5), who were certainly familiar with this work, were born in or near Urbino; Luca Signorelli (nos. 2 and 3), who was a pupil of Piero in the 1460s, was then greatly influenced by the cultural milieu of Urbino.

After he became signore of the city in 1444, Federico II da Montefeltro, condottiere and far-sighted connoisseur of the letters and the arts, surrounded himself with artists and intellectuals, creating a refined court where particular attention was paid to mathematics and architecture. Piero della Francesca was, in fact, the outstanding cultural figure in the city: spatial coherence and perspective rigour are two of the distinctive features of Piero's painting.

In the altarpiece he painted for the duke – and this is the work's great innovation – he places a group of figures in an organically depicted interior, closely linking the architecture to the figures. With their disposition, the figures echo the curve of the apse and have a rhythm similar to that of the marble panels covering it. The simplification of the figures, with an absence of emphatic gestures or expressions is also very typical of his work, as is the attention paid to the light. In Urbino, however, the leading role was played by the Montefeltro: it was Federico who guided the artistic and cultural choices, inviting figures that were most congenial to him; these even came from abroad, as in the case of the Flemings, experts in oil painting, which he particularly admired for its versatility: by placing one transparent layer of colour on the other the subtlest variations of lights and surfaces could be achieved. In this way he favoured cosmopolitan culture, but not the formation of a local school, and, in fact, Bramante, who grew up in this milieu, went to work elsewhere, firstly in Lombardy then in Rome, and, after the death of the duke, Urbino lost its role of cultural pre-eminence. (E.D.)

Piero della Francesca
(Sansepolcro, Arezzo 1415/20-1492)

1 *Brera Altarpiece (The Virgin and Child with St. John the Baptist, St Bernardine of Siena, St Jerome, St Francis of Assisi, St Peter Martyr and St John the Evangelist, Four Angels and Federico da Montefeltro)*
Tempera and oil on panel
251 x 172 cm
Acquired: 1811

This painting comes from the church of San Bernardino in Urbino, built by Federico da Montefeltro to house his tomb. Although it is not known what its original function was, the work evidently has a commemorative character that is particularly suited to a tomb, because it depicts the homage of the donor to the Virgin. In fact, the painting is open to a variety of interpretations. One of the most favoured is that it was executed in 1472 to commemorate the birth of the longed-for male heir and the death, a few months later, of Federico's wife, Battista Sforza. Thus mother and son are portrayed as the Virgin and infant Christ, while the ostrich egg hanging in the shell of the apse alludes to fertility and the miraculous maternity of the Virgin. According to other scholars, however, the presence of the saints with a marked penitential character suggests a personal invocation for mercy by the duke that was specially conceived for his tomb, particularly because, in the Middle Ages, the ostrich egg was the symbol of the divine grace that converts and saves.

In this later work – especially thanks to his sound grasp of the techniques of the Flemings, who painted by applying layers of transparent colour – Piero renders the lustre and diverse textures of the surfaces with sensitivity: note, for instance, the jewels worn by the angels, Federico's armour and the lambskin lining of the Virgin's mantle.

But, in any case, it is an abstract, still light that bathes forms and materials without rendering the vibration of the atmosphere or stressing excessively minute details. In this altarpiece, the distance between Italian and Flemish painting is illustrated by Federico's hands, painted in a very realistic manner by an artist who has been identified as Pedro Berruguete (room V, no. 2)

Luca Signorelli
(Cortona, Arezzo c. 1445-1523)

2 Virgin and Child

3 Flagellation
Tempera on panel
84 x 60 cm each
Signed on the entablature of the architecture "LVCE CORTONENSIS"
Acquired: 1811

These works – which had already been separated when they came to the Brera – were painted on the opposite sides of the same panel, originally the processional banner of the confraternity of the Raccomandati di Santa Maria del Mercato in Fabriano (the Marches). The link with a confraternity, the charitable functions of which included the care of foundlings and which practised self-flagellation, explains the choice of subjects. Signorelli, a pupil of Piero della Francesca who was influenced by the Florentine painting of the second half of the Quattrocento, made the banner after a valuable encounter with the art of Urbino, including its Flemish elements, in which particular attention was paid to naturalistic detail and the use of light effects to lending vividness to the various materials.

In the *Flagellation*, the diffused light, the classicizing architecture and the figure of Christ, the immobile centre of the scene that is stressed by his tormentors and their intertwining shadows, show the influence of Piero della Francesca, while the dynamism of the human figures, delineated with a supple contour, are the result of Signorelli's own interpretation of the painting of Pollaiuolo and Botticelli.

Donato Bramante
(Donato di Pascuccio d'Antonio)
(Monte Asdruvaldo, Fermignano, Urbino 1444-Rome 1514)

4 Christ at the Column
Oil (?) on panel
93.7 x 62.5 cm
On loan from the Abbey of Chiaravalle since 1915

Although the painter and architect Bramante was certainly influenced by the art of Urbino, especially the experimentation with architectural elements and perspective of which the *Brera Altarpiece* is an outstanding example, there are no works of his known to have definitely been executed in Urbino. When he was nearly thirty years old, having made a name for himself as a painter, he moved to Lombardy, where he stayed until 1499. He probably painted this work, which is, in effect, the recapitulation of various important artistic developments, shortly after 1490. The image is illusory, appearing to reach out towards the spectator, and it combines the spatial illusionism that the artist had learnt to use in his youth in Urbino with the experimentation into the human anatomy carried out by Leonardo, who was also in Milan in this period. The result is an imposing sculptural figure, its forms thrown into relief by the light, but in it there are surprisingly naturalistic details, such as the bruises, the arm pressed by a rope and the transparent tears trickling between the glossy hairs of the beard. According to some studies, the landscape seen beyond the pyx standing on the windowsill, with the sea on which strange craft sail, alludes to the landing of the Turkish fleet at Otranto in 1480, and the scourged Christ personifies the suffering of the Church in the struggle against the infidels.

Raphael (Raffaello Sanzio)
(Urbino 1483-Rome 1520)

5 *Marriage of the Virgin*
Oil on panel
170 x 118 cm
Signed and date on the temple
"RAPHAEL VRBINAS/MDIIII"
Acquired: 1805

This famous painting, originally in the chapel of St Joseph in the church of San Francesco in Città di Castello, was sold to the Brera by the Ospedale Maggiore in Milan. Raphael, the son of Giovanni Santi, a painter and habitué of Federico da Montefeltro's court, grew up in a very cultured and stimulating environment and, at an early age, he was apprenticed to Perugino, one of the leading painters of the day. Although this work is derived from a painting by his master having a similar subject, it bears witness to the independence and maturity of the young pupil. The scene depicted is the one narrated in the New Testament Apocrypha of the marriage between Mary and Joseph, decided after his rod miraculously flowered.

The composition is only apparently simple. The lines parallel to the short ends of the rectangles forming the pavement of the square reach the corners of the steps forming the basement of the temple and, if extended they converge on the open door through which the landscape is visible. In this way, the building becomes the pivot of a huge circular space. The main group of figures is, in its turn, disposed in a semicircle, thereby balancing the pattern formed by the architecture, while the single groups of male and female figures seem to mirror each other, especially as regards their colours, in a deliberate alternation of warm colours (reds and yellows) and cold ones (blues and greens). However, this does not lead to monotony, and, in fact, the positions are slightly varied and each figure is effectively portrayed. Raphael derived the balanced composition founded on precise mathematical ratios and the imposing architecture from the artistic tradition of Urbino, although in Città di Castello he had the chance to see numerous works by Signorelli, animated by vigorous figures that certainly made a strong impression on him. For example, the young man breaking his rod in the foreground derives from a work by Signorelli for that city.

Room XXVII
The painting of Central Italy in the 15th and 16th centuries

Room XXVII

Gaspare Sacchi
1

Timoteo Viti
2

Girolamo Genga
3

**Perino del Vaga
(Piero di Giovanni Bonaccorsi)**
4

**Bronzino
(Agnolo di Cosimo
di Mariano Tori)**
5

Giovanni Antonio Sogliani
6

**Francesco Salviati
(Francesco de' Rossi)**
7

Closely linked to the previous room, the paintings here illustrate, on the one hand, the precocious influence exerted by Raphael (nos. 1 and 2) and, on the other, the diffusion of the style that had developed from the second decade of the 16th century onwards in Rome, where artists were summoned from all over Italy to work on projects commissioned by both the popes and wealthy private patrons. These schemes provided opportunities for trying out new themes and new modes of artistic expression that were stimulated by the dominant figures of Michelangelo, Bramante and, above all, Raphael (nos. 3 and 4).

In fact, from 1508 until his death in 1520, Raphael lived in Rome and, in order to cope with numerous prestigious commissions, he organized an efficient workshop where very talented artists realized their master's ideas, completely assimilating his style. After the death of Raphael and the Sack of Rome in 1527 by the mercenary troops of the emperor Charles V, the adversary of the papacy, the majority of these artists were dispersed to various Italian centres, thus spreading the *maniera* (a word that is virtually a synonym of style) that had developed in Rome in this period of great ferment. This *maniera* originated from a profound study of the art of antiquity and the self-assured use of the styles of the leading masters. These were mixed together and combined with personal inventions, or else they were used in a new way that was remote from the naturalness and rationality that were among the fundamental norms that the artists of the Quattrocento and early Cinquecento learnt to respect.

In this way, the differences between the various regional schools of painting, hitherto very evident, gradually diminished. But, in the case of a number of artists – for instance, Bronzino (no. 5) – this free yet turbulent experimentation was replaced by an excessively refined style, the main features of which were affected poses, superb draughtsmanship and unnatural colours applied with a smooth, enamel-like surface, which, in the course of time, in the hands less gifted artists using repetitive formulae, was destined to fall into decline. (E.D.)

Gaspare Sacchi
(Imola, Bologna, active 1517-1536)

1 *Adoration of the Magi*
Oil on canvas
265 x 190 cm
Signed and dated on the step at the feet of the Holy Family
"IVSSV IOANNIS/BAPTISTAE BVTRI/GARII GVASPAR/SACCVS PINGEBAT/M.D.XXI"
Acquired: 1811

This altarpiece, which was originally in the Bottrigari Chapel in the church of San Francesco in Bologna, is an excellent illustration of the complex artistic culture of this little-known artist, who combines his direct knowledge of Raphael's works in Emilia with ideas derived from prints (in this case, especially the figure of the beggar in the foreground) and the intellectualistic bizarreness of early Tuscan Mannerism. This is particularly evident in the fantastic architecture crowded with small insubstantial figures and the choice of intense iridescent colours contrasting with the dark shadows.

Timoteo Viti
(Urbino 1469-1523)

2 *The Virgin Annunciate with St John the Baptist and St Sebastian*
Oil on panel
260 x 182 cm
Acquired: 1811

This painting comes from the church of San Bernardino in Urbino, where Piero della Francesca's *Brera Altarpiece* (room XXIV, no. 1) was formerly located. Timoteo Viti trained in the Bolognese workshop of Francesco Francia (room XXIII, no. 4), but, in this work, datable to around 1515, he combines the simple, balanced composition, tender expressions and composed gestures derived from his master with the unusual monumentality and sculptural emphasis he had discovered in the works of Raphael.

Girolamo Genga
(Urbino c. 1476-1551)

3 *Disputation over the Immaculate Conception*
Oil on panel
438 x 290 cm
Acquired: 1809

This huge painting came to the Brera from the church of Sant'Agostino in Cesena, in Romagna. A few months previously, three panels from its predella, depicting scenes from the life of St Augustine, had also arrived, but they were later exchanged for other works. They were only some of the parts of an extremely complex polyptych that comprised a pinnacle panel representing the Annunciation, an elaborate painted frame and two figures of Augustinian saints, unfortunately lost. The subject of this painting is complicated and unusual: God the Father looks down on a group formed by the Virgin, the Child, the infant St John the Baptist and six saints, at whose feet sit the four Doctors of the Church, engaged in their disputation over the dogma of the Immaculate Conception.

The altarpiece was executed between 1516 and 1518 by Girolamo Genga, a painter, architect and stage-designer who, in his youth, had been a pupil of Luca Signorelli. After a period spent in Tuscany he came into contact with the very lively Roman artistic milieu of the early Cinquecento, where Bramante, Raphael, Michelangelo and a number of North Italian painters such as Lotto and Bramantino (rooms XIV and XV) were all working at the same time. Genga assimilated ideas from this varied artistic experience, and this painting is virtually a very personal summary of the most up-to-the-minute Italian painting of the period. The scene, set in a deep but not clearly identifiable interior, is animated by solidly sculptural, eloquent figures, wrapped in loose draperies revealing the attention that the artist had paid to Raphael. By contrast, the anatomical details and faces with affected expressions are derived from Leonardo's research into various facial types and the expression of the sentiments. The views of the groups of angels above, the colour rich in iridescence, the agitated but elegant rhythm with which the gestures respond to each other and the dramatic appearance of God, lend a tone of bizarre affectation to the picture.

Perino del Vaga
(Piero di Giovanni Bonaccorsi)
(Florence 1501-Rome 1547)

4 *Crossing of the Red Sea*
Oil on canvas
118 x 201 cm
Acquired: 1826

Purchased as a work by Polidoro da Caravaggio, this painting has had a very confused history. Only after its recent restoration has it been possible to ascertain that it is an original work by Perino del Vaga, who, in 1522, executed it with remarkable virtuosity "in a day and a night", as Vasari wrote, for a chaplain of the church of San Lorenzo in Florence who had generously offered him hospitality.

After training in Florence, Perino del Vaga, when still very young (in 1517), was apprenticed to Raphael, with whom he participated in important schemes that had a significant effect on his later development. In this splendid example of the very elegant painting of this artist – who, with rapid brushstrokes of just a few colours sketches out fluid, artificially posed figures – the idea of simulating a bronze bas-relief with paint derives from Raphael.

Bronzino
(Agnolo di Cosimo di Mariano Tori)
(Florence 1503-1572)

5 *Portrait of Andrea Doria as Neptune*
Oil on canvas
115 x 53 cm
Acquired: 1898

Paolo Giovio, a writer and collector from Como, probably commissioned the work around 1530 directly from the artist for his gallery of portraits of illustrious men. The painting, purchased from Giovio's heirs, represents, in fact, the famous Genoese admiral, portrayed here half-naked with a trident like Neptune, the god who ruled the sea. This cultured choice of subject matter reveals an intellectualistic celebratory purpose, which is confirmed by the style of the portrait: static and refined, it echoes Michelangelo's *Moses*, but transforms the unease of the sitter into cold, confident composure. Bronzino's painting, with its sharp, graphic manner, contributes to this transformation, precisely delineating his anatomy, facial features, hair and the minutest details of his flowing beard.

Giovanni Antonio Sogliani
(Florence 1492-1544)

6 *St Catherine of Alexandria*
Oil on panel
82 x 67 cm
Signed on the base of the column on the right
"JOHANNES/ANTONIVS/FACIEBAT"
Acquired: 1978

This work was purchased on the London art market. The monumental figure of the saint, flanked by the solid bases of the columns, is an excellent example of Sogliani's modest but formally impeccable painting. Because of their clear symmetry, his figures – "honest, easy, sweet and graceful", as Vasari wrote – were a model for the Florentine painters most committed to following the decrees of the Council of Trent requiring sacred paintings to be immediately comprehensible.

Francesco Salviati (Francesco de' Rossi)
(Florence 1510-Rome 1563)

7 Lamentation over the Dead Christ
Oil on canvas
322 x 193 cm
Acquired: 1811

This painting was formerly located in the church of the monastery of Corpus Domini in Venice and was executed during the artist's brief sojourn (in 1539-40) in the city. Salviati did not ever directly encounter Raphael, but, when he reached Rome from Florence in 1531, he studied his works and was in contact with the circle of his pupils and assistants. At the same time, he was also influenced by works of Michelangelo, developing a style with sophisticated compositions and choices of colours.

The present painting, executed with the assistance of Salviati's pupil Giuseppe Porta in a number of the heads in the background, is characterized by careful drawing that clearly outlines the figures arranged in elegant poses – while their faces and clothes are also elegant – and, above all, colours juxtaposed with particular finesse: the whites and roses with which Mary Magdalene is dressed, the angel's iridescent robe and the accords of violets, greys and dull greens setting off the pale body of Christ.

XXXIII	XXXI	XXX	XXIX	**XXVIII**	XXVII	XXIV	XXIII	
XXXII								

Room XXVIII

Federico Barocci
[1]

Ludovico Carracci
[2] [3] [8]

Annibale Carracci
[4]

Francesco Gessi
5

Antiveduto Gramatica
6 7

**Guercino
(Giovan Francesco Barbieri)**
[9]

Guido Reni
[10]

The reaction to the Late-Mannerist formalism of the Roman and Tuscan schools of Vasari, Salviati and the Zuccari took place in Bologna, as did the birth of the new classicism. The latter sought to return to naturalistic realism – in contrast with artistic licence, abstraction, excessive refinement – but also to decorum and rules, without, however, renouncing sentiment, emotions and the sensuality of the soft, warm colours deriving from the Venetians as well as Correggio and Barocci (an outstanding, albeit eccentric, presence in this room, together with Antiveduto Gramatica). In the late 16th and early 17th centuries, Bologna was the second city in the Papal States: here Ludovico Carracci and his cousins Agostino and Annibale, all exceptional artists, exerted an enormous influence over the art of the 17th century, offering their contemporaries a style that was even more incisive and successful than that of Caravaggio, and paving the way for both the Baroque and classicism.

The artistic reform of the Carracci was elaborated in numerous fresco cycles, altarpieces, pictures for private patrons and precursory genre pictures, and was put to good use by their heirs – Guido Reni, Domenichino, Francesco Albani and Guercino, to mention just the leading names – who were considered, from the 17th century until the mid-19th century, true artistic geniuses. In fact, in his *Storia pittorica d'Italia* (1795/96), Luigi Lanzi, interpreting the current opinion, noted that "to write the history of the Carracci and their followers is tantamount to writing the art history of the whole of Italy in the last two centuries". The change in taste linked to Romanticism led to a decline in interest in the great Emilian school of the Seicento, which for almost a century was neglected by scholars, collectors and the wider public, and was only rehabilitated after the Second World War. (L.A.)

Federico Barocci
(Urbino 1528-1612)

1 *Martyrdom of St Vitalis*
Oil on canvas
302 x 268 cm
Signed and dated lower right
"FEDERICVS BAROCIVS/
VRBINAS P.A.D. M.DLXXXIII"
Acquired: 1811

Although this monumental painting was commissioned in 1580 by the Cassinesi monks for the basilica of San Vitale in Ravenna, Federico Barocci did not complete it until 1583. A work of fundamental importance for the development of Bolognese painting in the Seicento, it is dense and crowded, with a deliberate mixture of the high tones of lofty formal oratory and low notes taken from everyday life, while the light, bright colours draw attention to the essential elements of the narrative.

Ludovico Carracci
(Bologna 1555-1619)

2 *Adoration of the Magi*
Oil on canvas
260 x 175 cm
Signed and dated on the base
of the throne on the right
"Lud. Car. Bon. A.D. MDCXI"
Acquired: 1809

Executed towards the end of the artist's career, this work pays homage to Venetian painting and its dense colours. Despite its conventional composition, it is imbued – as the art historian Francesco Arcangeli noted in 1970 – with "nostalgic, nocturnal sadness" that invites the spectator to take part in meditative devotion, in accordance with the painter's religious and artistic beliefs.

Ludovico Carracci
(Bologna 1555-1619)

3 *Christ and the Canaanite Woman*
Oil on canvas
170 x 225 cm
Acquired: 1811

Executed for the Palazzo Sampieri in Bologna, where Ludovico, together with Annibale and Agostino, worked on a fresco cycle in 1593 and 1594, this painting was commissioned with two other canvases – *Christ and the Samaritan Woman* by Annibale (no. 4) and *Christ and the Woman Taken in Adultery* by Agostino (at present not on display). Refined and classicizing, the painting – in which the gestures have a noble and rhetorical ring – contains echoes of Venetian and Lombard painting, perceptible in the landscape and the feeling of participation in the event.

Annibale Carracci
(Bologna 1560-Rome 1609)

4 *Christ and the Samaritan Woman*
Oil on canvas
170 x 225 cm
Acquired: 1811

Formerly in the Palazzo Sampieri in Bologna – which, with its well-stocked picture gallery and frescoes, was, for the whole of the 17th and 18th centuries, an obligatory port of call for every cultured traveller – this painting was sold, together with other works, some of which are displayed in this room (nos. 3, 9, 10), to the Brera at the beginning of the 19th century by an heir to the Sampieri estate in financial difficulties. Executed with the great facility and the rich style characterizing Annibale's output, this painting, with its intense colour and the splendid invention of the landscape, belongs to the neo-Venetian period of his career, shortly before his departure for Rome at the end of 1595.

Francesco Gessi
(Bologna 1588-1649)

5 *Virgin and Child with St Lawrence, St Nicholas and St Frances of Rome*
Oil on canvas
238 x 153 cm
Acquired: 1809

Ascribed either to the early part of the artist's career, before 1520, or to the mid-1530s, the painting, which comes from the church of Santa Maria dei Poveri at Crevalcore, north of Bologna, is one of the very few works by this artist displayed in a public collection. For this reason, it has become the best-known painting by Gessi, a faithful assistant of Guido Reni, in whose wake he carried out most of his activity.

Antiveduto Gramatica
(Siena 1571-Rome 1626)

6 *Concord (St Cecilia with St Tiburtius and St Valerian)*

7 *Reason (The Disputation of St Catherine of Alexandria)*
Oil on panel
Diameter 70 cm
Acquired: 1855

For years, these two tondos, which came to the Brera with the rich and varied Pietro Oggioni bequest, were ascribed to Lucio Massari, a pupil of Ludovico Carracci, but, in the seventies, the art historian Federico Zeri attributed them to Antiveduto Gramatica or his son Imperiale, transferring them from the Emilian milieu to the Roman one. The religious interpretation of the subjects is a recent suggestion.

Ludovico Carracci
(Bologna 1555-1619)

8 *The Sermon of St Anthony Abbot to the Hermits*
Oil on canvas
320 x 210 cm
Acquired: 1809

Executed for the high altar of the church of Sant'Antonio in Bologna, this huge altarpiece, which was much admired in the 17th and 18th centuries, is now gloomier than it must have been originally, due to the emergence of the brown underpainting; this painting is one of the most impressive – and most inspired – works of Ludovico Carracci's late period. After being on long-term loan elsewhere, it was returned to the gallery and restored, and has been on display here since 1987.

Guercino
(Giovan Francesco Barbieri)
(Cento, Ferrara 1591-Bologna 1666)

9 *Abraham Driving out Hagar and Ishmael*
Oil on canvas
115 x 152 cm
Acquired: 1811

This painting, a celebrated example of the classicism of the Bolognese school in the Seicento, was commissioned in 1657 by the municipality of Cento (Ferrara), which intended it to be a gift for Cardinal Lorenzo Imperiali, the papal legate in Ferrara. In the mid-18th century it could be admired in the Sampieri Collection in Bologna. With its clear and simple poses, gestures, colours and spatial relationships, it is an excellent example of the lighter-toned works of the artist's last period.

Guido Reni
(Bologna 1575-1642)

10 *St Peter and St Paul*
Oil on canvas
197 x 140 cm
Acquired: 1811

An example – rare for the Brera – of a work that has retained its original frame, this painting was executed in Rome around 1605 and sent from there to the Sampieri family (see also nos. 3, 4, 9) in Bologna. It is one of the most important examples of the early manner of the artist, who shows he has assimilated Caravaggio's innovations in the foreshortening of St Peter's hand, the monumental force of the two figures placed close together and the light effects. Also evident are the artist's close links with Ludovico Carracci, from whom he derives his interest in the landscape, the taste for simplicity and the clarity of the composition.

Room XXIX

**Caravaggio
(Michelangelo Merisi)**
1

Mattia Preti
2 3

Spagnoletto (Jusepe de Ribera)
4

**Battistello
(Giovan Battista Caracciolo)**
5

Orazio Gentileschi
6

North European Caravaggista
7

The great artistic revolution brought about by Caravaggio in the late 16th and early 17th centuries would be inexplicable if the Lombard models that helped to form the painter were not taken into account. His return to naturalistic painting and the use of light to throw objects into relief – and even his first works, painted in Rome, in which perspective played an important role – are the result of the experimental climate that was still a feature of the Milanese and Lombard schools in the late 16th century. In their turn, these schools were influenced by the way vision and artistic representation were handled by the great artists working in Lombardy in the late Quattrocento: Vincenzo Foppa, Bramante and Leonardo da Vinci. Caravaggio's approach to nature, devoid of antiquarian and classicizing accretions, his refusal to measure himself against Raphael's classicism and his very manner of painting, in which paint was laid on thickly without any underdrawing to contain it, led to the development of light effects that had formerly been those of Savoldo, the Campi (especially Vincenzo) and Lomazzo. Ignoring the Mannerist phase, Caravaggio's naturalism appeared nearly as revolutionary as Galileo's scientific theories did; in his works, there is a dramatic existential conflict between light and darkness, and between revealed grace and the abyss of sin. One of his most outstanding works, the *Supper at Emmaus* in Brera (no. 1), a later version of a subject that he had treated previously (National Gallery, London), in its portrait of Christ's resigned acceptance of a fate that is about to be fulfilled, stands out from the different, and often more reductive, interpretations of his art offered by his followers. And there were many of these, both Italians and foreign artists, although Caravaggio did not have any pupils as such. The Italians include the Pisan Orazio Gentileschi, with his refined painting (no. 6) from a church in Como, in which there are almost literal borrowings from Caravaggio's masterpieces (the angel bearing the palm of martyrdom is modelled on the one in the *Martyrdom of St Matthew* in San Luigi dei Francesi, Rome); the Calabrian Mattia Preti, who painted two compositions treating the subject of pauperism (nos. 2 and 3) that are in perfect harmony with the subjects of Caravaggio's mature period, also as regards their high level of execution; and the Neapolitan Giovanni Battista Caracciolo, called Battistello, who painted the *Christ and the Samaritan Woman* (no. 5), which was thought to be by Caravaggio himself when it came to Brera because of its excellent quality. The foreign artists comprise the Spaniard Jusepe de Ribera, called Spagnoletto, (no. 4) and the North European painter of *St Sebastian* (no. 7). (P.C.M.)

Caravaggio (Michelangelo Merisi)
(Milan? 1571-Porto Ercole, Grosseto 1610)

1 *Supper at Emmaus*
Oil on canvas
141 x 175 cm
Acquired: 1939

This painting, coming from the Casa Patrizi in Rome, was bought from Caravaggio himself. The Associazione Amici di Brera purchased it from the marquis Patrizio Patrizi in order to donate it to the gallery. The work was executed in 1605 or 1606, at the end of the artist's Roman period, when he was about to flee, perhaps to Zagarolo or Paliano (two villages to the east of Rome). The second version of a subject the artist had already treated in the painting now in the National Gallery, London, a few years previously, it is a terse and dramatic work in which the contrasts of the chiaroscuro play a fundamental role. The paint appears to solidify or flow freely in a masterly manner according to whether or not it is bathed in the light, which, as the representation of grace and salvation, has a strong symbolic significance.

Mattia Preti
(Taverna, Catanzaro, 1613-
La Valletta, Malta 1699)

2 St Peter and the Tribute Money

3 A Mother Presenting her Sons to Christ
Oil on canvas
143 x 193 cm each
Acquired: 1812

These two paintings, which were donated to the Brera by the viceroy, Prince Eugène de Beauharnais, on the advice of Giuseppe Appiani, came from the Casa Bovara, about which nothing is known. Belonging to the period when Preti was most strongly influenced by the art of Caravaggio, they were probably executed in the 1630s, when the artist was in Rome and was under the sway of Caravaggio's compositions and his use of contrasting light effects. Despite the fact that the two subjects are both sacred ones, the artist depicts them as profane, with figures deriving from everyday life in accordance with the tenets of Caravaggism. The high quality of these works has been enhanced by a recent restoration.

Spagnoletto (Jusepe de Ribera) (attributed)
(Játiva, Valencia 1591-
Naples 1652)

4 *St Jerome in Meditation*
Oil on canvas
109 x 82 cm
Acquired: 1886

On close examination, this very dramatic painting proves to be harshly and cursorily executed and only apparently respects the Caravaggesque precepts; this is why a number of art historians have attributed it to the artist's workshop; moreover, Ribera repeated this subject many times during his career.

**Battistello
(Giovanni Battista Caracciolo)**
(Naples 1578–1635)

5 *Christ and the Samaritan Woman*
Oil on canvas
200 x 165 cm
Monogrammed lower left "GBC"
Acquired: 1820

This work was given to the Brera by Luigi Augusto Sivry in exchange for a painting by Marco Palmezzano, one by Carlo Crivelli, two by Cima da Conegliano and a copy of a work by Correggio. This apparent excess of generosity on the part of the gallery was justifiable at the time because the work received was believed to be an original painting by Caravaggio. This attribution lasted until 1915, when it was refuted by the art historian Roberto Longhi. The new attribution is confirmed by the monogram that appears on the canvas, which is typical of Caracciolo. This refined, splendidly executed painting may be dated to around 1620-22.

Orazio Gentileschi
(Pisa 1563-London 1639)

6 *The Martyrs Valerian, Tiburtius and Cecilia Visted by an Angel*
Oil on canvas
350 x 218 cm
Signed on the base of the organ
"HORATIVS GENTILESC(...)
FLORENTINVS FECIT"
Acquired: 1801

Coming from the church of Santa Cecilia in Como, this work was probably executed before 1607, when Cardinal Sfondrato, titular of the church of Santa Cecilia in Rome, visited the church in Como and described the work. Formerly attributed to the circle of Guercino, it belongs, in fact, to the most emphatically Caravaggesque period of Orazio Gentileschi, who has borrowed the motif of the canopy from Caravaggio's *Death of the Virgin* (Louvre, Paris) and the angel swooping down to offer the palm of martyrdom from his *Martyrdom of St Matthew* (San Luigi dei Francesi, Rome). A work of great compositional skill, it portrays an interior having a strong Late-Mannerist flavour, with touches of elegance in the drapery and the interlacing of the diagonals of light and shade.

North European Caravaggista
(active early 17th century)

7 *St Sebastian*
Oil on canvas
134 x 99 cm
Acquired: 1811

Part of the Cardinal Cesare Monti bequest to the Milan Archbishopric, this painting has been known since 1650, when it was attributed to Caravaggio. Although more recently it has been ascribed to a Neapolitan follower of the artist, it is possible that it was executed by a North European artist working in his circle in Rome in the second or third decades of the 17th century, possibly a follower of Gerrit van Honthorst. The painting is a striking interpretation of Caravaggio's style and is notable for the anatomical rendering of the saint's body, which, far from being idealized, is portrayed in all its plebeian verisimilitude.

Room XXX
Lombard painting in the 17th century

Room XXX

**Tanzio da Varallo
(Antonio d'Errico)**
1

Francesco del Cairo
2 11

**Morazzone
(Pier Francesco Mazzucchelli)**
3

Daniele Crespi
4

Cerano (Giovanni Battista Crespi)
5 10

Giulio Cesare Procaccini
6 8 9 12

**Morazzone, Cerano
and Giulio Cesare Procaccini**
7

The Caravaggesque reform did not have an immediate effect in northern Italy. In fact, in the late 16th and early 17th centuries, during the Spanish occupation, the elegant Mannerism of Giulio Cesare Procaccini – in which the influence of Correggio and Parmigianino is evident – and the sacred art of Cerano (no. 10) were particularly successful. The latter, however, became an interpreter of the message, with its strong, almost ascetic, moral and religious content, of St Charles Borromeo, transforming his earlier artistic language into a great illustrative and scenographic style in which the last echoes of the Roman Renaissance are detectable. A central figure in Lombard society in the last quarter of the century, St Charles Borromeo acted as a catalyst for the artistic trends in this period. Because of the force of his personality and the fact that he sought to alleviate the suffering of the plague-stricken population, his pastoral activity continued to have an effect long after his death in 1584. Charles's beatification in 1602 and, shortly afterwards, in 1610, his canonization, were opportunities for two memorable series of paintings – the first illustrating the main events of his life, the second his miracles – that were executed, under the direction of Cerano, by the leading Lombard artists of the day. The celebratory function of the first series, and the fact that both series were, to all intents and purposes, a gigantic *ex-voto*, meant they were a point of reference for the whole of Lombard art in the early decades of the 17th century. Thus the huge canvases illustrating Charles's life and miracles became a very popular commemoration of his life that was practically a concerted effort, and a complete expression of the art of the Counter-Reformation (every year, at the beginning of December, the canvases are displayed in Milan cathedral). Both Morazzone (no. 3) and Daniele Crespi (no. 4) were associated with this current, but it was only when Tanzio da Varallo returned from Central Italy that the spirit that had materialized, almost as if by magic, in the commemoration of St Charles's life, was transformed into a new artistic language that was naturalistic and, at times, harsh but always very human. Tanzio da Varallo practised a variety of Caravaggism that was perhaps more domestic and workaday, but he managed to give the ring of truth to his narrative, as is so wonderfully demonstrated by the *Martyrdom of the Franciscans in Nagasaki* (no. 1), in which there are even direct borrowings from Caravaggio. What is virtually a compendium of much of Lombard art in the early 17th century is concentrated in the *Martyrdom of St Rufina and St Secunda* (no. 7), also called "the picture by three hands" because it was painted by Cerano, Morazzone and Giulio Cesare Procaccini. (P.C.M.)

Tanzio da Varallo
(Antonio d'Errico)
(Riale d'Alagna, Vercelli c. 1580-
Varallo Sesia, Vercelli 1632/33)

1 *Martyrdom of the Franciscans in Nagasaki*
Oil on canvas
115 x 80 cm
Acquired: 1811

This work, which comes from the convent of the Grazie at Varallo, is a faithful depiction of the martyrdom of the Franciscans that took place in Nagasaki on 5 February 1597. One of Tanzio's most Caravaggesque works, it is certainly subsequent to his journey to Central Italy, and must, therefore, be dated about 1627-32. In fact, some of the figures seem to have been borrowed from paintings by Caravaggio, while the paint is applied in thick, enamel-like layers, with very dramatic light effects, especially in the foreground.

Francesco del Cairo
(Milan 1607-1665)

2 *Agony in the Garden*
Oil on canvas
76 x 62 cm
Acquired: 1964

Coming from the Cugini Collection in Bergamo, this work is one of various versions of the same subject painted by the artist. Of very high quality, it was executed in the early part of the artist's career, before 1633. Bathed in metallic light, the scene recalls the work of Morazzone, but the angel is Caravaggesque in taste and, stylistically, resembles works by Tanzio.

Morazzone
(Pier Francesco Mazzucchelli) (attributed)
(Morazzone, Varese 1573–before 1626)

3 *St Francis in Ecstasy*
Oil on canvas
99 x 75 cm
Acquired: 1949

Together with a similar painting in the Castello Sforzesco, Milan, this work has been variously ascribed to Cerano, Morazzone, Alessandro Magnasco and Francesco del Cairo; the latter attribution now tends to be more favoured than the traditional one to Morazzone. The harsh realism of this work seems, in fact, to evoke the output of del Cairo rather than that of Morazzone. If it is by Morazzone, this disturbing picture should be dated around 1608-09, but considerably later if it is by del Cairo.

Daniele Crespi
(Busto Arsizio, Varese 1597/1600-Milan 1630)

4 *Last Supper*
Oil on canvas
335 x 220 cm
Acquired: 1809

Formerly in the church of San Pietro in the convent of the Benedictine nuns at Brugora, in Brianza (the area to the north of Milan), this painting came to the Brera in 1805. As far as the composition and the high viewpoint are concerned, it resembles the *Last Supper* painted by Gaudenzio Ferrari for the church of Santa Maria della Passione in Milan, but there are also direct references to Leonardo da Vinci's *Last Supper* in the refectory of Santa Maria delle Grazie, also in Milan, such as the great animation, the attention paid to the characters and facial features of the disciples, and the grouping of the heads. Datable to after 1630, this work demonstrates the vitality of Milanese painting in the early 16th century.

Cerano
(Giovanni Battista Crespi)
(Cerano? Novara c. 1575-Milan 1632)

5 *St Francis in Ecstasy*
Oil on canvas
93.5 x 74 cm
Acquired: 1969

Datable to the second decade of the 17th century, this painting intended for private devotion is the prototype of a series of derivative works attesting to its great success. Less dramatic and emphatic than the version attributed to Morazzone (no. 3), this work is marked by greater mysticism and less insistence on the display of the stigmata.

Giulio Cesare Procaccini
(Bologna 1574-Milan 1625)

6 *The Mystic Marriage of St Catherine*
Oil on canvas
149 x 145 cm
Acquired: 1896

Formerly in the Cardinal Cesare Monti bequest to the Milan Archbishopric, this exquisite picture intended for private devotion is one of Procaccini's most famous works. Combining the legacy of Emilian Mannerism with elements of Tuscan painting – in particular echoes of Andrea del Sarto – it is datable to shortly after 1610. Splendidly executed, with streaks of iridescent paint and refined colours, it attests to the elegant style in vogue among the Milanese aristocracy in the Seicento.

Also from the Cardinal Cesare Monti Collection, this painting was mentioned, as early as 1625, as belonging to the collection of the Milanese nobleman Scipione Toso, who commissioned it, possibly on the advice of the man of letters and scholar Girolamo Borsieri.
Whether it is to be considered a refined display of skill or a sort of artistic competition, this work was the result of the collaboration, around 1622-25, between the three leading artists of the day: thus, Morazzone may have been responsible for the overall composition and the executioner in the centre; Cerano the warrior on horseback, the beheaded saint, painted with livid colours, the putto and dog on the left; and Procaccini the saint and boy on the right.
A refined, intellectualistic work that is both theatrical and ingenious, the painting attracted the attention of the literary circles of its day and was almost immediately purchased by Cardinal Monti, who then bequeathed it, together with the other works in his collection, to the Milan Archbishopric in 1650.

**Morazzone
(Pier Francesco Mazzucchelli)**
(Morazzone, Varese 1573-before 1626)

**Cerano
(Giovanni Battista Crespi)**
(Cerano? Novara c. 1575-Milan 1632)

Giulio Cesare Procaccini
(Bologna 1574-Milan 1625)

7 *Martyrdom of St Rufina and St Secunda*
("Picture by Three Hands")
Oil on canvas
192 x 192 cm
Acquired: 1896

Giulio Cesare Procaccini
(Bologna 1574-Milan 1625)

8 *St Cecilia*

9 *St Jerome*
Oil on canvas
165 x 65 cm each
Acquired: 1896

Although it is known that these paintings come from the church of Gesù in Pavia, documentary evidence for this is lacking. It is very likely that they are the two wings of a triptych executed by Procaccini after his sojourn in Genoa, in which case they must be dated later than 1618. Particularly effective, although perhaps a little overdone, is the blood spurting from the saint's neck, depicted with such immediacy and realism as to leave the spectator breathless. With its imposing, monumental structure, the painting of St Jerome is more Rubensesque in style.

Cerano
(Giovanni Battista Crespi)
(Cerano?, Novara c. 1575-Milan 1632)

10 *Virgin of the Rosary*
Oil on canvas
273 x 218 cm
Acquired: 1805

In this painting from the Dominican church of San Lazzaro alle Monache in Milan, Cerano's attempt to combine the requirements of the Counter-Reformation with the High Renaissance style of Raphael and Titian – mediated by Gaudenzio Ferrari and Lorenzo Lotto – is very evident. The work thus adds the "pious caution" counselled by Federico Borromeo to the clergy in the expounding of the Christian doctrine to the typically conservative and deferential art of Cerano. With its very refined execution and its colours based on contrasts between whites, reds and blacks, this painting must be dated to the end of the second decade of the 17th century.

Francesco del Cairo
(Milan 1607-1665)

11 *Portrait of Luigi Scaramuccia*
Oil on canvas
95 x 73 cm
Acquired: 1806

This is a portrait of the Perugian painter and historian Luigi Scaramuccia, who, in his work *Le finezze de' pennelli italiani* (1674), praised del Cairo (the latter died in 1665). Datable to around 1657, when Scaramuccia was in Milan, it is considered to be one of del Cairo's most outstanding portraits thanks to its remarkable expressiveness that reveals his familiarity with works by Bernini.

Giulio Cesare Procaccini
(Bologna 1574-Milan 1625)

12 *St Mary Magdalen*
Oil on canvas
135 x 97 cm
Acquired: 1811

Part of the bequest of Cardinal Cesare Monti to the Milan Archbishopric, this painting is contemporary with the artist's canvas depicting the *Mystic Marriage of St Catherine* (no. 6), and is also stylistically very similar. With the same refined use of colour and the same handling of the paint, which forms streaks of colour evoking precious silks, this work reflects the lesson learnt from Parmigianino and the monumental style of the High Renaissance artists of Central Italy.

Memo= Bilium
riam suorum,
fecit escam
mira= dedit. etc.
ps. 110.

Room XXXI
Flemish and Italian paintings of the 17th century

Room XXXI

Luca Giordano
1

Gioacchino Assereto
2

Orazio de Ferrari
3

Sir Anthony van Dyck
4

Joachim von Sandrart
5

Jacob Jordaens
6

Sir Peter Paul Rubens
7

Evaristo Baschenis
8 14

Candido Vitali
9 10

Bernardo Strozzi
11 16

Jan Fyt
12 13

Joseph Heintz the Younger
15

**Pietro da Cortona
(Pietro Berrettini)**
17

Traditionally devoted to foreign painters – represented in the Brera by relatively few works, some of which, however, are outstanding – this room still houses paintings by three great Flemish masters, protagonists of the Baroque era: Sir Peter Paul Rubens, Jacob Jordaens and Sir Anthony van Dyck, and also the German Joachim von Sandrart, who worked in Rome in the 1630s, when the new Baroque style spread outwards from Rome all over Europe. Together with these artists, there are Italians painters such as Pietro da Cortona, who, with his heroic and grandiose – albeit rhetorical and complex – vision of the themes of faith and human force, influenced the painting of the whole of Italy in this period, and Luca Giordano, who in the second half of the century gave a new, joyful interpretation to 17th-century painting, paving the way for the European art of the 18th century. In addition there are such Genoese artists as Bernardo Strozzi, Gioacchino Assereto and Orazio de Ferrari who had the privilege of seeing Rubens and van Dyck at work in their native city, which, at the beginning of the century, had become an animated meeting-place for North European artists arriving in Italy.

Likewise, the genre of the still life, which became very popular in the Seicento as a result of the opening of the art market to a wider public and the fondness of the bourgeoisie for small-scale works of art, is exemplified with paintings by foreign and Italian artists belonging both to the current influenced by the Counter-Reformation, with its allegorical and scientific content-matter seeking to convey moral messages, and to the independent one that is purely descriptive and splendidly decorative. Thus *Musical Instruments* (no. 8) and *Kitchen* (no. 14) by the Bergamasque Evaristo Baschenis – practically a fellow-countryman of Caravaggio, he painted some of the most splendid still lifes ever produced – are juxtaposed with the complex symbology of Vanitas (no. 15) by Joseph Heintz the Younger (a German working in Venice), two pictures of dead game (nos. 12 and 13) by Jan Fyt (a great painter of hunting pieces who diffused the exuberant still life in the manner of Franz Snyders throughout Italy) and two more pictures of dead game (nos. 9 and 10) in Flemish style. Although, until a few years ago, the latter were attributed to Felice Boselli, a painter from Piacenza influenced by the Genoese art of North European derivation, they are now ascribed to Pseudo Fardella or the Bolognese Candido Vitali. (L.A.)

Luca Giordano
(Naples 1634–1705)

1 *Holy Family with St Anthony of Padua*
Oil on canvas
365 x 224 cm
Acquired: 1809

This huge canvas, which recently returned to the Brera after having been on loan elsewhere for almost fifty years, originally came from the church of the Santo Spirito in Venice. Long considered to be an early work by Luca Giordano datable to 1652-54, it should, in fact, be assigned to a later period, 1664-65, when the artist left Naples to visit Florence, Venice and other Italian cities. Dominated by a flight of angels holding the cross in accordance with an unusual devotional scheme linked to the Franciscan and Carmelite reform, the complex, monumental composition – under the influence of Mattia Preti, Rubens and Pietro da Cortona – is decidedly Baroque in style.

Gioacchino Assereto
(Genoa 1600-1649)

2 *Circumcision*
Oil on canvas
228 x 163 cm
Acquired: 1806

This painting, of unknown provenance, belongs to the first group of works displayed in the Brera by Giuseppe Bossi (secretary of the Brera Academy during its early years), and until the 1930s it was ascribed to the Lombard Antonio Maria Crespi, called Bustino. Credit for the attribution to Gioacchino Assereto, and for the assignment to the early years of his career (1620-30), must go to the art historian Roberto Longhi, who recognized links with both the Lombard art of Cerano and the output of Assereto's fellow Genoese Giovanni Andrea Ansaldo and Bernardo Strozzi.

Orazio de Ferrari
(Voltri, Genova 1606-1657)

3 *Ecce Homo*
Oil on canvas
95 x 118 cm
Acquired: 1896

This painting came to the Brera together with others chosen by Giuseppe Bertini from the Cardinal Cesare Monti Collection bequeathed to the Milan Archbishopric in 1650, which had already been plundered in 1811 by Andrea Appiani. Showing the influence of the naturalism of both Assereto and Caravaggio, it also contains echoes of works by Strozzi and Reni.

Sir Anthony van Dyck
(Antwerp 1599-London 1641)

4 *Virgin and Child with St Anthony of Padua*
Oil on canvas
189 x 158 cm
Acquired: 1813

This work came to the Brera as the result of an exchange with the Louvre, which after obtaining five paintings by Venetian and Lombard artists chosen in 1811 by D. Vivant Denon, the director of the Louvre, compensated the gallery with the same number of Flemish works. This painting, datable to 1630-32, from a stylistic point of view, belongs to a group of works with religious subjects in which the influence of the Italian painting of the Renaissance is noticeable – in this case that of Titian, whom the artist had admired and studied in Genoa and Rome.

Joachim von Sandrart
(Frankfurt am Main 1606-Nuremberg 1688)

5 *The Good Samaritan*
Oil on canvas
133 x 133 cm
Signed and dated lower centre
"Joachimus Sandrart Fecit 1632"
Acquired: 1830

This work was purchased from the heirs of Andrea Appiani. The German von Sandrart, one of the most outstanding art historians of his day, was also a competent engraver and painter. A great traveller, he visited the whole of Europe staying, often at length, in London, Utrecht, Venice, Rome, Amsterdam, Munich and Vienna. Dating from his sojourn in Rome, when he frequented an international artistic milieu, this painting shows a whole variety of influences, including those of Titian, Johann Lyss and Claude Lorraine in the landscape, and of antique statuary, Caravaggio and Gerrit van Honthorst, his first teacher, in the figures.

Jacob Jordaens
(Antwerp 1593-1678)

6 *Sacrifice of Isaac*
Oil on canvas
242 x 155 cm
Acquired: 1813

After being sold by the artist's heirs in 1734, this painting – before it went to the Louvre and from there to the Brera – adorned the Palace of Sans Souci in Potsdam. Very Rubensian in style, but more sober and sharply defined, this canvas, characterized by strong contrasts of light and shade and a less brilliant range of colours than usual, is datable around 1625 and is notable for its immediate expressive force and the worldly, unheroic dimension given to the Biblical theme.

Sir Peter Paul Rubens
(Siegen, Westphalia 1557-Antwerp 1640)

7 *Last Supper*
Oil on canvas
304 x 250 cm
Acquired: 1813

This painting, which came to the Brera as part of the exchange with the Louvre mentioned above (no. 3), was commissioned by Catherine Lescuyer in memory of her father for the chapel of the Holy Sacrament in the church of St Romuald in Mechelen, and was executed between 1630 and 1632. Originally having two predelle (now in the Musée des Beaux-Arts, Dijon), this dark and magnificently conceived picture, painted with sweeping, but unusually sober, strokes, is – like many of the artist's late works – partly by his assistants. The influence of Italian painters is noticeable, particularly that of Titian, a large number of whose works Rubens had seen a few years previously at the Escorial, and also of Caravaggio and Veronese, whose paintings he had admired during his visits to Italy.

Evaristo Baschenis
(Bergamo 1617-1677)

8 *Still Life with Musical Instruments*
Oil on canvas
60 x 88 cm
Signed on the side of the casket
"Evaristo Baschenis F."
Acquired 1912

This painting, which was purchased by Ettore Modigliani (the director of the Brera Gallery from 1908 to 1934 and again from 1946 to 1947), played a fundamental role in the rediscovery of Baschenis in the 20th century. It is a work of particular importance in the career of this artist, a great professional who, with his compositions of musical instruments arranged in deliberate disorder, was able, like Zurbarán and Caravaggio, to transcend the genre of the still life. Interpreting it in a non-decorative manner, he paid careful attention to structural balance and perspective rigour, but without forgetting the symbolic and metaphorical meanings of the objects. In this case, the passing of time and death are alluded to by the layer of dust on the instrument in the foreground and the sense of immobile abandonment conveyed by the objects.

Candido Vitali
(Bologna 1680-1753)

9 *Game with a Live Pigeon*
Oil on canvas
64 x 68 cm

10 *Game with Hare*
Oil on canvas
64 x 69 cm
Acquired 1817

Like many still lifes, these two paintings were intended to be hung together. Devoted to the theme of game, extremely popular with Flemish painters, they were, for many years, ascribed to Felice Boselli (1650-1732), from Piacenza, noted for his enormous output. More recently they were assigned to Pseudo Fardella, a conventional name given to the unknown artist who painted a group of still lifes in a Tuscan context, but this attribution has now been rejected in favour of the Bolognese Candido Vitale.

Bernardo Strozzi
(Genoa 1581-Venice 1644)

11 *Portrait of a Knight of Malta*
Oil on canvas
129 x 98 cm
Acquired: 1904

This portrait of an unknown Knight of Malta, which came to the Brera as part of the Casimiro Sipriot bequest and is datable to around 1629, before the artist moved to Venice, has clearly been influenced by the works Rubens and van Dyck executed in Genoa. The realism and magniloquence of this work, and the dense brushstrokes, thick with colour, exalt the grandeur and high social standing of the sitter.

Jan Fyt
(Antwerp 1611-1661)

12 *Dead Game with a Crossbow*
13 *Dead Game with a Cat*
Oil on canvas
106 x 145 cm each
Acquired: 1806

These two paintings, datable to 1640-55, are typical works by this Flemish artist, a great painter of hunting scenes, who was famous for the delicacy of his colours and his strong sense of realism linked to a scenographic, very decorative sense of composition.

Evaristo Baschenis
(Bergamo 1617-1677)

14 *Still Life in a Kitchen*
Oil on canvas
94 x 145 cm
Signed bottom right
"EVARISTVS BASCHENIS F. BERGOMI"
Acquired: 1915

Selected by the former director of the Brera, Ettore Modigliani, after careful research – it was, in fact, the only kitchen scene by the artist that was signed, and thus certainly autograph, known at the time – this huge stone table with poultry, game, biscuits and cheese, giblets and kitchen utensils is considered to be a masterpiece of the artist's late maturity and displays the same skill as Baschenis's other output in the field of still life painting.
Derived from Spanish models, this artist's kitchen scenes – simple tabletops with ordinary, but not poor, foodstuffs, juxtaposed with everyday objects that are humble, but perfectly modelled – are conceived in accordance with the same procedure adopted in his still lifes with musical instruments, by composing and rearranging the same elements in structures of varying degrees of simplicity, with different perspectives, in which the clear, very refined light plays a fundamental role.

Joseph Heintz the Younger
(Augsburg 1600-Venice 1678)

15 *Vanitas (Allegory of Love?)*
Oil on canvas
130 x 177 cm
Acquired: 1983

This painting, attributed to Joseph Heintz the Younger, a German painter who worked in Venice for a long period, is composed like a *Vanitas*, a symbolic still life conceived as a *memento mori* full of allusions to the passing of time and the fragility of worldly things. These are evoked by the hour-glass, skull and round mirror, while the picture is further enriched by the theme of Love conquering Time in a bizarre, enchanted vision that is typically North European in character.

15

Bernardo Strozzi
(Genoa 1581-Venice 1644)

16 *The Infant St John the Baptist*
Oil on canvas
70 x 55 cm
Acquired: 1855

Until a few years ago, this painting, which came to the Brera as part of the Pietro Oggioni bequest, was relegated to the storerooms. Datable to between 1620 and 1625, in the artist's Genoese period, it is a minor work, but certainly autograph.

16

Pietro da Cortona (Pietro Berrettini)
(Cortona, Arezzo 1596-Rome 1669)

17 *Virgin and Child with St John the Baptist, St Felix of Cantalice, St Andrew and St Catherine*
Oil on canvas
296 x 205 cm
Signed lower centre
"PETRVS BERETINVS CORTON.SIS F"
Acquired: 1811

This painting, coming from the church of the Cappuccini in Amandola, in the Marches, where it was documented on the high altar in 1728, is datable to 1628-29. The circumstances in which it was commissioned are unknown, although they are linked to the family of Pope Urban VIII (original name Maffeo Barberini, pope 1623-44), in a web of relationships and coincidences associated with the presence of St Felix of Cantalice, a Capuchin saint. Possibly executed for the church of the order in Rome – built by Cardinal Antonio Barberini, the pope's brother, who was also a Capuchin – the painting may then have been taken to Amandola when the artist painted the altarpiece now on the altar of the church. Composed with great confidence and Raphaelesque narrative eloquence, the huge altarpiece is a replica, with some modifications, of the *Virgin with Saints* in the church of Sant'Agostino in Cortona, his most outstanding work in this period.

17

■ **Room XXXII Room XXXIII**
**Flemish and Dutch paintings
of the 16th and 17th centuries**

VIII
VII
VI | IX
IA | II | III | IV | V
I
XIV
XIX
XXXVIII
XV
XXXVII
XVIII
XXXV | XXXVI
XX
XXI
XXXIV
XXII
XXXIII
XXXII | XXXI | XXX | XXIX | XXVIII | XXVII | XXIV | XXIII

Room XXXII

Master of 1518 or Master of the Abbey of Dielegem (Jan van Dornicke)
1

Antwerp school of the 16th century (Jan de Beer?)
2

Jan de Beer
3

Master of the Female Half-Figures
4

Herman Rode
5

El Greco (Domenikos Theotokopoulos)
6

Room XXXIII

Dirck van Santvoort
7

Sir Anthony van Dyck
8

Jan Brueghel the Elder (Jan Velvet) and Sir Peter Paul Rubens (copy)
9

Nicolaus Knüpfer
10

Rembrandt Harmensz van Rijn (Circle)
11

Jan Philip van Thielen
12

Jan Joseph van Goyen
13

Jan Brueghel the Elder (Jan Velvet)
14

Abraham Govaerts
15

These two small rooms, constructed in the 1950s using part of the adjacent room, considered at the time to be too long and severe, house works by Flemish and Dutch artists – or painters associated with these schools – dating from the beginning of the 16th to the second half of the 17th centuries. Some of these works came to the Brera with the Pietro Oggioni bequest in 1855, others as a result of exchanges and purchases, or as gifts; with their diversity, they are in marked contrast to the rest of the gallery's collection.

The German Herman Rode (no. 5), an emulator of Hans Memlinc and Dieric Bouts, flanks artists of the Antwerp school – such as the Master of 1518 (no. 1, identified with Jan van Dornicke) and Jan de Beer (nos. 2, 3) – which, between 1507 and 1530, was influenced by the Italian Renaissance due to the presence in Mechelen (Malines) of the Italianized court of Margaret of Austria. El Greco is also represented here with a work (no. 6) of particular importance as regards its subject-matter, although it was, in fact, executed by his workshop.

The genre of the portrait, a favourite with the Flemish and Dutch artists, is illustrated by an intense portrait of a young upper-class man (no. 7) by Dirck van Santvoort, a very refined painter working in Amsterdam in the second half of the 17th century, and also by an aristocratic female figure (no. 8) by Sir Anthony van Dyck and a small portrait of a young woman (no. 11) by a follower of Rembrandt. Landscape painting, alternating views of actual places, with depictions of real-life, and fantastic scenes animated by figures taken from mythology and the Bible, is represented by small paintings by Jan Brueghel the Elder (no. 14), Abraham Govaerts (no. 15) and Jan van Goyen (no. 13). (L.A.)

Master of 1518 or Master of the Abbey of Dielegem (Jan van Dornicke)
(active in Antwerp in the first quarter of the 16th century)

1 *Adoration of the Magi*
Oil on canvas
106 x 72 cm
Acquired: 1889

This painting was attributed to various artists until the conventional name of the Master of 1518 was chosen; he was then identified as Jan van Dornicke, a painter and art dealer who had a busy workshop in Antwerp in the early 16th century, when the city was the leading centre for commerce and the arts in southern Flanders. Originally flanked by two wings, now in a private collection in Brussels, this work was probably executed with the assistance of Pieter Coecke – the artist's son-in-law – and may be dated to the late 1620s. Both the subject and the composition, which combines ruined classical architecture with landscape, indicate that this is an example of the huge output of the "Antwerp Mannerists", whose works were very popular all over Europe.

Antwerp School of the 16th century (Jan de Beer?)
(Antwerp? 1475-after 1520)

2 *St Luke Painting the Virgin*
Tempera on canvas
93.5 x 145 cm
Acquired: 1896

This painting, which is irremediably worn and faded, came to the Brera together with other works in the Cardinal Cesare Monti Collection, Milan, where it was attributed to Lucas van Leyden. According to a very popular Byzantine legend of the sixth century, St Luke was not only an Evangelist, but also a painter who made a portrait of the Virgin. The artist treats the subject, which is frequently found in the art of northern Europe, with an eye for realistic detail, without, however, neglecting the symbolic value of many everyday objects – such as the washbasin with a pitcher of water, the towel and the mirror – alluding to the purity of the Virgin.

Jan de Beer
(Antwerp? 1575-after 1520)

3 *Adoration of the Magi; Nativity; Rest on the Flight to Egypt*
Oil on panel
Central panel 156 x 123 cm
Left panel 159 x 58 cm
Right panel 157 x 57 cm
Acquired: 1808

When this triptych came to the Brera from a church in Venice – which has not, so far, been identified – it was ascribed to Albrecht Dürer. The attribution to de Beer is fairly recent; very few works are known by this artist, who was registered with the Antwerp Guild of Painters from 1504 to 1520. A masterpiece of his mature period, this triptych is composed in a very refined manner that is both ornate and analytical; on the back of the wings are monochrome paintings of the Virgin and the Annunciatory Angel. The carefully chosen bright, enamel-like colours are accompanied by a wealth of detail and curious episodes in the backgrounds, in the Italianate architecture and in the foregrounds crowded with figures and objects.

Master of the Female Half-Figures
(active in Flanders in the second quarter of the 16th century)

4 *St Catherine*
Oil on panel
45 x 36 cm
Acquired: 1839

This is a typical work by the anonymous Flemish painter in the circle of Bernard van Orley (Brussels c. 1488-1541) who was known by the conventional name of Master of the Female Half-Figures because he only portrayed figures of women, usually saints, half-length, with their eyes lowered and in demure poses like those of the ladies of the court, absorbed in reading, writing or playing musical instruments.

Herman Rode
(active in Lübeck 1485-1504)

5 *Portrait of a Man Praying*
Oil on panel
35 x 27 cm
Acquired: 1855

Like many other works by non-Italian artists in the Brera Gallery, this picture arrived as part of the Pietro Oggioni bequest. The attribution to Rode was first proposed in 1930 and has not been changed since then. He was a German artist who had absorbed Flemish and Netherlandish styles during sojourns in the Netherlands between 1450 and 1460, and then again at the end of the 1460s and in the early 1490s. Clearly influenced by Dieric Bouts and, above all, Hans Memlinc, who had perfected the portrait type in which the sitter is depicted against a landscape background, this very small work, with its restraint and bright colours, must have formed part of a devotional diptych, the left-hand side of which consisted of a sacred image to which the young man was addressing his prayer.

El Greco
(Domenikos Theotokopoulos)
(Phodele, Heraklion,
Crete 1541-Toledo 1614)

6 *St Francis in Meditation*
Oil on canvas
108 x 66 cm
Signed in Greek characters bottom right
Acquired: 1931

Purchased as an autograph work by El Greco, this painting is now considered to be a product of his workshop. The mystical exaltation found in all of the artist's works determined his predilection for St Francis, whom he represented numerous times in many different ways. First used around 1590, the compositional scheme of the saint, who, accompanied by Brother Leone, meditates on death by contemplating a skull, was frequently repeated and nearly forty examples of it are known. Of these, six are wholly autograph, while the others are products of his workshop or are contemporary copies.

Dirck van Santvoort
(Amsterdam 1610-1680)

7 *Portrait of a Young Man*
Oil on canvas
190 x 120 cm
Signed and dated upper right
"D.D. Santvoort 1643";
at the bottom is the inscription
"Aet. XVII 1/2"
Acquired: 1927

This portrait of a young man, in which, following the severe Dutch fashion, the sitter wears dark clothes, belongs to the rich current of Dutch portraiture of the 17th century. In Amsterdam this took the form of the extremely realistic bourgeois portrait, representing not only individuals, but often also family groups or guilds. Van Santvoort, who, after the death of Rembrandt, became the portraitist of the leading families of Amsterdam, specialized in painting children and adolescents. Renowned for his serene style combining realism and refinement, he became a very successful artist.

Sir Anthony van Dyck
(Antwerp 1599-London 1641)

8 *Portrait of a Woman*
Oil on canvas
140 x 107 cm
Acquired: 1813

This painting came to the Brera as part of the exchange with the Louvre mentioned previously (room XXXI, no. 4). For a long time it was considered to be a portrait of Amalia von Solms, the princess of Orange and wife of the governor of the Netherlands who became regent after his death, but this identification must be rejected because it bears no resemblance to the official portraits of the princess. According to the most recent studies, the painting represents a lady belonging to the noble du Croy family of Brussels. This sober painting has recovered all the freshness and subtlety of its execution after the restoration of 1988, which has returned softness to the flesh-colours and given prominence to the whiteness of the lace and pearls and the spectacular yellow of the curtains. Thus justice has been done to the fame of van Dyck, court painter in Brussels and then in London, who was enormously successful as a portrait artist, obtaining commissions from various countries, and was able to combine psychological analysis with celebration of the sitter's social status.

Jan Brueghel the Elder (Jan Velvet)
(Brussels 1568-Antwerp 1625)

Sir Peter Paul Rubens
(Siegen, Westphalia 1577-Antwerp 1640)

9 *The Nymph Syrinx Pursued by Pan* (copy)
Oil on panel
33 x 43 cm
Acquired: 1855

Part of the Pietro Oggioni bequest, this work is a copy, made by Rubens's workshop, of a painting (National Gallery, London) executed jointly in 1623 by Brueghel, who was responsible for the landscape and the animals, and Rubens, who painted the figures.

Nicolaus Knüpfer
(Leipzig c. 1603-Utrecht 1660)

10 *The Parable of Dives and Lazarus*
Oil on panel
28 x 45 cm
Acquired 1855

This work also belonged to the Oggioni bequest. Knüpfer was a pupil of Abraham Bloemaert in Utrecht, from whom he derived his Mannerist style, a penchant for asymmetry, foreshortening and diversity in his compositions, which allowed him to represent his subjects in a varied and pleasing manner.

Rembrandt Harmensz van Rijn (circle)
(Leyden 1606-Amsterdam 1669)

11 *Portrait of a Young Woman*
Oil on panel
60 x 50 cm (oval)
Initialled and dated upper left
"RHL.VAN.RYN. 1632"
Acquired: 1813

Received by the Brera as part of the exchange with the Louvre mentioned above (room XXXI, no. 4), this painting was, for a long time, considered to be autograph, and the young woman was identified as Lijsbeth, the artist's sister. However, the authoritative *Corpus of Rembrandt's Painting*, published in 1986, has rejected the artist's authorship of this painting (the authenticity of the signature has also been challenged), which is thought to have been executed by a painter in the circle of Rembrandt. He appears to have been inspired by Rembrandt's *Portrait of a Young Woman* in the Museum of Fine Arts, Boston, which, in effect, this work closely resembles, although there are variations in the pose and the dark veil hanging from the sitter's shoulders.

Jan Philip van Thielen
(Mechelen 1618-Boisschot 1667)

12 *Vertumnus and Pomona in a Festoon of Flowers*
Oil on canvas
86 x 66 cm
Signed and dated lower right
"I.P. Van Thielen Rigouldt F. An. 1648"
Acquired: 1822

This painting was executed in the early years of the career of this artist, a pupil of Daniel Seghers, who was specialized in compositions in which sacred and mythological themes were surrounded, until they were almost covered, by gaily coloured festoons of flowers. A compositional scheme that was very popular in the Netherlands, it is presented here in a very faithful manner.

Jan Joseph van Goyen
(Leyden 1596-The Hague 1656)

13 *Seascape*
Oil on panel
36 x 46 cm
Monogrammed and dated on the boat
"JVG 1645"
Acquired: 1832

The result of an exchange with the Roman antiquary Filippo Benucci, who gave four Flemish and Dutch works for ten paintings, including two works by Carlo Crivelli and two by Nicolò Alunno, the painting belongs to the genre of naturalistic landscape that represents the real world in a simple, straightforward way, but with a high lyrical content. Van Goyen, a painter of the flat seascapes of Holland and its waterways, excelled at this type of picture, and was imitated by a host of pupils.

13

Jan Brueghel the Elder
(Jan Velvet)
(Brussels 1568-Antwerp 1625)

14 *Village*
Oil on copper
21 x 32 cm
Signed and dated lower right
"Brueghel 1607"
Acquired: 1809

The provenance of this painting is unknown. Jan Brueghel, the second son of Pieter Bruegel the Elder, spent some time in Italy, and was in Naples in 1590 and then Rome in 1591, where he made contact with the Cardinal Federico Borromeo, who became his main patron and brought him to Milan in 1595. After his return to Antwerp, he continued to send works to Borromeo and other Milanese patrons. Thus it is reasonable to hypothesize a Lombard provenance for this painting, a complex view of a village that is both elegant and detailed, like all the works by this artist, who, apart from landscapes, specialized in flower paintings, visions of hell and conflagrations.

14

Room XXXIII

15

Abraham Govaerts
(Antwerp 1589-1626)

15 *A Wood (Abraham and Isaac in a Landscape)*
Oil on panel
53 x 79 cm
Signed and dated "A. Govaerts 1615"
Acquired: 1876

Coming from the bequest of the Marquis Massimiliano Stampa Soncino, the last descendent of Cardinal Cesare Monti, this painting derives from the models of Jan Brueghel the Elder, of whom Govaerts was a faithful follower, to the extent of being a plagiarist. The luxuriant and intricate wooded landscape is also influenced by works by Gillis van Coninxloo.

Room XXXIV
Religious painting of the 18th century

Room XXXIV

Pompeo Batoni
[1]

Carlo Innocenzo Carloni
2

Nicola Malinconico
3 4

Francesco Solimena
5 6

Luca Giordano
[7]

Giambattista Tiepolo
[8]

Martin Knoller
9

Giuseppe Bottani
10

Pierre Subleyras
[11] [16]

Sebastiano Ricci
[12] 15

Giuseppe Maria Crespi
[13]

Ubaldo Gandolfi
14

The theme of this room is the art of the 18th century and its relationship with sacred painting, which had become an academic genre as the ideological and religious function of art — now increasingly specialized and diversified — was attenuated. Here there are works painted for churches or, at any rate, having sacred subjects, that reflect the often contrasting variety of tastes, tendencies and interests characterizing the century until the advent of the prevalently secular art of Neoclassicism.

The last splendid examples of the grandiose Baroque style, the unique and undisputed mode that was about to be transformed into the delicacy and grace of Rococo, may be seen in the paintings of Giambattista Tiepolo, Sebastiano Ricci, Luca Giordano, Francesco Solimena and Ubaldo Gandolfi, while the leading exponents of Classicism, the dominant current in Rome, were Pierre Subleyras, Pompeo Batoni and Giuseppe Bottani.

An isolated figure due to his capacity to depict, often in an emotional manner, the real world, Giuseppe Maria Crespi was the main protagonist of the return to naturalism in this century. (L.A.)

Pompeo Batoni
(Lucca 1708-Rome 1787)

1 *Virgin and Child with St Joseph, St Zacharias, St Elizabeth and the Infant St John the Baptist*
Oil on canvas
403 x 288 cm
Acquired: 1799

Originally in the church of the Santi Cosma e Damiano alla Scala in Milan, which was suppressed in 1796 and converted into the Teatro dei Filodrammatici, this painting – together with another two by Pierre Subleyras (nos. 11, 16) and one by Giuseppe Bottani (no. 10) – was one of the very first works to reach the Palazzo di Brera. Although these were originally only in store, they may be regarded as the original nucleus of the gallery's collections. Commissioned together with the other three paintings – as may be seen in the bills now in the State Archives, Milan – and executed between 1738 and 1740, when Batoni, who had left his native Lucca for Rome ten years previously, was beginning to make a name for himself in the international milieu of the rich and often aristocratic travellers visiting the city, an obligatory port of call on the Grand Tour, this painting is a perfect example of the Classicism with which the artist's works were imbued. This was derived not only from his studies of Raphael's works and antique statuary, but also from such 17th-century artists as Guido Reni, Domenichino, Nicolas Poussin, Giovanni Lanfranco and Carlo Maratta.

Carlo Innocenzo Carloni
(Scaria d'Intelvi, Como 1683-1775)

2 *The Triumph of Faith*
Oil on canvas
57.5 x 57.5 cm
Acquired: 1935

Linked to the frescoes Carloni executed between 1766 and 1773, towards the end of his career, in Asti cathedral – in particular, it is a study for the vault of the last bay in the left aisle – this small painting, which has been cut down along the bottom edge, appears in the inventory of oil-sketches for "sacred works, domes, semidomes and vaults of churches" that remained in Carloni's studio at the time of his death. It displays the elegance and breadth of vision that characterized the entire output of this great Lombard decorator who worked not only in Italy, but also in Austria, Germany, Bohemia and Moravia.

Nicola Malinconico
(Naples 1663–1721)

3 *Joshua Halting the Sun*
Oil on canvas
108 x 114 cm

4 *The Transport of the Holy Ark*
Oil on canvas
108 x 102 cm
Acquired: 1962

Until a few years ago, these two paintings, representing episodes taken from the Book of Joshua, were assigned to Luca Giordano and dated between 1692 and 1702, when the artist was working at the court of Charles II in Spain. In 1990, however, they were attributed to Nicola Malinconico, a pupil of Giordano, who was later in the circle of Francesco Solimena, and the complex events accompanying their execution were reconstructed. In fact, the two oil-sketches, in which there is a strong echo of Pietro da Cortona, correspond, with some modifications, to the two canvases executed between 1692 and 1694 for the nave of the basilica of Santa Maria Maggiore in Bergamo, where Malinconico received a difficult commission in Giordano's stead because the artist was no longer available, having left for Spain.

Francesco Solimena
(Canale di Serino, Avellino 1657-Barra, Naples 1747)

5 *St Willibald, a Monk at Montecassino, and Pope Gregory III*

6 *Encounter between Rachis, King of the Lombards, and Pope Zacharias*
Oil on canvas
43 x 75 cm each
Acquired: 1805

These two paintings, originally in the church of San Giorgio Maggiore in Venice, were selected by Pietro Edwards, the commissioner for requisitions in that city. In 1958 the two oil-sketches, notable for the unusual mod-

Room XXXIV 283

4

6

eration of their classicizing style, were identified as studies for the fresco decoration of the chapel of San Carlomanno, painted between 1701 and 1705 by Solimena in the church of the abbey of Montecassino, which was destroyed during the Second World War. In 1990 the cultural background underlying the choice of the themes for the Carlomanno cycle was reconstructed: this led to the identification of the subjects – associated with important figures in the history of the abbey, such as Rachis, Pope Zacharias and St Willibald – which had previously been hastily indicated as *The Pope Presenting the Rule to St Benedict* and *St Leo the Great Meeting Attila*.

Luca Giordano
(Naples 1634–1705)

7 Ecco Homo
Oil on canvas
158 x 155 cm
Acquired: 1979

This painting must be assigned to 1659-60, when the young artist, a pupil of Jusepe de Ribera, adapted the modes of his rival Mattia Preti to the neo-Venetian style that was popular in Rome. This dramatic work, with its thick layers of paint and strong contrasts of light, is freely derived from an engraving by Dürer forming part of the Passion series of 1512-13, and demonstrates Giordano's skill as a copyist and "forger": a well-known work by this artist is *Christ Healing the Cripple* "signed" by Dürer and himself.

Martin Knoller
(Steinach, Tyrol 1725-Milan 1804)

9 *Assumption of the Virgin*
Oil on panel
96 x 53 cm
Acquired: 1839

Purchased directly from the artist's son, the painting hung in the gallery until 1940, but was then put into storage and it was only recently (1992) that it was once again put on display. The modello for the huge altarpiece executed in 1788 for the high altar of Merano cathedral, it is a work of Knoller's mature period, and is notable for the moderation of its equipoise between the Late-Baroque style and the now dominant Classicism.

Giambattista Tiepolo
(Venice 1696-Madrid 1770)

8 *Madonna del Carmelo with St Simon Stock, St Teresa of Avila, St Albert of Vercelli, the Prophet Elijah and the Souls in Purgatory*
Oil on canvas
210 x 650 cm
Acquired: 1925

With its complex iconography, this painting recapitulates the main events in the history of the Carmelite order and the adoration, aimed at the salvation of the soul, of the large scapular (held by the Virgin) and the small scapular (held by Christ). Commissioned in 1721 for the chapel of the confraternity of the Suffragio del Carmine in the church of Sant'Apollinare in Venice, the work had not yet been completed in 1727. After being acquired by the state in 1810, it was then sold by auction in 1865; then, for commercial reasons, it must have been divided into two parts before 1880, the date of a painting by Giacomo Favretto entitled *Vandalism*, also belonging to the Brera, which clearly depicts the part containing only the Madonna. Thus divided, the work reappeared on the Paris antique market and was purchased by the Chiesa family in Milan and donated to the Brera. The canvas was recomposed in 1950, when it was hung on the wall opposite the present one. An early work by Tiepolo, when the artist measured himself with the religious output of Piazzetta, this painting, although it was designed to be seen from the side due to its original position on the wall of a chapel, still has a dramatic visual and emotional impact when viewed frontally, although it was designed to be seen from the side due to its original position on the wall of the chapel.

Giuseppe Bottani
(Cremona 1717-Mantua 1784)

10 *The Departure of St Paula Romana for the Holy Land*
Oil on canvas
410 x 231 cm
Signed and dated lower right "Joseph Bottan/Faciebat Romae/Anno 1745"
Acquired: 1799

The provenance and patron of this work, commissioned between 1738 and 1745, link it to the one by Pompeo Batoni (no. 1) and the two by Pierre Subleyras (nos. 11, 16) that have been on display together in this room since 1980, when the painting returned to the Brera after being on loan for eighty years to various other institutions.
An imposing academic work displaying a marked classicistic taste, this huge, serene and well-composed picture is dedicated to St Paula, a Roman matron associated with the order of the Hieronymites, titulars in Milan of the church of Santi Cosma e Damiano alla Scala, its original provenance.

Pierre Subleyras
(Saint-Gilles-du-Gard 1699-Rome 1749)

11 *St Jerome*
Oil on canvas
408 x 232 cm
Signed and dated lower right "Petrus Subleyras Gallus Fecit Romae 1739"
Acquired: 1799

Having the same provenance as the previous work, this painting, executed in 1739, when the artist, who had been living in Rome for about ten years, was at the height of his fame, is marked by restrained theatricality that lends classical vigour to the composition, which is based on academic models in the manner of Guido Reni.

Sebastiano Ricci
(Belluno 1659-Venice 1734)

12 *St Cajetan Ministering to a Dying Man*
Oil on canvas
222x 134 cm
Acquired: 1919

This painting is mentioned by all the Bergamasque sources as being in a small chapel situated at the side of the sacristy of the cathedral in Bergamo, a city where the artist worked on a number of occasions from 1704 onwards. Datable to 1725-27, this work is of particular interest for the choice of colours and the handling of the light, and also for the religious subject, treated with unusual concreteness and realism linking it to the extreme unction in the series of the seven sacraments that were common in the 18th century.

Giuseppe Maria Crespi
(Bologna 1665-1747)

13 *Crucifixion*
Oil on canvas
292 x 187 cm
Acquired: 1811

This painting comes from the church of Santa Maria Egiziaca in Bologna, for which it was executed not later than 1729 after being commissioned by a Bolognese merchant. The restoration (1990) allowed a number of pentimenti to re-emerge – the hand of the soldier with a flag, that of the figure seen from behind on the right – and revealed the whole of the lower part, which was formerly indistinct. One of the most inspired and stimulating artists of the late 17th and early 18th centuries, Crespi was influenced by the Carracci, Guido Reni, Mattia Preti and the Venetians of the Cinquecento, but was wholly modern and anti-academic. He treated both secular subjects and, as in this case, religious themes with great naturalness and a remarkable expressive capacity, aiming at pictorial immediacy and light effects, but avoiding any rhetoric.

Ubaldo Gandolfi
(Bologna 1728-Ravenna 1781)

14 *St Francis Receiving the Stigmata*
Oil on canvas
263 x 180 cm
Inscribed on the reverse
"Uboldo Gandolfi 1768"
Acquired: 1811

Executed in 1822 for the church of Santo Spirito at Cingoli, in the Marches, this painting was sent to the church of Sant'Anna at Besozzo, near Varese, whence it was returned in 1978 in order to be displayed in the gallery. A mature work by Uboldo Gandolfi, who played a leading role in Bolognese art during the 18th century, this splendid altarpiece is notable for its display of academic skill, as well as its immediacy, languorous sensibility and light, bright palette of Tiepolesque origin.

Sebastiano Ricci (attributed)
(Belluno 1659-Venice 1734)

15 *Martyrdom of St Erasmus*
Oil on canvas
118 x 95 cm
Acquired: 1978

Formerly believed to be an early work by Alessandro Magnasco or, alternatively, by his teacher, Filippo Abbiati, this painting is now attributed to Sebastiano Ricci. It is likely to have been executed during the period in which he most closely identified with Magnasco, whom Ricci, in the words of the Genoese historian Giuseppe Ratti, "loved like a brother, and they were always to be seen together and it seemed that one could not live without the other".

Pierre Subleyras
(Saint-Gilles-du-Gard 1699-Rome 1749)

16 *Crucifixion with St Mary Magdalen, St Eusebius and St Philip Neri*
Oil on canvas
408 x 232 cm
Signed and dated bottom centre
"Petrus Subleyras Pinxit Romae 1744"
Acquired: 1799

Characterized by austere Classicism synthesizing the French and Italian modes, this huge altarpiece, due to its breadth of conception and clarity of vision, is one of the most complete expressions of the great artistic skill that was the key to Subleyras's success in the international milieux of 18th-century Rome.

Room XXXV Room XXXVI
Venetian paintings, Italian genre paintings and portraits of the 18th century

Room XXXV

Giovan Battista Pittoni
1 2

Pietro Longhi (Pietro Falca)
3 5

Marianna Carlevaris
4

Bernardo Bellotto
6 10

**Canaletto
(Giovanni Antonio Canal)**
7 9

Giovanni Battista Piazzetta
8 31

Francesco Guardi
11 13

Francesco Zugno
12

Giambattista Tiepolo
14

Gian Domenico Tiepolo
15

Passage between rooms XXXV-XXXVI

Nicolas de Largillière and assistants
16

Sir Joshua Reynolds
17

Giovan Domenico Ferretti
18

Anton Raphael Mengs
19

Room XXXVI

Giovan Pietro Ligari
20

**Fra Galgario
(Vittore Ghislandi)**
21 27

Gaspare Traversi
22

**Pitocchetto
(Giacomo Ceruti)**
23 24 25 26 28

Giuseppe Maria Crespi
29 30

Francesco Londonio
32

These two small rooms placed opposite each other, and the passage separating them, house a series of European paintings intended for private use and essentially profane in character. In room XXXV, on the left, there is a splendid overview of the trends in landscape and genre painting for which the Venetian painters of the 18th century working in the Rococo style are rightly famous. Paradoxically, it was in the 18th century, when the image of Venice appeared to have been consolidated, with the superimposition of Baroque buildings on the Gothic and Renaissance substratum, and its fame had spread throughout Europe – especially, thanks to the *vedutisti*, to Britain – that the city's economic and political decline began. The frequent tendency of the Venetian nobility to isolate themselves and seek solace in the beauty of a city that had now attained what was virtually aesthetic perfection is excellently illustrated in the portraits executed by Rosalba Carriera – although none of her works are to be found in the Brera, the pastel displayed here, now attributed to Marianna Carlevaris (no. 4) after previously being ascribed to Carriera herself, is inspired by her style – the depictions of the futile daily lives of both the nobles and the bourgeoisie by Pietro Longhi (no. 3) and, by contrast, the luminous views of Canaletto (nos. 7, 9) and Guardi (no. 11). The development of a more realistic, more morally committed style is to be found in the very different painting of Giovanni Battista Piazzetta (no. 8) and the views of Bernardo Bellotto – by whom there are two works entitled *View of Gazzada* (nos. 6 and 10) from his brief Lombard period – where the use of strong contrasts of light and shade seems to suggest a more transient, less joyful world.

The room opposite shows how these signals were received by other Venetian painters – for instance, Fra Galgario, in his pitiless portrayal of the Venetian nobility (no. 27) and Pitocchetto, in his fascination with the world of the forgotten and the humble (nos. 24 and 28). Together, these two rooms offer a cross section of 18th-century art with its duplicity and ambivalence in the period between the decline of the Baroque and the birth of the age of Enlightenment. And, in the middle, there is a small selection of portraits by European artists of this period, in which the *Portrait of the Singer Domenico Annibali* (no. 19) by Anton Raphael Mengs and the *Portrait of Lord Donoughmore* (no. 17) by Sir Joshua Reynolds seem to extend the same dichotomy to the rest of Europe. (P.C.M.)

Giovan Battista Pittoni
(Venice 1687–1767)

1 *Hannibal Swearing Vengeance on the Romans*
Oil on canvas
41 x 72 cm
Acquired: 1913

Various replicas are known of this small painting, datable to around 1723, which is an excellent example of the style of Pittoni, who was specialized in history pictures.
In this version, taken from the Roman historian Livy, the figures are arranged as if they were on a crowded stage where the architecture forms illusory backcloths. Although rapidly executed, this incisive work is precisely executed even as regards the details, which, at times, seem to be depicted with subtle irony.

Giovan Battista Pittoni
(Venice 1687-1767)

2 *Bacchus and Ariadne*
Oil on canvas
50 x 70 cm
Acquired: 1955

Having adopted a mythological theme, the artist creates a rich and refined narration, emphasized by a more fluent use of line and handling of paint. This is the fortunate period of Pittoni's adhesion to the Rococo, when the figures are mantled with the ethereal grace that was so popular with his followers and patrons. Numerous small replicas are known of this painting, which is datable to 1730-32.

Pietro Longhi (Pietro Falca)
(Venice 1702-1785)

3 *The Quack Dentist*
Oil on canvas
50 x 62 cm
Signed on the left "Pietro Longhi"
Acquired: 1911

Possibly from the Gambardi Collection in Florence, this painting was executed between 1746 and 1752. It is one of the most felicitous works by Longhi, who has prepared this narrative scene with sagacity and affection, so that it is comparable to the contemporary performances of Goldoni's theatre. Portrayed as a variety of social and physical types, the characters each display different emotions.

Marianna Carlevaris
(Venice 1703-after 1750)

4 *Portrait of an Unknown Man*
Pastel on paper
47 x 42 cm
Acquired: 1904

Formerly attributed to Rosalba Carriera, this portrait, datable to 1737, is now thought to be by Marianna Carlevaris, a pastel artist who was the daughter of the painter Luca Carlevaris and a contemporary of Carriera. In this sensitive work, the artist's precision and descriptive skill, especially with regard to certain details, allow the character of the gentleman to be portrayed with great freshness.

Pietro Longhi (Pietro Falca)
(Venice 1702-1785)

5 *The House Concert*
Oil on canvas
50 x 62 cm
Acquired: 1911

Also possibly from the Gambardi Collection in Florence, this painting is datable to the early 1760s and is probably the pendant to the *Quack Dentist* (no. 3). In this case, the composition is broader and a soft light bathes the whole scene – which appears to have been frozen for an instant – in delicate colours. Echoes of contemporary French painting and the English conversation pieces are particularly evident in this work.

Bernardo Bellotto
(Venice 1720–Warsaw 1780)

6 *View of Gazzada*
Oil on canvas
64.5 x 98.5 cm
Acquired: 1831

This painting was purchased by a private collector together with the *View of Villa Melzi at Gazzada*, also displayed on this wall (no. 10). It was executed after the artist's brief stay in Lombardy in 1740, before he left Italy in 1744 in order to work in Dresden. Considered to be one of the finest works by Bellotto, who was Canaletto's nephew, this painting foreruns the modern representation of landscape. The view is bathed in the light of the early morning and the vast space is skilfully depicted with strong emotional involvement.

Canaletto
(Giovanni Antonio Canal)
(Venice 1697-1768)

7 *The Bacino di San Marco from the Point of the Dogana*
Oil on canvas
53 x 70 cm
Acquired: 1928

This painting, which came to the Brera with its pendant (no. 9), was executed between 1740 and 1745, before the artist went to England. There are at least three almost identical versions of this work (Wallace Collection, London; formerly in the Fraenzl Collection, Berlin; formerly in the Holford Collection, London), other subsequent versions in private collections and another three previous ones (Woburn Abbey and the Uffizi, Florence). Although this is not one of Canaletto's greatest masterpieces, it must be regarded as a notable example of his output.

Giovanni Battista Piazzetta
(Venice 1683-1754)

8 *Rebecca at the Well*
Oil on canvas
102 x 137 cm
Acquired: 1916

Bequeathed to the Brera by Emilio Treves, this work, which can be dated around 1735-40, may be identified with a painting formerly belonging to Alvise Contarini that was reproduced as an engraving by Pietro Monaco in 1740. In the same collection there was what might be considered the pendant of this painting (*Judith and Holofernes*, now in a private collection in Milan). The religious theme is treated as if it were a pastoral scene, with echoes of models from Rubens's painting. The handling of the paint is fresh and spontaneous, while the colour is imbued with light, producing effects of radiant joyousness.

Canaletto
(Giovanni Antonio Canal)
(Venice 1697-1768)

9 *The Grand Canal towards the Point of the Dogana, from Campo San Vio*
Oil on canvas
53 x 70 cm
Acquired: 1928

The pendant of the view hanging on this wall (no. 7), this work is considered to be autograph, although perhaps slightly weaker than the other. One of the artist's favourite views, he repeated it on numerous occasions; among the most outstanding replicas are the version in the Thyssen-Bornemisza Collection (Museo Reina Sofía, Madrid) and the one in the Gemäldegalerie, Dresden, the former datable to around 1720, the latter to about 1723. The version at Holkham Hall (Earl of Leicester Collection) may be dated to around 1727.

Bernardo Bellotto
(Venice 1720-Warsaw 1780)

10 *View of Villa Melzi at Gazzada*
Oil on canvas
64.5 x 98.5 cm
Acquired: 1831

A pendant of the *View of Gazzada* (no. 6), this work, together with the other painting, has always been considered to be one of Bellotti's masterpieces, and has been highly regarded since it first came to the Brera. But, unlike the other one, this view does not correspond precisely to the topography of the site, as it combines real elements with imaginary ones. Nonetheless, it is possible to make out Lake Varese, the small village of Bodio on its shore and, in the distance, Monte Rosa. It must certainly be seen as a remarkable example of *plein-air* painting, executed with clear contrasts of light and shade as if a summer storm had just blown over.

Francesco Guardi
(Venice 1712-1793)

11 *Grand Canal with the Fabbriche Nuove at the Rialto*
Oil on canvas
56 x 75 cm
Acquired: 1855

Like the other view of the Grand Canal (no. 13), this painting was part of the Pietro Oggioni bequest, and, like its pendant, was executed after 1754. The artist, previously a figure-painter in the workshop of his father, Domenico, reveals here the extent to which he was influenced by the modes of Canaletto in his use of perspective and the composition of his landscapes. However, his use of patches of colour, together with his freer handling of the paint, help to render a vibrant, almost tormented atmosphere, foreshadowing his later output of capriccios.

Francesco Zugno
(Venice 1709-1787)

12 *Portrait of a Young Singer*
Oil on canvas
45 x 38 cm
Acquired: 1932

In the past, this work, formerly in the Giovanelli Collection in Venice, was attributed to Pietro Longhi, and it appears that its subject is derived from Rosalba Carriera's *Portrait of Faustina Bordoni* (Gemäldegalerie, Dresden) and Giuseppe Nogari's *Allegory of Music* (formerly in the Rovelli Collection, Rome). The young woman is portrayed in great detail, with her elegant attire and the fresh grace of her facial features, at the moment when the last notes of her song are dying away. With its echoes of Tiepolo's style, this work may be dated to the last decades of the 18th century.

Francesco Guardi
(Venice 1712-1793)

13 *Grand Canal towards the Rialto with the Palazzo Grimani and the Palazzo Manin*
Oil on canvas
56 x 75 cm
Acquired: 1855

This work, which also formed part of the Pietro Oggioni bequest, may be dated to after 1754 due to the presence, in the background, of the campanile surmounted by an onion dome that was built in that year. Various replicas of this painting exist, such as the one in the Galerie Koetser, Zurich, and the two views belonging to the Duke of Buccleuch. In this work, Guardi extends the representation of real space by adopting a very low and intentionally distorted viewpoint, so as to give prominence to the threatening sky, which is rendered with rapid, vigorous brushstrokes.

Giambattista Tiepolo
(Venice 1696-Madrid 1770)

14 *Temptation of St Anthony*
Oil on canvas
40 x 47 cm
Acquired: 1929

Datable around 1725, this is an early work by Giambattista Tiepolo, belonging to the period in which he frequently treated scenes of hermitic life and saints. In this composition there is a dramatic, symbolic contrast between the two ages of man, powerfully rendered by the soft, sensual treatment of the female figure and the meagre, withered effect used for St Anthony. This fantastic vision, without a precise horizon to separate earth from sky, is illuminated by a rosy light that models and exalts the figures.

Gian Domenico Tiepolo
(Venice 1727-1804)

15 *The Battle*
(St Faustinus and St Jovita Appearing in Defence of Brescia)
Oil on canvas
52 x 70 cm
Acquired: 1855

Also part of the Pietro Oggioni bequest, this work may be dated to 1754/55, like the modello, now in a private collection in Bergamo, for the fresco of the *Martyrdom of St Faustinus and St Jovita*. The artist displays the calligraphic, emphatically descriptive style that is typical of his painting, which he soon distanced from the models of his father, Giambattista. The rapid, darting line gives a fantastic air to the scene, where the back lighting throws the horses and their riders into the foreground as they are engaged in the hurly-burly of the battle. Evidently the artist was familiar with drawings by Rembrandt that were to be found in Tiepolo's workshop.

Nicolas de Largillière and assistants
(Paris 1656-1746)

16 *Portrait of a Lady*
Oil on canvas
82 x 65 cm
Acquired: 1911

Both the provenance of this portrait and the identity of the sitter are unknown. Typically Rococo in style, it is similar to other works by the artist, which are, however, frequently of a higher quality. The very precise rendering of many details (the carnations, the lace and the dress) reveal the Flemish training of the artist, while the softer, more powdery flesh-colours resemble the style of English painting. This work may be assigned to the end of the 1720s.

Sir Joshua Reynolds
(Plympton, Devon 1723- London 1792)

17 *Portrait of Lord Donoughmore*
Oil on canvas
126 x 100 cm
Acquired: 1933

Purchased in London with the aid of the Associazione Amici di Brera (Association of the Friends of Brera), this work depicts Sir Richard Hely Hutchinson (1756-1825), Lord Donoughmore, who became a member of the Irish Parliament. In fact, he is portrayed here in the red uniform of the Irish army, while the compositional scheme – a half-length figure against a tree, with a landscape in the background – was in vogue in England from about 1740 onwards. In this late work by Reynolds, with its classical style, echoing the Italian portraits of the Cinquecento and Seicento, and the fluid handling of the paint, the artist's skill in the psychological rendering of the sitter is evident.

Giovan Domenico Ferretti
(Florence 1692-1768)

18 *Self-Portrait*
Oil on canvas
110 x 85 cm
Acquired: after 1811

This painting has recently been attributed to Giovan Domenico Ferretti as a result of a comparison with his *Self-Portrait* in the Uffizi and other autograph works of his. Considered to be one of the finest examples of Florentine portraiture in the first half of the 18th century, this work may be dated around 1708 and is notable for the vivacity of the artist's expression, its splendid oval frame in stone and the passage of still life visible in the foreground, where some of the painter's tools are displayed.

Anton Raphael Mengs
(Aussig, Bohemia 1728-
Rome 1779)

19 *Portrait of the Singer Domenico Annibali*
Oil on canvas
125 x 95 cm
Dated 1750 on the base of the columns
Acquired: 1837

This work portrays the famous singer Domenico Annibali (1705-1779) from Macerata, in the Marches, who was summoned to the court of Dresden, as well as to London and Rome. The sitter is depicted as if he were an important member of the court, and the magnificence of his proud pose and sumptuous clothes are in the manner of the official portraits of the European courts around the middle of the 18th century. His face appears to be lively and intelligent, and is painted in a style resembling that of the contemporary portraits by Pompeo Batoni.

Giovan Pietro Ligari
(Sondrio 1686-1752)

20 *Portrait of Gervasio Ligari, the Artist's Father*
Oil on canvas
98 x 70 cm
Acquired: 1831

Certainly painted prior to 1724, the year when the artist's father died, this portrait is a masterpiece by Giovan Pietro Ligari, an artist from Sondrio in the Valtellina, a valley in Lombardy to the north of Lake Como. Executed while the artist was living in Milan, perhaps around 1720, this is on a par with the finest examples of the "painters of reality" thanks to the straightforward rendering of the sitter, who is portrayed without idealization or embellishment, as in the most outstanding portraits by Pitocchetto and Fra Galgario.

Fra Galgario
(Vittore Ghislandi)
(Bergamo 1655-1747)

21 *Portrait of a Painter*
Oil on canvas
75 x 60 cm
Acquired: 1813

This painting is a revival by Fra Galgario of the fluent and vigorous Venetian mode that characterized his works in the 1720s. But the artist also seems to be more attentive to the effects of chiaroscuro and modelling of Lombard origin, with results similar to those of the late output of Francesco del Cairo.

Gaspare Traversi
(Naples c. 1732-Rome 1769)

22 *The Old Woman and the Urchin*
Oil on canvas
80 x 105 cm
Acquired: 1938

This is an early work by Gaspare Traversi, a Neapolitan artist who took a particular interest in the world of the humble and the poor. Probably inspired by the plays of Domenico Barone, the marquis of Livari, Traversi's subjects appear to draw their strong expressiveness and facial features from them. This is noticeable in the foreground of this picture, in the lined and tormented face of the old woman, which recalls the strong contrasts of light and shade characterizing the followers of Caravaggio.

Pitocchetto (Giacomo Ceruti)
(Brescia 1698-1767)

23 *Portrait of a Man*
Oil on canvas
72 x 53 cm
Acquired: 1813

This painting comes from the Brera Academy with a group of other portraits that were intended to be used for teaching purposes. Only recently recognized as being a work by Ceruti, this picture must belong to his Venetian period, as is indicated by the refined colourism and tonal relationships based on shades of dull green. The humble appearance of the sitter should not allow the high quality of this work to be underestimated.

Pitocchetto
(Giacomo Ceruti)
(Brescia 1698-1767)

24 *Porter Sitting on a Basket*
Oil on canvas
130 x 91.5 cm
Acquired: 1966

Donated to the Brera by Gilberto Algranti, this painting is the pendant of the *Porter Sitting with a Basket, Eggs and Poultry* (no. 28), which is displayed a little further along the same wall. These two canvases are identified with those mentioned by a Brescian source as being in Casa Barbisoni in Brescia in 1760. Regarded as Ceruti's greatest masterpieces, they may be dated around 1735. This painting is marked by the simplicity of the composition, the very humble setting and the light of neo-Caraveggesque origin that make it an example not only of pictorial style, but also of social comment.

Pitocchetto
(Giacomo Ceruti)
(Brescia 1698-1767)

25 *Still Life with Pumpkin, Pears and Walnuts*

26 *Still Life with Pewter Plate, Crayfish, Lemon and Other Objects*
Oil on canvas
43 x 59 cm each
Acquired: 1805

Fra Galgario
(Vittore Ghislandi)
(Bergamo 1655-1747)

27 *Portrait of a Gentleman* (*Flaminio Tassi*?)
Oil on canvas
127 x 98 cm
Acquired: 1918

In a Venetian style, with a background that seems about to turn into a stormy landscape, this painting is executed with vaporous colours, the figure being carved out with light. Datable to around 1715, it must certainly be regarded as one of the masterpieces of Galgario's mature period, although it does not take the investigation of the sitter's features and anatomy to the point of revealing his hidden nature and exposing his abjection and faults.

These two canvases were listed among the items kept in the apartment of the secretary of the Brera Academy, Carlo Bianconi, in an inventory drawn up on his death in 1802. Attributed to Ceruti by the new secretary, Giuseppe Bossi, in 1806, their critical history has been somewhat chequered due to the fact that no other still lifes by Ceruti were known until a few years ago. Today they are considered to be the acme of the painter's investigation of naturalism, enhanced by great precision in the representation of detail and the effects of light and shade, which makes them comparable to the output of most outstanding European still-life painters, from Chardin to Liotard.

Pitocchetto (Giacomo Ceruti)
(Brescia 1698-1767)

28 *Porter Sitting with a Basket, Eggs and Poultry*
Oil on canvas
130 x 95 cm
Acquired: 1966

Donated by the Milanese writer and art critic Giovanni Testori, this painting is the pendant of *Porter Sitting on a Basket* described above (no. 24), with which it is associated by its similar composition and subject. Also datable around 1735, this work incorporates ideas originating from the Genoese painter Bernardo Strozzi, although these are well concealed by its Brescian and Bergamasque modes. The extraordinary sadness of this painting, with the boy's expression recorded as in a snapshot, immediately draws the spectator's attention to the tragedy of poverty and the miserable lives of the humble.

Giuseppe Maria Crespi
(Bologna 1665-1747)

29 *Self-Portrait*
Oil on canvas
42 x 30 cm
Acquired: 1914

This painting constitutes the replica of the upper part of a self-portrait of the artist in the Pinacoteca in Bologna. The artist is getting on in years (the work must be dated around 1725-30), and has a bitter, but dignified, almost haughty, expression. The engraving accompanying the biography of the artist written in 1769 by his son Luigi was copied from this self-portrait.

Giuseppe Maria Crespi
(Bologna 1665-1747)

30 *A Fair with Quack Dentists*
Oil on canvas
76 x 87.5 cm
Acquired: 1916

This work is an excellent example of this Bolognese artist's enormous output of genre paintings, which he may have begun to produce after he had worked at the court of the grand duke Ferdinando de' Medici in Florence. Here, after 1708-09, Crespi had an opportunity to see the work of the Dutch painters and the "Bamboccianti", specialists in genre pictures depicting scenes from everyday life, as in the present painting. The artist does not, however, allow the quack dentist theme to dominate his picture, which also incorporates a large portion of landscape and many other people at work, without seeking to take a moralizing stance, as is the case with the "painters of reality" in Lombardy.

Giovanni Battista Piazzetta
(Venice 1683-1754)

31 *St Philip Neri in Prayer*
Oil on canvas
46 x 37 cm
Acquired: 1908

This may be a preparatory sketch for the figure of the saint that appears in the *Virgin Appearing to St Philip Neri* in the church of Santa Maria della Fava in Venice. Some scholars, however, believe that it is a copy from this model, since Piazzetta was specialized in the execution of heads and half-figures, known as *têtes di caractère*, for sale to collectors and art lovers. These images with their strong contrasts of light and colour were very successful and were also engraved by his pupils.

31

Francesco Londonio
(Milan 1723-1783)

32 *Eight Studies of Figures*
Oil on paper
43 x 28.5 cm each
Monogrammed lower left "F.L"
Acquired: 1837

These small paintings on paper by Francesco Londonio, displayed here in a single frame, are studies for larger works now in the Museo del Castello Sforzesco, Milan, and private collections in Milan and Rome. The painting in the Museo del Castello Sforzesco, to which the study of the *Peasant Girl* relates, is datable to around 1760, the period to which the other "young shepherds" portrayed here may also be dated. One of these bears a resemblance to the *Porter Sitting with a Basket, Eggs and Poultry* by Ceruti, displayed in this room (no. 28).

Room XXXVII Room XXXVIII
Italian paintings of the 19th century

Room XXXVII
Martin Knoller
1
Andrea Appiani
2 7 26 27
Giuseppe Bossi
3 28
Giuliano Traballesi
4
Sir Thomas Lawrence
5
Domenico Aspari
6
Francesco Hayez
8 11 13 14 15 16 17 18
Marco Gozzi
9
Pierre-Paul Prud'hon
10
Federico Faruffini
12
Giovanni Segantini
19
Federico Zandomeneghi
20
Silvestro Lega
21
Giovanni Fattori
22 24
Filippo Carcano
23
Giovanni Estienne
25

Room XXXVIII
Giuseppe Pellizza da Volpedo
29
Umberto Boccioni
30

Devoted to Italian painting of the 19th century, the last rooms in the gallery house a small sample of the collections from this period belonging to the Brera that were dispersed to the Civica Galleria d'Arte Moderna in Milan (this was set up at the beginning of the 20th century, largely thanks to paintings and sculptures from the Brera) and various public buildings, including the Prefecture, the Law Courts and many others. The last room has, in fact, been drastically reduced in size due to the presence here of a storeroom viewable from the outside, which will be removed as soon as new space is available in the nearby Palazzo Citterio. Neoclassicism and the artistic milieu that grew up around the Academy of Fine Arts in the late 17th and early 18th centuries – when, under Napoleon's rule, Milan became the capital of the Kingdom of Italy, and the building programme that had already been started during the period of Austrian rule was continued – are recalled by a small but fascinating series of self-portraits by teachers at the Academy. These include Martin Knoller, Domenico Aspari and Giuliano Traballesi, who introduced the principles of Neoclassicism to painting, and also Giuseppe Bossi and Andrea Appiani, the leading exponents of the movement in Lombardy, who were responsible for setting up the Brera Gallery and its collections. Besides them, there is Antonio Canova, the most popular artist of his day, fluently portrayed by Sir Thomas Lawrence (no. 5), and Count Giovanni Battista Sommariva, the leading collector of the period, who between 1800 and 1802 was the real master of Milan and built up an immense fortune. He is depicted by Pierre-Paul Prud'hon (no. 10), an exceptional artist with a delicate technique who was an involuntary rival of David.

The long period of Romanticism and the social and patriotic commitment of history painting are exemplified almost exclusively by Francesco Hayez, who, as professor of painting at the Brera Academy, a post he held for fifty years, exerted an enormous influence over Italian art. The new themes of the Macchiaioli and Divisionists are present in celebrated works, such as the silent, sun-scorched scene in the Giovanni Fattori's *Red Wagon* (no. 22); the small closed, but serene, world, populated by women, in Silvestro Lega's *Pergola* (no. 21); the dazzling light imbued with mysticism in Giovanni Segantini's *Spring Pastures* (no. 19); and the fascinating, unfinished *Human Flood* (no. 29) by Pellizza da Volpedo. With their diversity, these works mirror the devotion to nature, the desire for sincerity, the immediacy of their vision, and also the social demands and the love for modernity that the Italian artists had in common with the vast European Realist movement. (L.A.)

Martin Knoller
(Steinach, Tyrol 1725-
Milan 1804)

1 *Self-Portrait*
Oil on canvas
97 x 74.5 cm
Signed and dated "Mart. Knoller seipsum pinxit an. 1803/aetatis suae 78"
Acquired : 1806

Intended for the Gabinetto dei Ritratti dei Pittori (collection of portraits of painters) that Giuseppe Bossi decided to set up in the Brera on the model of the famous one in the Uffizi, this self-portrait depicts the artist in the conventional pose of a painter, as if crystallized in timeless maturity that hardly seems to reflect the stated age of seventy-eight, although, in accordance with the tenets of Neoclassicism, he is portrayed with a determined expression and enlightened frankness.

Andrea Appiani
(Milan 1754-1817)

2 *Self-Portrait*
Oil on panel
19 x 15 cm
Acquired : 1823

Donated by Count Sarau, the Austrian governor of Lombardy, this small self-portrait was executed in the early 1790s with great freedom and immediacy that confirm its private destination.

Giuseppe Bossi
(Busto Arsizio, Varese 1777-Milan 1815)

3 *Self-Portrait*
Oil on panel
38 x 30 cm
Acquired: 1841

Bequeathed to the Brera by Gaetano Cattaneo, an illustrious figure in Milanese cultural circles in the early 19th century who was a friend and biographer of Bossi and a close friend of the literary figures Carlo Porta, Tommaso Grossi and Alessandro Manzoni, the painting is characterized by the introspective intensity of the artist's gaze and the rapid, cursory handling of the paint. It was executed just a year before the death of the artist, a man of the world, collector and fascinating orator who was a friend of Canova and Angelica Kauffmann, and, as secretary of the Brera Academy, played a leading role in the promulgation of Neoclassicism, of which he was both historian and critic.

Giuliano Traballesi
(Florence 1727-Milan 1812)

4 *Self-Portrait*
Oil on canvas
95 x 73 cm
Acquired: 1806

Intended for the Gabinetto dei Ritratti dei Pittori that Giuseppe Bossi set up in the Brera, this painting displays 18th-century grace and charm, in the manner of Chardin, but the style is wholly realistic. It may dated to around 1780.

Sir Thomas Lawrence
(Bristol 1769-London 1830)

5 *Portrait of Antonio Canova*
Oil on canvas
46 x 36 cm
Acquired : 1873

Purchased for its interesting subject, this painting is one of the numerous versions of the portrait executed by Lawrence in 1816, after Canova had stayed in London in the autumn of the previous year, and is particularly appreciated for its free and spontaneous handling, its pleasant naturalness deriving from models by Sir Joshua Reynolds.

Domenico Aspari
(Milan 1745-1831)

6 *Self-Portrait*
Oil on canvas
40 x 36 cm
Acquired : 1805

A great engraver and professor of figure-painting at the Brera Fine Arts Academy, Aspari painted this self-portrait in 1805 at the request of Giuseppe Bossi, who wanted it for his Gabinetto dei Ritratti dei Pittori, which was presented to the public in the Brera in 1806. Supported by clear draughtsmanship and straightforward handling of the light, this incisive portrait is one of the most unrestrained examples of Neoclassical painting.

Andrea Appiani
(Milan 1754-1817)

7 *Olympus*
(Coronation of Jupiter)
Oil on canvas
45 x 136 cm
Acquired : 1838

This canvas, which was the pendant of *Parnassus*, now lost, was intended to decorate a study in the Palazzo Reale in Milan, but it was never installed there. The painting was later purchased for display in the collection of Appiani's works on the first floor of the Palazzo di Brera. A transparent allegory of Napoleon's power, the *Olympus* is datable to 1806 and displays the academic and courtly aspect of the personality of Appiani, the most famous exponent of the Neoclassical movement in Milan, and also Napoleon's *premier peintre* (court painter) in Italy and official portrait painter to his family, a powerful commissioner for the fine arts and promoter of the plan for requisitioning works of art that formed the basis of the new art gallery.

Francesco Hayez
(Venice 1791-Milan 1882)

8 *Portrait of the Borri Stampa Family*
Oil on canvas
125 x 108 cm
Acquired : 1900

This work forms part of the Stefano Stampa bequest (1879): the collector is depicted here as a child absorbed in writing and leaning on the knees of his mother, Teresa Borri, the widow of Stefano Decio Stampa and future wife of the novelist Alessandro Manzoni, portrayed with her first family on the model of the conversation piece that had spread from England to the rest of Europe. This painting, which shows great refinement of manners and sentiment, was painted in 1822-23. Unable at first to meet the requirements of his client, Hayez had to make some modifications, lightening the landscape and improving the appearance of the widow, who complained about her ugly neck.

Marco Gozzi
(San Giovanni Bianco, Bergamo 1759-Bergamo 1839)

9 *A Stream in the Valsesia*
Oil on canvas
80 x 57 cm
Signed and dated "Gozzi P. 1818"
Acquired: 1818

This painting is the only one of numerous landscapes by this artist – over twenty – in the Brera collections at present on display in the gallery. Marco Gozzi, the doyen of Lombard landscape painters, who, also because of his age, continued the Arcadian and classicizing modes in vogue in the 18th century, was linked to the Brera by a government commission that, from 1807 onwards, engaged him, firstly under the French, then, after the Restoration, under the Austrians, to deliver three landscapes a year to the Brera Academy of Fine Arts in exchange for a stipend and travel expenses.

These views, centring on places originally chosen by the Ministry of the Interior – which wanted to document characteristic spots in Lombardy (although this picture shows a valley in Piedmont), especially if linked to important productive activities – are characterized by total topographical fidelity, down-to-earth enlightenment and serene good taste, while love for peace and order predominates.

Pierre-Paul Prud'hon
(Cluny 1758-Paris 1823)

10 *Portrait of Count Giovanni Battista Sommariva*
Oil on canvas
210 x 156 cm
Signed lower left "P.P. Proud'hon f.bat"
Acquired: 1873

This work, bequeathed to the Brera by Emilia Sommariva Seillière, together with a portrait of herself and other portraits of her family, jewellery and a collection of enamels reproducing the paintings in Giovanni Battista Sommariva's famous collection, is one of the most splendid Neoclassical portraits executed between the Empire and the Restoration.

Powerful and ambitious, Sommariva had risen to the highest offices in the Cisalpine Republic before Count Francesco Melzi d'Eril came to power, and had then, thanks to his immense fortune, engaged in a remarkable activity as patron and collector. Here he has been portrayed in the English manner, with a landscape background together with his favourite statues by Canova, *Palamedes* and *Terpsichore*, which, at the same time, celebrate the "divine art" of the sculptor, whom he greatly admired, and the supremacy of the collector's taste. Commissioned in 1813 for his princely Paris palace – which was so crammed with pictures and statues both old and new that it rivalled the Louvre – the painting was immediately exhibited at the Salon of 1814.

Francesco Hayez
(Venice 1791-Milan 1882)

11 *Mary Queen of Scots Receiving Her Death Sentence*
Oil on panel
45 x 58 cm
Signed and dated lower left
"F.co Hayez/1827"
Acquired: date unknown

The theme of this painting – a favourite with Romantic artists and writers, it was popularized by Schiller's play *Maria Stuart* (1800) – was treated by Hayez in two monumental works that attracted considerable attention. This work has been identified as an oil sketch commissioned from the artist by the great Torinese collector Gaetano Bertolazzone d'Arache that was displayed at the Brera exhibition of 1829.

Federico Faruffini
(Sesto San Giovanni, Milan 1831-Perugia 1869)

12 *Sordello and Cunizza*
(*The Poet's Love*)
Oil on canvas
115 x 86 cm
26 x 86 cm (lunette)
Acquired: 1865

Executed in 1864, this painting was purchased for the Brera Academy the following year by the Ministry of Education. Well known thanks to a vast number of reproductions and because it was often displayed in exhibitions, this picture – which, with its experimental combination of Romanticism and Realism, bears a resemblance to the output of the English Pre-Raphaelites – is not wholly successful in the way it is divided into the central part, portraying Sordello (a troubadour mentioned in Dante's *Divine Comedy*) and the countess of San Bonifacio, and the gilded lunette, showing his encounter with Dante and Virgil.

Francesco Hayez
(Venice 1791-Milan 1882)

13 *The Kiss
(Youthful Episode.
14-Century
Costumes)*
Oil on canvas
112 x 88 cm
Acquired: 1886

Bequeathed to the Brera by the Count Alfonso Maria Visconti, who had commissioned it from Hayez, this painting was displayed at the Brera exhibition of 1859, a few months after the triumphal entry of Vittorio Emanuele II and Napoleon III into Milan. The canvas, which was intended to celebrate the victories of the Second War of Independence, immediately became extremely popular both as a patriotic symbol and a good omen for the successful growth of the young nation.

Probably the most frequently reproduced Italian painting of the 19th century, the fascination of this work lies in the theatrical quality conveyed by the natural gestures, its formal equipoise and the splendid sheen of the girl's dress that has its precedents both in Titian and Savoldo – in other words, in the great Venetian tradition, of which the artist regarded himself as the last exponent – and in the purist style of the contemporary school of Munich.

The leading protagonist of history painting concerned with the issues of the Risorgimento and supported by his patriotic fervour, Hayez, now nearly seventy years old, had unintentionally created the manifesto for the struggle for independence, which he experienced as a conflict between, on the one hand, his devotion to his country and a need for freedom and, on the other, affection for his family.

Francesco Hayez
(Venice 1791-Milan 1882)

14 *Portrait of Teresa Manzoni Stampa Borri*
Oil on canvas
117 x 92 cm
Signed and dated lower left
"Francesco Hayez italiano/
della città di Venezia 1849"
Acquired: 1900

Commissioned by Stefano Stampa in 1847 and completed in the following year, this portrait then remained for two years in Hayez's studio, during which time the artist signed and dated the work, adding the patriotic word "Italian" to his name. It came to the Brera with the other works in the Stampa bequest. The favourite portraitist of Milanese society – which consisted not only of aristocrats, the upper middle class and cultural figures, but also of *noveaux riches* and singers at the Scala Theatre – Hayez produced a series of pictures that, in various ways, became emblems of Romanticism and contemporary society. Thanks to his capacity to subject his sitters to penetrating psychological introspection and the remarkable manner in which he stressed their different social and cultural roles, Hayez's output is comparable to that of the leading European portrait artists of his day. Like the portrait executed in 1841 of the sitter's second husband, Alessandro Manzoni (no. 16), to which it is the pendant, this picture was created as a private work. A gift from a son to his mother, it mirrors the supreme refinement of manners, thoughts and affection, which is made perceptible by the everyday nature of the composition and the choice of sober, dull colours interrupted only by the whiteness of the lace and hands, and the bright blue of the ribbon.

Francesco Hayez
(Venice 1791-Milan 1882)

15 *The Last Moments of the Doge Marin Faliero on the Staircase Known as "del Piombo"*
Oil on canvas
238 x 192 cm
Signed and dated lower left "Francesco Hayez da Venezia/dipinse dell'età di/anni 77/in Milano 1867"
Acquired: 1867

Donated by the artist to the Brera Academy after the annual exhibition of 1867, this is his last work in the genre of history painting. With the modes of a great academician, the artist depicts a scene from Byron's dramatic poem of 1821, painting his self-portrait as the old doge condemned to death, thus assuming – perhaps because he was disappointed by the turn events were taking in Italy – the tragic and bitter role of the hero who succumbs to the intrigues of power.

Francesco Hayez
(Venice 1791-Milan 1882)

16 *Portrait of Alessandro Manzoni*
Oil on canvas
120 x 92.5 cm
Acquired: 1900

Part of the Stefano Stampa bequest, Manzoni's step-son, this portrait, which is by far the best-known of the novelist, was executed in 1841. It was commissioned by Teresa Borri Stampa (she had been married to Manzoni for four years at that time) for whom Hayez had previously painted the *Portrait of the Borri Stampa Family* (no. 8) and a history painting with a patriotic theme, *The Plot of the Lampugnani*. Completed after fifteen sittings, because the artist wanted it to be wholly natural and painted from life, this portrait has a humble, everyday air that is a reflection of the religious and social ethic professed by the writer, and is notable for its sober, but not severe, range of colours.

Francesco Hayez
(Venice 1791-Milan 1882)

17 *A Vase of Flowers on the Window-Sill of a Harem*
Oil on canvas
125 x 94.5 cm
Acquired: 1882

Bequeathed to the Brera by the artist himself, this painting was executed in 1881 and was immediately a success because it appeared to be "a ray of youth shed by the ever alert spirit of an agreeable old man". The ninety-year-old artist was, in fact, able to work confidently and felicitously, creating a festive display of colour.

Francesco Hayez
(Venice 1791–Milan 1882)

18 *Melancholy*
Oil on canvas
138 x 101 cm
Acquired: 1889

This painting was bequeathed to the Brera by the marquis Filippo Ala Ponzoni. Executed between 1840 and 1842, it contains a number of the recurrent features of Hayez's painting: an interest in Romantic themes and a taste for adding veiled patriotic allusions to the subject; the refinement of the colour and the echoes of Venetian painting present in the splendid dress of light blue satin, which, like the one in *The Kiss* (no. 13), is derived from Titian and Savoldo; the delight in asserting his skill as a virtuoso by painting, as if it were a picture in the picture, a magnificent still life of flowers emulating Flemish finesse; and his very evident interest in female beauty.

Giovanni Segantini
(Arco, Trento 1858-Schafberg, Engadine 1899)

19 *Spring Pastures*
Oil on canvas
95 x 155 cm
Initialled and dated lower right "G.S. 1896"
Acquired: 1957

Donated to the Brera by the Associazione Amici di Brera, this painting soon became one of the most popular works in the gallery. The artist considered it to be one of his most outstanding, and he immediately sent it to international exhibitions in Munich, Zurich and Venice. The work belongs to the "mystical", Symbolist series of his later years, when Segantini, isolated in the solitude of the Maloja, in Engadine (Switzerland), became a legend, but, at the same time, it is a felicitous return to the themes of peasant life and mountain landscapes that he treated in the 1880s. Making skilful use of the Divisionist technique, Segantini manages to give the greatest possible luminosity and clarity to the green pastures dominated by the whiteness of the mountains and the huge cow in the centre, which recalls the ancestral themes of maternity and celebrates the purity and solitary peace of the high Alps.

Federico Zandomeneghi
(Venice 1841-Paris 1917)

20 *The Curl* (*The Toilet*)
Oil on canvas
89.5 x 47 cm
Signed lower left "Zandomeneghi"
On loan since 1950 from the Civica
Galleria d'Arte Moderna, Milan

Executed in Paris, where the artist made his home in 1874 – coming into contact with the Impressionists, with whom he exhibited from 1878 onwards – this work may be dated between 1894 and the very first years of the 20th century. It shows the influence of Degas and Renoir, whose choices, including those of colour, are offered here in a simpler, more ordinary style with intimist, bourgeois overtones.

20

Silvestro Lega
(Modigliana, Forlì 1826-Florence 1895)

21 *The Pergola* (*Early Afternoon*)
Oil on canvas
75 x 93.5 cm
Signed and dated lower left
"S. Lega 68"
Acquired: 1931

Donated by the Associazione Amici di Brera, this painting soon became deservedly popular. Executed at Piagentina, on the hills near Florence where the artist had his studio from 1861 onwards, attracting many Macchiaioli friends who went there to paint from life, this is an exquisitely made work that portrays the closed world of bourgeois women, depicting it with a serenity that is almost mythical in flavour and with an attention to the effects of light that elsewhere is only to be found in early Monet.

21

Giovanni Fattori
(Leghorn 1825-Florence 1908)

22 *The Red Wagon*
Oil on canvas
88 x 170 cm
Signed lower left "Gio. Fattori"
Acquired: 1937

Purchased by Ettore Modigliani (a former director of the Brera Gallery), this painting comes from the Riccardo Gualino Collection in Turin, one of the most outstanding Italian collections at the time. Executed soon before it was displayed at the Esposizione Nazionale in Venice in 1887, this work was regarded by Fattori himself as one of his best works. During the 20th century it has become well-known and is now considered to be one of the greatest masterpieces of Italian 19th-century Realism. A painter of the Maremma (a marshy coastal area in southern Tuscany) and the sea and countryside around his native Leghorn, peasants, stone-breakers and women carrying water, horses, oxen and carts, Fattori has focused on the theme of repose and peace that unites the herdsman to the white oxen as they wait in the intense midday heat, made tangible by the simple contrasts of light and shade.

Filippo Carcano
(Milan 1840-1914)

23 *A Game of Billiards*
Oil on canvas
78 x 106 cm
Signed bottom centre
"Carcano Filippo"
Acquired: 1872

Datable to 1867, the year in which it was displayed at the annual exhibition at the Brera, this work was long regarded as a forerunner of Divisionism. In reality it is a personal and original experiment into the effects of light by the artist, who was particularly concerned in this period with Realist subjects and influenced, in this case, by the results of photography, which had begun to arouse the interest of painters.

Giovanni Fattori
(Leghorn 1825–Florence 1908)

24 *Prince Amedeo of Savoy Wounded at the Battle of Custoza*
Oil on canvas
100 x 265 cm
Acquired: 1872

Executed in 1870, this painting was displayed in 1872 at the Esposizione Nazionale di Belle Arti in Milan. Fattori has illustrated the epic of the Risorgimento in an unusual manner, without rhetoric, by painting the scenes behind the lines, the camps and the wagons with the wounded and supplies. For him, battles are composed of weariness and the tedious wait for orders, the sweat and suffering of men and horses alike, and, at times, terrible confusion. Thus the incident of the prince wounded during the bloody Battle of Custoza is only portrayed during a pause in the fighting, after the ambulance has arrived and, although he is in the centre of the picture, supported by his aide-de-camp, the prince is almost hidden by the soldiers and horses.

Giovanni Estienne
(Florence 1840-after 1892)

25 *The Third National Shooting Competition in Florence*
Oil on canvas
46 x 56 cm
Acquired: 1951

Donated by a Lombard collector of 19th-century Italian painting, this work was formerly ascribed to Raffaello Sernesi, by whom there were another eleven paintings in this collection. This attribution was first questioned in the 1980s, while it is only recently that the subject has been identified – the national shooting competition that was inaugurated at the Cascine, in Florence, on 18 June 1865 and lasted a whole week (the previous title was *Patriots at the Shooting Range*) – while the artist is now thought to be Giovanni Estienne, a little-known young painter who had hitherto only produced still lifes and portraits. Despite this change of attribution, the picture continues to symbolize a passion for the real world and an interest in contemporary life and ordinary, workaday things, portrayed with the simple colours and light of the Macchiaioli painters who met at Piagentina (see no. 21).

Andrea Appiani
(Milan 1754-1817)

26 *Venus and Cupid;*
Venus and Adonis Bathing;
Adonis Held Back by Venus and Cupid;
The Death of Adonis
Oil on canvas
81 x 112 cm each
Acquired: 1996

These four paintings, which still have the original frames designed by Giocondo Albertolli, were executed between 1805 and 1810 for the Milanese residence of Count Francesco Melzi d'Eril. The most outstanding figure in Milan during the Napoleonic occupation, the latter was vice-president of the Cisalpine Republic, then grand chancellor when the Kingdom of Italy was proclaimed. Depicting the myth of Venus and Adonis, these are works from the artist's mature period and are distinguished by serene Neoclassicism, with its delicate 18th-century character and remarkable grace, and intense chiaroscuro, efficaciously portraying figures from a lesser repertoire for private use. *Venus and Adonis Bathing* is a replica, with only minor variations, of the central figures in the small panel painting of *Mars and Venus* (1801), now in the Galleria d'Arte Moderna, Milan.

Andrea Appiani
(Milan 1754-1817)

27 *Portrait of Ugo Foscolo*
Oil on canvas
88 x 72 cm
Acquired: 1884

This portrait of the great Romantic poet is dated to 1801-02, when his novel *Jacopo Ortis* was first published in Milan; the poet's features, from his aquiline nose to his thick red hair, are improved and made softer according to an idealising taste which was rather frequent in Appiani's portraits. This portrait is memorable as a translation into images of the wealth of dreams, gloomy thoughts and stormy moods that makes *Jacopo Ortis* one of the most famous novels of the period.

27

28

Giuseppe Bossi
(Busto Arsizio, Varese 1777-Milan 1815)

28 *Self-Portrait with Gaetano Cattaneo, Giuseppe Taverna and Carlo Porta*
Oil on canvas
51 x 64 cm
Acquired: 1998

A masterpiece of Bossi's portraiture and a typical example of Italian Neoclassicist painting, this small canvas was for private use. It depicts the artist with his friends Gaetano Cattaneo, a numismatist and outstanding intellectual in early 19th-century Milan, Giuseppe Taverna, a public figure from an illustrious noble family, and Carlo Porta, a vernacular poet. Due to the presence of the latter the painting was long known as the *Cameretta portiana*, but, in 1973, it was pointed out that it does not represent the famous literary group associated with the poet (the "cameretta portiana" of the title) that played an important part in the birth in Romanticism because Bossi died in 1816, before it was founded. This fascinating work is based on the evocative power of the faces, stressed by the effects of light and shade, and is notable for the severe colours and the way the image appears to be focused due to the lack of a background.

Giuseppe Pellizza da Volpedo
(Volpedo, Alessandria 1868-1907)

29 Human Flood
Oil on canvas
225 x 438 cm
Acquired: 1986

Until the 1940s the property of the artist's heirs, this work was subsequently sold by auction and donated to the Brera. This scene, of monumental breadth, with the group of striking labourers who step forward confidently and united, had its precedents in a series of sketches, cartoons and drawings collected together under the edifying title of *Ambasciatori della fame* (*Ambassadors of Hunger*), was executed, accompanied by various drawings and a sketch, in 1895 and 1896. Not satisfied with the results, the artist did not finish the work and, after a pause for reflection, in 1896 portrayed the same subject again in a new huge painting, *Il Cammino dei lavoratori* or *Il Quarto Stato* (*The Workers' Way* or *The Fourth Estate*, Civica Galleria d'Arte Moderna, Milan). Completed in 1901-02, this was destined to become the manifesto of the class struggle and the emancipation of the working class. Dedicated to the topical theme of political commitment, towards which he, as a progressive intellectual, was guided by his social conscience, this enormous canvas, which has remained as an imposing sketch, plays a central role in Divisionist painting thanks to its great symbolic value and the rigorous and complex technique used, with a wealth of experimental features.

Umberto Boccioni
(Reggio Calabria 1882-
Verona 1916)

30 *Self-Portrait*
Oil on canvas
70 x 100 cm
Signed and dated upper right
"U. BOCCIONI-1908"
Acquired: 1951

Donated by Vico Baer, a friend of the artist and a collector of his works, this self-portrait with a fur hat, a souvenir of his visits to Russia in 1906 and 1907, was executed in Milan, in his studio-flat in Via Adige. Here the artist has used a confident and free Divisionist technique. The outskirts of Milan, with houses under construction, are clearly depicted for the first time in this work; these were to play an important part in his pre-Futurist works and are also to be seen in his sketch for the *City Rises* (room I, no. 3).

On the reverse of the canvas there is another self-portrait, datable to 1905-06, partially destroyed by the artist himself, but brought to light again by restoration in 1981.

**Index of artists
Glossary
Select Bibliography**

Index of artists

Alunno (Niccolò di Liberatore) _191_
Andrea di Bartolo _64_
Anguissola Sofonisba _153, 160_
Anselmi Michelangelo _214_
Appiani Andrea _313, 327, 328_
Aspari Domenico _315_
Assereto Gioacchino _257_
Barnaba da Modena _56_
Barocci Federico _233_
Baronzio Giovanni _55_
Bartolomeo da Reggio _59_
Bartolomeo di Tommaso _191_
Bartolomeo Veneto _172_
Basaldella Afro _19_
Baschenis Evaristo _260, 263_
Bassano Jacopo (Jacopo da Ponte) _121_
Bastiani Lazzaro _75_
Batoni Pompeo _281_
Battistello (Giovan Battista Caracciolo) _244_
Bellini Gentile _105_
Bellini Giovanni _86, 88, 89, 105_
Bellini Jacopo _62_
Bellotto Bernardo _295, 297_
Bembo Bonifacio _67_
Benzoni Geminiano _205_
Bergognone (Ambrogio da Fossano) _148, 167_
Berruguete Pedro _73_
Bissolo Francesco _85_
Boccaccino Boccaccio _163_
Boccaccino Camillo _160_
Boccioni Umberto _20, 330_
Boltraffio Giovan Antonio _172_
Bonifacio Veronese (Bonifazio de' Pitati) _133_
Bonnard Pierre _20_
Bonsignori Francesco _109_
Bordone Paris _96, 134, 135, 136, 137_
Bossi Giuseppe _314, 328_
Bottani Giuseppe _286_
Bramante Donato (Donato di Pascuccio d'Antonio) _220_
Bramantino (Bartolomeo Suardi) _143, 144_
Braque Georges _21_
Bronzino (Agnolo di Cosimo di Mariano Tori) _228_
Brueghel Jan the Elder (Jan Velvet) _273, 276_
Campi Antonio _154, 160_
Campi Bernardino _159_
Campi Giulio _161, 163_
Campi Vincenzo _157_
Campigli Massimo _21, 47_
Canaletto (Giovanni Antonio Canal) _296, 297_
Caravaggio (Michelangelo Merisi) _241_
Carcano Filippo _325_
Cariani (Giovanni Busi) _93, 132_
Carlevaris Marianna _294_
Carloni Carlo Innocenzo _281_
Carpaccio Vittore _82, 83_
Carrà Carlo _22-23_
Carracci Annibale _234_
Carracci Ludovico _233, 234, 236_
Cerano (Giovanni Battista Crespi) _250, 251, 252_
Cesare da Sesto _170_
Cima da Conegliano (Giovanni Battista Cima) _76, 77, 84, 104, 106_
Correggio (Antonio Allegri) _213, 214_
Costa Lorenzo _181_
Crespi Daniele _250_

Index of artists

Crespi Giuseppe Maria	*287, 308*
Crivelli Carlo	*193, 194, 195, 196*
Crivelli Vittore	*197*
Daddi Bernardo	*59*
de' Bardi Donato	*175*
de Beer Jan	*269, 270*
de Ferrari Orazio	*258*
de Pisis Filippo (Filippo Tibertelli)	*24-29*
de' Predis Giovanni Ambrogio	*174*
de' Roberti Ercole	*206*
del Cairo Francesco	*249, 253*
del Cossa Francesco	*180*
Dossi Dosso (Giovanni di Niccolò Luteri)	*207, 209*
El Greco (Domenikos Theotokopoulos)	*272*
Estève Maurice	*30*
Estienne Giovanni	*326*
Faruffini Federico	*318*
Fattori Giovanni	*325, 326*
Ferrari Gaudenzio	*141, 142*
Ferretti Giovan Domenico	*302*
Figino Giovanni Ambrogio	*158, 159*
Fogolino Marcello	*108*
Follower of Leonardo da Vinci	*171*
Foppa Vincenzo	*144, 145, 146*
Fra Carnevale	*189*
Fra Galgario (Vittore Ghislandi)	*303, 306*
Francesco di Gentile	*69*
Francia Francesco (Francesco Raibolini)	*215*
Fyt Jan	*262*
Gandolfi Ubaldo	*288*
Garofalo (Benvenuto Tisi)	*208*
Genga Girolamo	*226*
Gentile da Fabriano	*65, 66*
Gentileschi Orazio	*245*
Gessi Francesco	*235*
Giampietrino (Giovan Pietro Rizzoli)	*171*
Giordano Luca	*257, 284*
Giorgio di Andrea	*64*
Giovanni Agostino da Lodi	*156, 175*
Giovanni d'Alemagna	*73*
Giovanni da Bologna	*62*
Giovanni da Milano	*58*
Girolamo da Santacroce	*75*
Girolamo da Treviso the Elder	*74*
Girolamo di Giovanni	*190*
Govaerts Abraham	*277*
Gozzi Marco	*318*
Gramatica Antiveduto	*235*
Guardi Francesco	*298, 299*
Guercino (Giovan Francesco Barbieri)	*237*
Hayez Francesco	*316, 318, 319, 320, 321, 322, 323*
Heintz Joseph the Younger	*264*
Jacopino da Reggio	*59*
Jordaens Jacob	*259*
Knoller Martin	*285, 313*
Knüpfer Nicolaus	*274*
Largillière Nicolas de	*301*
Lawrence Sir Thomas	*315*
Lega Silvestro	*324*
Leonbruno Lorenzo	*185*
Liberale da Verona	*81*
Licini Osvaldo	*30*
Ligari Giovan Pietro	*303*
Lomazzo Giovan Paolo	*155, 158*

Lombard painter	173
Londonio Francesco	309
Longhi Pietro (Pietro Falca)	294, 295
Lorenzetti Ambrogio	57
Lorenzo Veneziano	60
Lotto Lorenzo	94, 95, 96, 115, 126
Luini Bernardino	148, 169, 170
Master Giorgio	74
Master of 1518 (Jan van Dornicke)	269
Master of Mocchirolo	51
Master of Violantria (Amico Aspertini?)	182
Master of the Female Half-Figures	270
Master of the Gesuati	179
Master of the Pala Sforzesca	147
Master of the Pesaro Crucifix	56
Mafai Mario	31
Maineri Giovan Francesco	182
Malinconico Nicola	282
Mansueti Giovanni	107
Mantegna Andrea	87, 88, 89, 111
Mantuan painter	184
Marco d'Oggiono	149
Marini Marino	32-33
Martini Arturo	34
Martini Giovanni da Udine	81
Mazzola Filippo	185
Mazzolino Ludovico	207
Melone Altobello	153, 162
Mengs Anton Raphael	302
Michele da Verona	103
Modigliani Amedeo	35
Montagna Bartolomeo	83, 110
Morandi Giorgio	36-39
Morazzone (Pier Francesco Mazzucchelli)	250, 251
Moretto da Brescia (Alessandro Bonvicino)	126, 127, 128
Moro (Francesco Torbido)	93
Morone Francesco	111
Moroni Giovan Battista	97, 128, 131
Nicolò di Pietro	63
Nicolò Pisano (Niccolò di Bartolomeo dell'Abrugia)	204, 205
North European Caravaggista	245
Ortolano (Giovanni Battista Benvenuti)	209
Padovanino (Alessandro Varotari)	117
Palma Giovane (Jacopo Negretti)	98, 99
Palma Vecchio (Jacopo Negretti)	109, 137
Palmezzano Marco	183, 202
Paolo di Giovanni Fei	61
Pellizza da Volpedo Giuseppe	329
Perino del Vaga (Piero di Giovanni Bonaccorsi)	227
Peterzano Simone	154
Piazza Callisto	156, 162
Piazza Martino	155
Piazzetta Giovanni Battista	296, 309
Picasso Pablo	40
Piero della Francesca	219
Pietro Alamanno	192
Pietro da Cortona (Pietro Berrettini)	264
Pisan painter	55
Pitocchetto (Giacomo Ceruti)	304, 305, 306, 307
Pittoni Giovan Battista	293
Poliakoff Serge	40
Pordenone (Giovan Antonio de' Sacchis)	125
Preti Mattia	242
Previtali Andrea	85

Index of artists

Procaccini Giulio Cesare *251, 252, 253*
Prud'hon Pierre-Paul *317*
Raphael (Raffaello Sanzio) *221*
Raphaël Antonietta *41*
Rembrandt Harmensz van Rijn (circle) *274*
Reni Guido *237*
Reynolds Sir Joshua *301*
Ricci Sebastiano *287, 288*
Rode Herman *271*
Romanino (Gerolamo de' Romani) *125, 129, 131*
Rondinelli Niccolò *201, 203*
Rosai Ottone *41*
Rosso Medardo *42*
Rubens Sir Peter Paul *259, 273*
Sacchi Gaspare *225*
Salviati Francesco (Francesco de' Rossi) *229*
Sandrart Joachim von *258*
Savoldo Gian Gerolamo *130*
Scipione (Gino Bonichi) *42-43*
Scotti Giovan Stefano *147*
Scotti Giovanni Bernardino *147*
Segantini Giovanni *323*
Serra Pere *61*
Severini Gino *43*
Signorelli Luca *220*
Simone da Corbetta *51*
Sironi Mario *44-45*
Soffici Ardengo *46*
Sogliani Giovanni Antonio *228*
Solario Andrea *168, 174*
Solimena Francesco *282*
Spagnoletto (Jusepe de Ribera) *243*
Stefano da Verona (Stefano da Zevio) *66*
Strozzi Bernardo *261, 264*
Subleyras Pierre *286, 289*
Sustris Lambert *134*
Tanzio da Varallo (Antonio d'Errico) *249*
Tiepolo Giambattista *285, 299*
Tiepolo Gian Domenico *300*
Tintoretto (Jacopo Robusti) *98, 118, 119*
Titian (Tiziano Vecellio) *94, 115*
Traballesi Giuliano *314*
Traversi Gaspare *304*
Tura Cosmè *181*
van Dornicke Jan (Master of 1518) *269*
van Dyck Sir Anthony *258, 273*
van Goyen Jan Joseph *276*
van Santvoort Dirck *272*
van Thielen Jan Philip *275*
Venetian painter *184*
Veronese (Paolo Caliari) *116, 120, 121*
Vitali Candido *260*
Viti Timoteo *225*
Vivarini Alvise *103, 108*
Vivarini Antonio *73*
Wols (Otto Wolfgang Schulze) *47*
Zaganelli Bernardino *184, 201*
Zaganelli Francesco *183, 201, 203*
Zandomeneghi Federico *324*
Zavattari (Second master of Monza) *68*
Zugno Francesco *298*

Glossary

Altarpiece: A devotional work of art set on, above or behind an altar in a church.

Bole: Clay containing iron oxide, usually reddish-brown in colour, used as the underlayer for gold leaf in water-gilding.

Cassone (-nes, -ni): An Italian marriage-chest, often richly decorated, especially in the 15th century, with carved and gilt mouldings and painted panels.

Chiaroscuro: The technique in painting of modelling form by contrasting effects of light and shade; pioneered in the Renaissance by Leonardo da Vinci, it is especially associated with Caravaggio.

Cinquecento: The 16th century in Italian art.

Condottiere (-ri): A leader of a troop of mercenaries from the 13th to the 16th centuries.

Counter-Reformation: The reform movement of the Roman Catholic Church in the 16th and early 17th centuries aimed at countering the effects of the Protestant Reformation.

Donor: The person who commissioned a painting, especially late medieval altarpieces, and is portrayed in the work itself with the other religious figures.

Ex-voto (ex-votos): A painting or other work of art given to shrine as a votive offering for a personal favour or blessing received.

Faldstool: A backless seat (frequently folding) used by a bishop or other prelate when not occupying his throne.

Grotesque: A style of ornamentation, derived by Renaissance architects and painters from Ancient Roman decorations, in which fantastic human and animal figures are combined with leaf and flower forms interlaced with ornate arabesques.

Modello (-lli, -llos): A small, often highly finished, version of a larger painting or sculpture prepared for the patron's approval.

Pentimento (-ti): A trace of earlier painting beneath a layer of paint, indicating the artist changed his mind while executing the work.

Pinnacle panel: The topmost panel of a multi-tiered altarpiece.

Polyptych: A painting consisting of more than three panels fastened together, usually by hinges; a *diptych* is composed of two panels; a *triptych* is made of three panels; the outer ones or *wings*, are usually hinged to fold over the central one.

Predella (-lle): A long, narrow panel running along the lower edge of an altarpiece; it is usually divided into a series of smaller paintings (*predelle*), often depicting scenes from the lives of the saints represented in the panels above.

Quattrocento: The 15th century in Italian art.

Reliquary: A container in which a relic or relics are kept.

Scuola (-le): The buildings in Venice where the medieval religious confraternities or guilds used to meet; the confraternities or guilds themselves.

Seicento: The 17th century in Italian art.

Settecento: The 18th century in Italian art.

Sfumato: The technique of softening outlines and allowing tones and colours in oil painting to shade gradually into one another.

Signore: The *de facto* political head of a city; *signoria* was the governing body of any of various Italian medieval republics.

Sinopia (-pie): A preliminary rough sketch for a fresco, done with red iron oxide pigment also known as sinopia (originally from Sinope, in Asia Minor).

Sotto in su: The depiction of figures from below with extreme foreshortening.

Tempera: An emulsion used as a medium for pigment, traditionally made with whole eggs or egg-yolk. Particularly used by Italian 14th- and 15th-century painters.

Trecento: The 14th century in Italian painting.

Tridentine: Of or relating to the Council of Trent, the council of the Roman Catholic Church that met between 1543 and 1563 at Trent (Trento), South Tyrol.

Underpainting: The preliminary layer, or layers, of paint subsequently overlaid by another coat.

Vedutista (-sti): Italian 18th-century painters who produced *vedute* (detailed, accurate landscape paintings, usually townscapes).

Select Bibliography

For a list of publications (all in Italian) regarding the Brera Gallery see the Italian edition of this book. The following are publications in English providing useful information about the various schools and artists represented in the Brera:

Beck, James, *Italian Renaissance Painting*, Harper & Row, New York, 1981.

Bomford, David et al., *Art in the making: Italian Painting before 1400*, exhibition catalogue, The National Gallery, London.

Braun, Emily, ed., *Italian Art in the Twentieth Century*, exhibition catalogue, Prestel Verlag, Munich and Royal Academy of Arts, London, 1989.

Brown, Patricia Fortini, *The Renaissance in Venice: A World Apart*, Everyman Art Library, George Weidenfield & Nicolson, London, 1997.

Cole, Alison, *Art of the Italian Renaissance Courts*, Everyman Art Library, George Weidenfield & Nicolson, London, 1995.

Freedburg, S.J., *Painting in Italy 1500-1600*, Penguin History of Art, Penguin Books, Harmondsworth, 1979.

Hartt, Frederick, *History of Italian Renaissance Art: Painting, Sculpture, Architecture*, 4th edition, revised by D. Wilkins, Thames and Hudson, London, 1994.

Martineau, Jane, and Andrew Robison, eds., *The Glory of Venice: Art in the Eighteenth century*, exhibition catalogue, Royal Academy of Arts, London, 1994.

Martineau, Jane, and Charles Hope, eds., *The Genius of Venice 1500-1600*, exhibition catalogue, Royal Academy of Arts, London, and Weidenfield and Nicolson, London, 1983.

Murray, Linda, *The High Renaissance and Mannerism: Italy, the North and Spain 1500-1600*, World of Art, Thames and Hudson, 1977.

Shearman, John, *Mannerism, Style and Civilization*, Penguin Books, Harmondsworth, England, 1967.

Steer, John, *Venetian Painting: A Concise History*, World of Art, Thames and Hudson, London, 1970.

Welch, Evelyn, *Art and Society in Italy 1350-1500*, Oxford History of Art, Oxford University Press, Oxford, 1997.

White, John, *Art and Architecture in Italy 1250-1400*, Penguin Books, Harmondsworth, England, 1987.

Wittkower, Rudolf, *Art and Architecture in Italy 1600-1750*, Penguin Books, Harmondsworth, England, 1980.